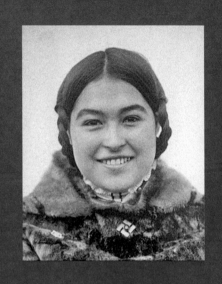

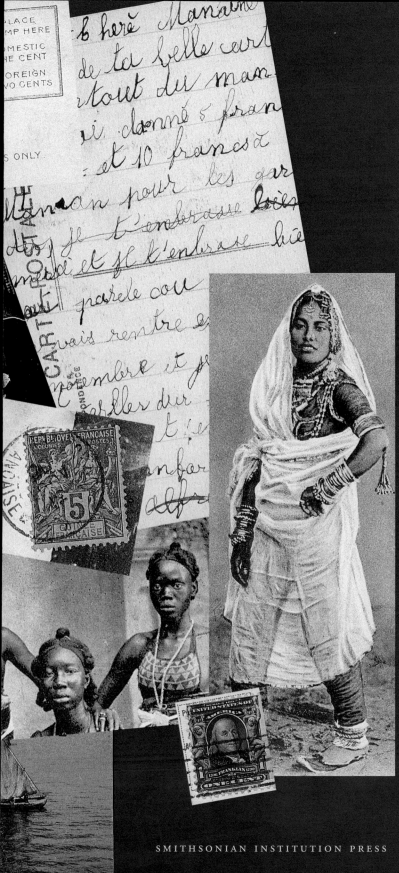

DELIVERING VIEWS

Distant Cultures in Early Postcards

Edited by

CHRISTRAUD M. GEARY and

VIRGINIA-LEE WEBB

SMITHSONIAN INSTITUTION PRESS

WASHINGTON AND LONDON

© 1998 by the Smithsonian Institution
All rights reserved

Copy editor: Nancy Eickel
Production editor: Jack Kirshbaum
Designer: Kathleen Sims
Production manager: Martha Sewall

Library of Congress Cataloging-in-Publication Data

Delivering views: distant cultures in early postcards / edited by Christraud
M. Geary and Virginia-Lee Webb
 p. cm.
 Includes bibliographical references and index.
 ISBN 1-56098-759-6 (cloth : alk. paper)
 1. Postcards—History—19th century—Themes, motives.
2. Postcards—History—20th century—Themes, motives.
I. Geary, Christraud M. II. Webb, Virginia-Lee.
NC1872.D46 1998
741.6'83'09034—dc21 98-10925

British Library Cataloguing-in-Publication Data is available

Manufactured in the United States of America
05 04 03 02 01 00 99 98 5 4 3 2 1

 The paper used in this publication meets the minimum requirements of
the American National Standard for Information Sciences—Permanence
of Paper for Printed Library Materials ANSI Z39.48-1984.

For permission to reproduce illustrations appearing in this book, please
correspond directly with the owners of the works, as listed in the individ-
ual captions. Smithsonian Institution Press does not retain reproduction
rights for these illustrations individually or maintain a file of addresses for
photo sources.

CONTENTS

ACKNOWLEDGMENTS

The idea for this book came about after we, in our professional positions of being responsible for major postcard collections, had participated in several discussions about the interpretation of photographic postcards and after we had worked with colleagues on related projects. A great deal of time and work passed between the initial idea and this final publication about the ways in which images of distant cultures were recorded and distributed through postcards in the late nineteenth and early twentieth centuries.

We would not have been able to bring this project to fruition without the intellectual and technical support of many people. We are especially grateful to the authors whose essays appear in this volume: Howard Woody, Robert W. Rydell, Patricia C. Albers, and Ellen Handy. Without their insight and research, this book would not have been realized.

We are also indebted to our numerous colleagues who repeatedly discussed the subject of postcards with us. Many were extremely generous with their time and expertise, shar-

ing their unpublished research and offering stimulating ideas about a variety of associated subjects. In particular we would like to acknowledge Professor Richard Chalfen of Temple University; Professor Raymond Corbey of Tilburg University in The Netherlands; Professor David Prochaska of the University of Illinois at Urbana-Champaign; Professor Jayasinhji Jhala of Temple University; the late Professor Arnold R. Pilling, Wayne State University; and Professor Victoria Wyatt, University of Columbia, B.C., Canada.

In addition, several friends and colleagues shared our enthusiasm in this project. We benefitted greatly from their thoughtful suggestions, scholarship, and encouragement. Special thanks go to Professor Suzanne Preston Blier, Professor Elizabeth Edwards, Dr. Alisa LaGamma, Dr. Bernard Gardi, Douglas Newton, and Dr. Nadine Orenstein. We also wish to thank Toma Fichter and John C. Geary for their personal support throughout this lengthy project.

This book would not have been possible without the co-

operation of those individuals at museums, archives, and private collections of postcards who granted us access to conduct research and allowed us to reproduce their holdings. In particular, Patricia C. Albers and Howard Woody were generous not only with their expansive knowledge but also with their extensive personal collections of postcards.

We received a great deal of support from our respective institutions. Our most sincere thanks are offered to Dr. Roslyn Walker, director of the National Museum of African Art in Washington, D.C. This project was initiated by Sylvia H. Williams, who served as director of the museum until her untimely death in February 1996. Assistant Director Patricia L. Fiske has lent her steady guidance to our endeavors. As usual, Professor Roy Sieber, former associate director, provided marvelous constructive comments. We also thank the staff of the Eliot Elisofon Photographic Archives—Anita M. Jenkins, Doris Johnson, and Paul Wood, archivist—for their patience and encouragement. We are indebted as well to Franko Khoury, staff photographer, who made many of the exquisite copy photographs that appear in this book.

Our colleagues in several departments at the Metropolitan Museum of Art in New York deserve our thanks. In the Department of the Arts of Africa, Oceania, and the Americas, our special thanks go to Julie Jones, curator in charge, for her support of the project. Deborah Saleeby provided research assistance and helped with numerous other details, as did Amee Yunn in the early stages of our undertaking. J. Ross Day and Barbara Mathé of the Robert Goldwater Library skillfully obtained many interlibrary loans and answered numerous reference questions. Mary Doherty and her staff in the Photograph and Slide Library furnished creative solutions to the complicated situations we encountered in our research. Joseph Smith of the Design Department also provided valuable assistance.

We are sincerely grateful to Daniel H. Goodwin, director of the Smithsonian Institution Press, for granting us the opportunity to complete this publication. We are especially thankful to acquiring editor Amy Pastan for the enthusiasm and patience she exhibited at every step. Kate Gibbs supplied a great deal of assistance as well. Also at the Smithsonian Institution Press we extend our warm regards to production editor Jack Kirshbaum, who guided us through the many stages of this project. We were fortunate to have worked with Nancy Eickel, who in her role as copy editor skillfully unified the essays and kept a close eye on details. Kathleen Sims worked with us to create a beautiful design for this book.

Lastly, we would like to dedicate this book to John C. Geary and Ann C. Webb.

Monsieur

M. Linens,

B.P. 44

Thysville.

Congo Belge.

MM. RETIK
C. F. C.
Thysville (Congo Belge)
R.E.C.P. N° 21.079a

CHRISTRAUD M. GEARY AND VIRGINIA-LEE WEBB

INTRODUCTION

Views on Postcards

Today, historical postcards depicting foreign peoples and distant places can be purchased not just in specialty stores and flea markets but also through postcard collectors clubs, dealers of historical postcards, and even newsletters.[1] Postcards from Africa, for example, can be found throughout Europe and often in the capital cities of former colonial powers, such as Belgium, England, Portugal, Italy, and Germany. Even postcard dealers in the United States frequently carry assortments of postcards that depict Africa and its peoples. Yet, with the exception of South Africa, very few of these cards are found on the African continent today. Small lots may be in the possession of private collectors and in some archives and libraries, such as the Senegalese National Archive in Dakar, the Bibliothèque Nationale in Abidjan (Côte d'Ivoire), and the National Archives of Zimbabwe in Harare. This holds equally true for postcards from other parts of the world, including South America, Japan, India, Mexico, and the Pacific

Islands. The majority of postcards are in public and private collections in Europe and America.

This situation is telling, for picture postcards of Africa, New Zealand, Australia, and Japan were produced mainly for Western consumption. With few exceptions, European or Euro-American photographers living or traveling in many regions of the world took the images that decorate postcards. They either established postcard businesses themselves or they produced images that were distributed by retail merchants and other entrepreneurs who were clients of postcard printing businesses. In fact, the photographers could be sponsors themselves, that is, clients of major printing houses. The postcard business of photographer and retail merchant François-Edmond Fortier in Dakar, Senegal, or the enterprise of Lisk-Carew Brothers in Freetown, Sierra Leone, exemplify how these two roles merged. These intricate networks, established during the heyday of postcard consumption, are de-

scribed in detail in Howard Woody's essay "International Postcards: Their History, Production, and Distribution (Circa 1895 to 1915)."

Photographers and sponsors shipped scenes of the colonies to large cities and the centers of empire, where they were turned into postcards by specialized firms in Europe or by big companies in the United States. As soon as cards had been shipped back to the distant sponsors in foreign territories, Westerners[2] bought them as personal souvenirs of their travels abroad, inscribing them with brief messages to family and friends before mailing. These cards thus traveled in a circular fashion after they were sent or brought back from the farthest reaches of the empire to active metropolitan centers. Many cards that remained in Europe or the United States became collectors' items.

Not all postcards were created for and circulated in international markets. Many of the authors in this volume clearly distinguish between local postcards and those produced for international tourist and collectors' markets or those made in conjunction with particular events, such as world's fairs and expositions. Woody discusses the complexity of the postcard industry, which ranged from printing companies with large international distribution networks to small local printers who quickly turned out a lower quality product to meet popular demand. While postcards produced by international publishers for tourists and collectors tended to be highly conventionalized and stereotypical, local postcards were often idiosyncratic in their depiction of various themes of immediate importance to consumers. Patricia C. Albers observes in her essay "Symbols, Souvenirs, and Sentiments: Postcard Imagery of Plains Indians, 1898–1918" that photographic images and, by derivation, postcards taken by small-town photographers in the western parts of the United States frequently contained a wider variety of themes and depended less on established photographic conventions. In her essay "Different Visions? Postcards from Africa by European and African Photographers and Sponsors," Christraud M. Geary distinguishes between smaller, local publishers along the West African coast and the polished output of major photographer-sponsors who catered to the international market. This distinction between the international and local realms in the complex postcard industry also influences the way postcards should be critically assessed before they are utilized as historical sources.

FROM PHOTOGRAPH TO PICTURE POSTCARD

The history of the postcard format is complex. The artifact as such grew out of a fortuitous intersection of several technological innovations and social advancements. As Woody shows, nineteenth-century postal regulations changed to accommodate the mailing of a non-letter format, an unsealed communication that affected the types of messages sent. The development of the picture postcard, or view-card, also depended on two major inventions, photography and printing processes, such as the collotype, color lithographs, and use of halftones.

Of the three necessary preconditions for the introduction of the picture postcard, contributors to this book give most attention to the importance of photography. In *"Japonisme and American Postcard Visions of Japan: Beauties and Workers, Cherry Blossoms and Silkworms,"* Ellen Handy explores the relationship of the well-established photographic tradi-

tion in Japan and the popular medium of postcards. Photographs that were used in postcards produced for tourists and collectors underwent frequent transformations and manipulations, and they were elaborately colorized to attract attention in the competitive market. Virginia-Lee Webb also explores this connection of postcards to photography in her essay "Transformed Images: Photographers and Postcards in the Pacific Islands." By focusing on individual photographers, she examines industrial practices in Australia and New Zealand, and attributes postcard images to several photographers. Albers also provides specific examples of photographs that were manipulated for use as postcards. Together, these three authors present data to sort out the context of original images and thus supply a first step in using postcards as sources for historical research.

In addition to manipulating original photographs, the captioning of photographs and postcards often poses interesting questions. Not only do captions frequently change from photographs to postcards, but they also shift the significance of an image. Geary, for example, discusses how a portrait of a young Bamum girl, privately taken by a female missionary photographer and guarded in a photographic album, was transformed by a new caption into a generic depiction of missionary success in Africa. The girl was transposed from a specific individual into a cute Christian convert.

The question then arises of how photographic conventions of the late nineteenth and early twentieth centuries affected the postcard medium and were consolidated through it. Albers and Webb clearly demonstrate that many of the conventions of visual representation in the fine arts and photography were carried over into the postcard format. Postcards thus perpetuated and enforced previously established standards of visualizing the Plains Indians, the inhabitants of the South Seas, or the Zulu in South Africa.

SOME USES OF POSTCARDS

The past and contemporary uses of these postcards can be divided into four major categories: souvenirs, vehicles of communication, collectibles, and sources for research. On a local level they may become mnemonic devices recapturing particular historical events, such as the arrival and departure of colonial dignitaries in West Africa (see fig. 125). This does not imply, however, that each postcard had a specific, singular use. Looking at the life history of postcards,[3] they change meaning and weave in and out of these categories. A postcard initially mailed and intended for communication may end up in an album or collection. One purchased as a souvenir or as an addition to a collection can still be mailed. As souvenirs or collectibles, they represent a moment in time or commemorate an event. Postcards in collections may ultimately become the focus of scholarly attention. Just as the actual artifact is a complex and multilayered product, the multiple uses to which the cards are subjected can be broad and flexible.

POSTCARDS AS SOUVENIRS

Westerners purchased picture postcards as souvenirs during vacations and when living or traveling abroad. Similarly, Euro-Americans bought cards depicting Native Americans when visiting the central and western parts of the United States. Postcards are indeed ideal souvenirs. It is the nature of

the souvenir to preserve an exhilarating moment in time through a reduction of the physical dimensions of the seen and experienced into a portable (here, mailable) format.[4] Postcards encapsulate memorable occasions and inspiring sites in their small two-dimensional format. As souvenirs, they were purchased in the context of the environment they depict, which, in addition to the quality of the actual photographic image, gives them their authenticity and mnemonic power. Postcards of foreign peoples could be purchased in harbor towns, railroad stations, and hotels. Popular tourist attractions, such as world's fairs and exhibitions, routinely provided the impetus for the production and sale of postcards. In an ironic twist, postcards of foreign peoples performing at fairs became photographic souvenirs. Robert W. Rydell explores this phenomenon in "Souvenirs of Imperialism: World's Fair Postcards." As a souvenir produced in multiple copies, the postcard undergoes a transformation through the personal act of purchasing. The buyer turns it from a mass-produced item into a private, meaningful possession. The purchaser may ultimately inscribe the postcard with a private communication, which adds another personal aspect to the uniform image and caption (Stewart 1984, 138).

To this day, the functional and desirable characteristics of the picture postcard as souvenir have been its major attraction and selling point. These qualities, especially before smaller cameras allowed travelers to take their own photographs, were a driving force behind the postcard industry. In his essay, Woody links the international development of the postcard industry to widespread tourism. As Albers and Webb point out, many of these internationally produced cards follow prescribed and conventional themes. Since postcards had to conform to popular taste and market forces, it is not surprising that many cards contain stereotypical imagery,

reconstructing and repeating similar visual tropes across the globe.

POSTCARDS AS COMMUNICATION

Both a postcard's caption and the sender's communication may create a verbal narrative that accompanies and at times complements the postcard image, which increases the card's multiple layers of meaning.[5] Through the process of writing and mailing, the sender appropriates and privatizes the postcard and moves this mass-produced object into the realm of social interaction and communication. If mailed to a friend or family member, the postcard becomes a gift and creates ties between sender and recipient. In other words, it establishes a relationship of obligation between sender and receiver (Stewart 1984, 138). Indeed, the role of postcards in the process of communication has received relatively little systematic attention. As symbolic and material connections, they represent an important element in a fabric of social relationships.

Several of these essays imply that many interesting aspects of communication might be pursued through the study of postcards. As Handy mentions, Japanese postcard production was directed not just toward Western visitors and collectors but also toward Japanese consumers. What kinds of dynamics shaped Japanese postcard production and consumption? How did the Japanese assimilate the postcard medium into their own culture? Geary alludes to similar issues concerning postcards produced by African photographer-sponsors at the turn of this century. From a historical perspective, the process of how postcards were adopted and integrated into non-Western cultures may be difficult to reconstruct due to a lack of sufficient documentation, yet avail-

able historical materials might allow for certain assumptions and conclusions to be made.

One way is to search archives and collections for postcards written by local people. In certain collections are a few cards written by educated Africans in large cities or by Africans in the service of Europeans, to whom, judging by the messages, they sent postcards while they were on home leave. African students, well aware of Westerners' delight in postcards, occasionally mailed cards to their teachers.[6] Other cards went to family and relatives. One such example is a card that was very likely written by an African student to his godmother (fig. 1). The card, which was published by A. Albaret (active from circa 1900 to 1915 in Dakar, Senegal), shows a class in the indigenous school at Dakar, which alludes to the identity of the sender. On the verso of the card, "Alfred" writes (fig. 2):

Chére Marraine

Merci de ta belle carte et surtout du mandat. J'ai donné 5 francs a [sic] père [?] et 10 francs à Maman pour les garder. Merci et je t'embrasse bienfort [sic] par le cou. Je vais rentre [sic] en classe le 5 novembre et je vais travailler dur et la bien sage et je t'embrace bienfort [sic]. Alfred[7]

Unfortunately, such written records are few. An innovative research strategy should be developed to retrieve these historical modes of communication and patterns of use.

Despite obvious methodological pitfalls, further insights might be achieved by analyzing postcards in contemporary cultural praxis in African, South American, Asian, and Pacific countries and carefully projecting these findings to the past. Research from local contemporary perspectives is beginning to be carried out, especially among Native Americans who have long been the subject of postcard images. In the exhibition and publication *Partial Recall,* historical photographs were interpreted by contemporary Native American authors, many of whom are currently taking photographs in their own communities.[8] By making museum and archive collections of photographs and postcards known to local communities, the interpretive process can be opened to a wider range of cultural perspectives.

POSTCARDS IN ALBUMS AND COLLECTIONS

Postcards traditionally have been assembled into albums and collections. At the turn of the nineteenth century, during the golden age of the postcard, this collecting craze was a major stimulus for postcard production. Large postcard emporiums with ever-changing product lines catered to avid collectors (see fig. 22). The practice of collecting logically grew out of the nature of postcards as souvenirs or keepsakes. Once they are placed into a systematic order or assembled in albums, however, postcards of distant regions and peoples might signify the collector's antiquarian urge to appropriate and order the foreign, and to delight in exotic aesthetics (Stewart 1984, 142).

Some postcard collections of foreign peoples and places are enormous. One is the Caroline H. Ober Postcard Collection at the University of Washington, which includes 67,000 cards. Handy researched the Japanese postcards in the New York Public Library and the Jefferson R. Burdick collection of printed ephemera in the Department of Drawings and Prints at the Metropolitan Museum of Art in New York. Webb, the archivist of the Photograph Study Collection in the Department of the Arts of Africa, Oceania, and the Americas at the Metropolitan Museum, studied photo-

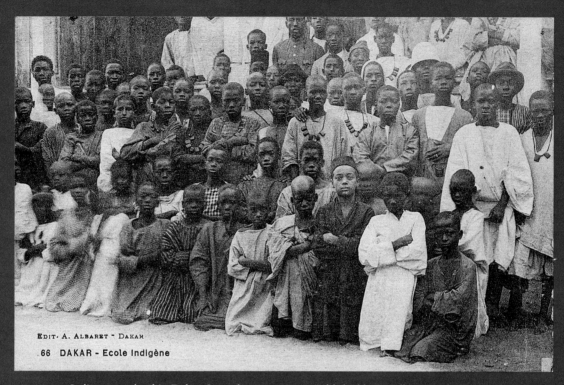

EDIT. A. ALBARET - DAKAR

66 DAKAR - Ecole Indigène

FIGURE 1. Indigenous school in Dakar, Senegal, ca. 1900–1915. Published by A. Albaret, Dakar, Senegal.

FIGURE 2. Verso of Indigenous school in Dakar, Senegal, ca. 1900–1901

graphs and postcards related to Oceania in the extensive postcard collection under her care. Geary's essay draws on a large collection of more than 7,000 postcards housed in the Eliot Elisofon Photographic Archives of the National Museum of African Art at the Smithsonian Institution in Washington, D.C. Indeed, authors Albers and Woody are both long-time collectors with extensive holdings of postcards. This volume only begins to study the different types of postcard collections and how the collections and albums themselves become cultural artifacts.

Several albums and holdings of African postcards demonstrate that studying collections as artifacts with cultural and social significance can benefit our understanding of the dynamics that shaped the collecting process. Although many African postcard albums are still in the possession of families in Europe and the United States, some have entered archives, such as an album of West African postcards that was assembled primarily from cards mailed to England by a British colonial who at one point lived in Lagos, Nigeria.[9] This postcard album, inscribed with the words "From me to you" and the year 1906, seems to have been an encouraging gift to the collector. Most cards were sent in 1907 and 1908 to two women living at the same address in Brighton/Cheshire, England. One addressee was Eva Jones, who received thirty-five cards; the other was Mrs. W. Soutkerk, who received thirty-four cards. Most cards carry no message; three or four simply state that a longer letter had been delayed. On one card showing a bird's-eye view of the west end of Lagos, the sender wrote, "The cross is where I live." This album with images of Lagos, colonial Freetown, Sierra Leone, and other parts of the West African coast reflects not only the purchaser's choices and interests but also the female collectors' efforts to assemble a larger group of postcards from Africa.

Since some cards lack a written message and are blank, they apparently were never mailed.

In 1987 the philosopher Raymond Corbey acquired an album of over one hundred postcards from French Africa, all depicting nude women in more or less seductive poses. A French *colon* by the name of "Nic," who worked for the Département Pas de Calais in France, sent these cards to his family from various French colonies between 1900 and 1925, asking his parents to keep them for his future album. Subsequently, Corbey analyzed the collection of imagery and texts as expressions of Western colonial discourses on Africa.[10]

CONTEMPORARY APPROACHES TO POSTCARD RESEARCH

Since postcards provide rich historical information through images, captions, written messages, and stamps, they have been the focus of research or have been integrated into various research projects. Among the first steps in conducting research with postcards is to reconstruct the history of the relevant card's format. Identifying the photographer, sponsor, producer, and printer, and most importantly, determining the date of the postcard, helps to establish a time line from which to begin interpretation. Webb's essay exemplifies how information on photographers and dating should form the basis of any research endeavor. It also shows how complex this frustratingly difficult task can become, because compiling such basic data is not always an easy task.

Postcards often lack explicit identification. Imprints referring to photographers, sponsors, or printers must all be deciphered. A great part of the postcard industry around 1900 was subjected to rapid change, partly due to new technolo-gies and developing markets, but most certainly due to the transient nature of many companies involved in the production and distribution process. Postcard production was not for the faint-hearted; it was a big business that appealed to entrepreneurs everywhere. Consequently, historical documents about the postcard industry are often missing or were never kept. Trade secrets and ferocious competition contributed to the clandestine nature of the operations. The two World Wars led to the destruction of many records in major European countries that produced postcards.

Carefully reconstructing the entire output of a postcard photographer and producer by analyzing existing postcards is one way to collect basic data. Fortunately, a few published works take this approach, such as Philippe David's study of the production of photographer Fortier in Dakar (see figs. 116 and 121).[11] In addition, David discusses different reissues of successful postcards over a twenty-year period, which again provides valuable insights for scholars working with the cards.

Which topics do contemporary postcard researchers pursue? In today's world, these old postcards have taken on multiple roles in research. Besides an interest in postcards as a form of communication, these postcards can be studied from different vantage points: as a popular art form, as historical sources on peoples, and as materials recording the ways Westerners represented and perceived the world.

As expressive works of popular culture, the composition and iconography of postcard images may be studied from an art historical perspective. Photographers and sponsors such as Fortier often left their stylistic imprint on the cards. Fortier clearly was influenced by orientalist imagery and re-created similar settings and poses in some of his postcards (see fig. 116). Other photographers, including Lisk-Carew Brothers in Sierra Leone, possessed excellent artistic and

technical skills. They were able to integrate the Victorian aesthetic of portraiture into their images of sitters (see fig. 127). In this book, Handy and Webb have brought the perspectives of art and photography historians to the study of postcards and have applied them to the formal aesthetic choices that were determined by the photographer and later by the printer. A full appreciation of postcards based upon an art historical process of inquiry remains difficult to achieve.

Among studies that examine postcards in terms of the Other is Rydell's essay on postcards at world's fairs. He perceives both the fairs and the postcards as part of an "exhibitionary complex" that characterized Europe and the United States during the second half of the nineteenth century and the first decades of the twentieth. As Western powers established and expanded their control over foreign territories, postcards spread imperial propaganda far beyond the realm of the actual fairs (see, for example, figs. 39 and 41).

Several authors in this book look at postcards of foreign peoples as part and parcel of Western discourses on the Other. Like other photographic formats (in particular, *cartes de visite,* cabinet cards, and stereographs), postcards construct, disseminate, and perpetuate stereotypical images of non-Western peoples. This rich field of investigation has been stymied by the lack of firm data, such as missing photographer attributions and failures to look at entire production lines, dates on postcards, and the overall nature of the industry.

Other authors investigate Western depictions of foreign peoples and their reality. Handy, for one, describes the Western invention of the Japanese geisha, and Webb discusses the erotic depiction of women from Oceania (see fig. 102). This specific "postcard idiom of representation" might well cut across geographic and ethnic lines. Indeed, some depictions of European "exotic types" show women in regional dress in rural areas: the Spanish flamenco dancer, the Hungarian shepherdess, and the Irish peasant. By their very definition, international postcards are distancing, and the subject of the image is quickly transformed into the Other.

A new direction of research has the potential to move forward and shift paradigms found in studies of postcards as expressions of the Other. Geary presents challenging examples of indigenous postcard photography and sponsorship from the West African coast. Even though data about non-Western postcard production remains thin, and no effort has been made to compile existing information, what is available offers an interesting avenue for understanding representations of the Self and the Other. Do images on postcards represent the Other, even if they were taken by photographers and produced for sponsors who are the Other themselves? By their nature, do postcards of peoples—no matter whether of the Self or the Other—show the Other, either in one's own society or abroad? Or did the market forces (i.e., the consumer) that affected both Western and indigenous postcard photographer-sponsors dictate a particular vision? These questions cannot yet be answered satisfactorily, although elements of them should be considered in interpreting the dynamics of postcard representation.

THE POSTCARD SUBJECT GAZES BACK

Many historical postcards became part of racist, sexist, and colonial discourses. Although it may be painful to look at such cards today, examining them becomes a necessary and important exercise when dealing with the legacy of racism and Western imperialism that shaped aspects of postcard

production. Similar underlying assumptions continue to reverberate in postcards to this day.

In the groundbreaking book *The Colonial Harem,* the Algerian writer Malek Alloula describes his angry, emotional reaction to the denigration of Algerian women in orientalist postcard imagery. He tries to reveal the nature and meaning of the colonial gaze and to subvert the stereotype that "is so tenaciously attached to the bodies of women."

> A reading of the sort that I propose to undertake would be entirely superfluous if there existed photographic traces of the colonized upon the colonizer. In their absence, that is, in the absence of a confrontation of opposed gazes, I attempt here, lagging far behind History, to return this immense postcard to its sender.[12]

Looking at the sepia-toned images in his elegantly produced book evokes a strange sense of nostalgia in the viewer, one that presumably was quite unintended by the author. In a way, those women who were made to pose for these images are once again subjected to the Western gaze. The exotic aura of these foreign peoples has not diminished over the decades, and if not critically exposed as what they are, the images may indeed reinvoke their original context. In this vein, should such postcards be reprinted at all? This question poses a dilemma that should certainly be kept in mind when looking at the images in this book.

It becomes apparent from Alloula's writing that the voices of those depicted in the postcards need to be heard—yet they remain silent. If the subjects in these historical cards could express themselves, a scenario similar to the following might unfold. On 27 February 1991, an article in the *Daily Nation,* a newspaper published in Nairobi, Kenya, described the "saga of the Samburu postcard."[13] According to this fascinating report, a Kenyan woman took a postcard publisher to court because her image appeared on a postcard without her permission.

The story began in October 1978, when eighteen-year-old Graziella Koitanoi, now a teacher in a childcare program, married James Lelenguiya, now a headmaster of a primary school. Both belonged to clans of the Samburu peoples, and their traditional wedding ceremony joined the in-laws together. For the occasion, bride and groom were dressed in the indigenous Samburu way. An Italian priest who witnessed the ceremony "sneaked up on the bride who was resplendent in a traditional costume and took her photograph." This photograph not only appeared on a postcard—a friend sent it to the couple, not knowing that it actually depicted Graziella—but it was also printed in a tourist brochure. Graziella and her husband objected to the postcard for several reasons. It conjured up the image of a backward, exotic native. In addition, she found the caption "Samburu Girl with the Fertility Necklace" humiliating and misleading, especially since she was now a married woman, and the multicolored bead necklace, similar to an engagement ring, signified that she was about to get married. Her family and friends took offense as well. They accused the couple of making a profit from the image, of betraying the Samburu community, and of being too Westernized since they obviously collaborated on the postcard.

The source of the postcard, the KAS Company Limited, was a bookstore and publisher in Nairobi. When the couple failed in their efforts to have the postcard recalled, they hired a lawyer and sued for damages. The judge awarded them 200,000 Kenya Shillings (approximately U.S.$4,000, then the average annual wage of a Kenyan school teacher) for damages, a large amount for a Kenyan wage earner.

We know little about whether the people shown in historical postcards consented to have their picture taken and ultimately to appear on postcards. From the images on old postcards we may occasionally guess the kind of relationship that the photographer entered into with the subject. Many im-

ages suggest coercion: look at the defiant facial expressions and the resentful or uncomfortable body language (see fig. 118). Other strategies become obvious through careful interpretation. Rydell's subtle analysis of a postcard portrait of an Inuit woman named Columbia is instructive. Columbia, a performer at one of the world's fairs, smiles brightly back at the viewer, a rather uncommon occurrence in postcards (see fig. 44). By analyzing her facial expression and interpreting the little that is known about her personal history, Rydell postulates that her smile was one of the "weapons of the weak," a way to force the viewer to acknowledge the presence of another human being.

Ultimately, this book on depictions of foreign peoples in postcard images represents a beginning. It compiles relevant and challenging research on these postcards, and it presents a world of Western imagination and fantasy that does not necessarily correspond to reality. In developing their own visual language and ideological constructs, postcards have shaped Western thinking over time. As popular and ever-present artifacts, postcards have helped to create standard views of the world and have been integrated into communication, commemoration, and history. Thus, these essays raise familiar and stimulating new issues about the representation of the Other. Hopefully, future studies will deepen and expand our understanding of this unique phenomenon, both in historical and contemporary contexts.

NOTES

1. Large networks of postcard enthusiasts exist in the United States and Europe. Regular newsletters, such as the *Teich Newsletter* and the monthly *Barr's Postcard News,* serve as a way to sell postcards and to publish interesting essays on them.

2. The term Westerners, which refers to Europeans and Euro-Americans, is used here with some hesitation. It helps to delineate indigenous populations pictured on postcards from those who simply ac-

quired postcards. Another term used in this connection is the designation of "the Other" or "Others," terms coined by anthropologists "to designate human beings whose similarity or difference is experienced by alien observers as in some profound way problematic" (George W. Stocking, Jr., ed., *Objects and Others: Essays on Museums and Material Culture,* History of Anthropology 3 (Madison: University of Wisconsin Press, 1985), p. 4.

3. Reconstructing the life history of a thing, such as the postcard, allows us to trace how objects are endowed with different meanings within changing contexts. This approach has been suggested by Igor Kopytoff in "The Cultural Biography of Things: Commoditization as Process," *The Social Life of Things: Commodities in Cultural Perspective,* ed. Arjun Appadurai (Cambridge, England: Cambridge University Press, 1986), pp. 64–91.

4. Susan Stewart, *On Longing: Narratives of the Miniature, the Gigantic, the Souvenir, the Collection* (Baltimore: Johns Hopkins University Press, 1984), p. 138.

5. We thank Richard Chalfen and Jayasinhji Jhala, professors of visual anthropology at Temple University in Philadelphia, for their stimulating writings about postcards as communication.

6. This pattern of communication through postcards seems to have been maintained to this day, as many former European and American expatriates in Africa have experienced.

7. The letter reads:

Dear Godmother

Thank you for your beautiful card and above all the money order. I gave 5 francs to father [?] and 10 francs to mother to keep them. Thank you and I hug you firmly around the neck. I will return to school on November 5 and I will work hard and smartly. I embrace you firmly. Alfred

(Translation provided by the author.)

8. See Lucy R. Lippard, ed., *Partial Recall* (New York: New Press, 1992).

9. This album, purchased in Great Britain in 1992, contains 128 postcards from the British colonies and protectorates along the West African coast, particularly Sierra Leone and Nigeria. It is now in the Eliot Elisofon Photographic Archives at the National Museum of African Art, Smithsonian Institution, in Washington, D.C.

10. Raymond Corbey, *Wildheid en beschaving. De Europese verbeelding van Afrika* (Baarn, The Netherlands: Ambo, 1989).

11. Philippe David, *Inventaire générale des cartes postales Fortier,* 3 vols. (Saint-Julien-du-Sault: Fostier, 1986–88).

12. Malek Alloula, *The Colonial Harem* (Minneapolis: University of Minnesota Press, 1986), p. 5.

13. Ngugi wa Mbugua, "Saga of the Samburu Postcard," *Daily Nation* (Nairobi), 27 February 1991, i, ix. We thank Professor Sidney Kasfir of Emory University for sending a copy of this newspaper article to us.

CARTE PO[STALE]

Ce côté est exclusivement [réservé à l'adresse]

M. Mourad van

Rue Galé.

Constantinople

Turquie.

A DAKAR SÉNÉGAL

p. Saffary.
qau H Roui
...Sénégal

1 HOWARD WOODY

INTERNATIONAL POSTCARDS

Their History, Production, and Distribution (Circa 1895 to 1915)

Spectacular historical postcards, or view-cards, from the so-called golden era of postcard production record richly detailed images found in distant lands a century ago. Initially, several European industrial countries produced commercial picture postcards. The popularity of these cards spread first throughout central Europe, then to extended trading partners, and finally to the colonies under European domination. This golden era of postcards began about 1895, when the development of the printing trades permitted an excellent, mass-produced card to be manufactured at a reasonable cost.

By the late 1890s industries associated with tourism, such as housing, transportation, and personal services, considered postcards to be an excellent way to advertise. They began to sponsor and order postcards, which were sold everywhere: at train depots and steamer lounges; at resorts, hotels, restaurants, and retail stores; and at tourist sites, fairs, circuses, souvenir stands, and street vendor displays. "London Life.—

Omnibus," attributed to J. J. Samuels (fig. 3), shows the larger business version of the street vendor, while pushcarts and backpack display units were used by independent peddlers.

Postcards attracted everyone. Envisioning profitable enterprises, entrepreneurs soon started postcard businesses that continually created new and unique sets as well as series of political and military events, scenes of disasters, cards for charitable causes, and holiday greeting issues. With such broad use and popular appeal, postcards could easily be called the first art form for the unlettered person.

In many ways, collectors stoked the industrial machine of postcard production. Hobbyists developed voracious appetites for new and exciting cards, and they continually pressured local merchants to expand their stock with new issues. To further these ends, insatiable collectors badgered acquaintances to mail cards from distant locations. Young and old collectors joined regional (fig. 4), state, national, and interna-

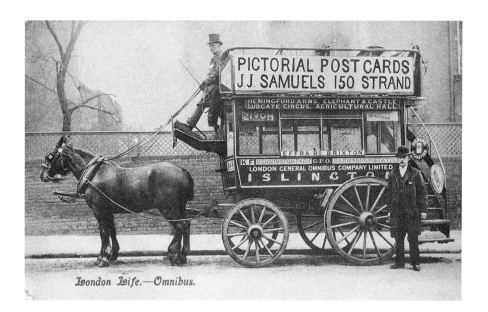

FIGURE 3. "London Life.—Omnibus," ca. 1907. Sepia collotype. Printed by Eyre and Spottiswoode, London. Sponsored by J. J. Samuels, London, England.

tional postcard exchange clubs that published membership lists and newsletters with information about postcard sources, supplies, and paraphernalia. One collection of that era, the Caroline H. Ober Postcard Collection at the University of Washington,[1] contains 67,000 cards that document the historical importance of this medium and the international network of contacts existing in the late nineteenth century.

A BRIEF HISTORY OF THE POSTCARD

The history of the postcard began in the 1860s. Until that time, international postal regulations in Europe and the United States allowed the general public to mail only sealed letters of private correspondence for a fixed price. In the United States, mailing such letters and similar items in that format cost two cents. The earliest U.S. copyright for a private

"mailing card" was issued to John P. Charlton of Philadelphia in 1861. The copyright was then transferred to H. L. Lipman, also of Philadelphia, who began to print and sell "Lipman's Postal Card" that same year. These cards, which were often used for advertisements, were in continual use until the first governmental postals appeared in 1873.[2]

Germany's postmaster general was the first to propose a governmental correspondence card in 1865, but it was not approved. The idea of a one-half rate governmental postal card for short public messages or advertisements was turned down by many governments due to fears that postal services would lose revenue on these issues. Finally, on 1 October 1869, Austria began to offer a plain *Correspondenz Karte* (correspondence card) to the public, and many countries followed suit within one or two years. (A U.S. postal card was approved on 8 June 1872 [Burdick n.d., 7].) These govern-

mental issues created the format for international commercial postcards. For this new product to succeed, however, it had to be not only profitable for manufacturers but also a successful advertising medium for businesses and a good sales item for retailers. Most importantly, it had to excite the public's imagination. The picture postcard, or view-card, was the answer.

First introduced in the United States around 1873, these one-cent issues were blank on the message or front side, where an advertisement or picture could be placed. The back or verso side was limited to the address only. Entrepreneurs soon began to use these postal cards for their advertisements, but the cards proved to be rather expensive. To reduce costs, publishers lobbied for a private souvenir card of similar dimensions, with the user absorbing the mailing expenses (Burdick n.d., 11).

Postcard use started slowly, and the transformation of the correspondence card into the picture postcard took some time. Small, inexpensive, mass-produced pictures on postcards first appeared as line drawings and block prints in the 1870s and 1880s. As the lithographic trade evolved in Germany and other industrial European countries, a high-quality polychromatic product developed. *Gruss aus* (Greetings from) issues were made for virtually every town and resort. The labor-intensive artistic productions were elegant and expensive, but they quickly became popular, fast-selling novelties. As the types of cards expanded, postcard companies shifted into creating specialized products for the tourist, pro-

FIGURE 4. "The Chattahoochee Valley Collectors' Club," Columbus, Georgia, ca. 1910. Color lithograph. Printed by Curt Teich Company, Chicago. Distributed by S. H. Kress and Company.

motional, and collector clienteles. Some of the lithographic *Gruss aus* companies redirected their energies into collectors' sets. One example is the J. Miesler Company in Germany, which produced "Vue De Port Au Prince" (fig. 5). Its artistic arrangement of small vignettes showing the president of Haiti, the palace, and a panoramic view of the port city suggests the card was once part of a "Countries of the World" set. Others, such as the Paul Finkenrath Company in Berlin, directed attention to artistically designed greeting, holiday, and special collector issues. Sensing economic potential in view-cards, Knackstedt and Näther, Stengel and Company, and other German firms accepted millions of small contracts from local clients (called sponsors) to document each community. In doing so, they created a historical visual record that encompassed the world.

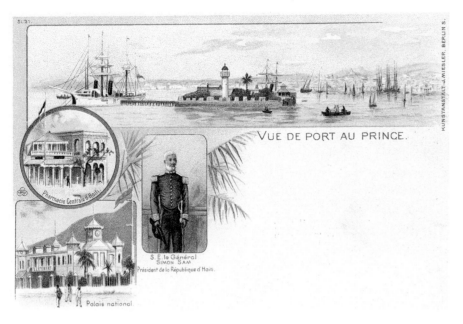

KUNSTANSTALT J. MIESLER BERLIN S.

VUE DE PORT AU PRINCE.

Pharmacie Centrale d'Haiti

S. E. le Général
SIMON SAM
Président de la République d'Haiti.

Palais national.

FIGURE 5. View of Port au Prince, Haiti, ca. 1895. Color lithograph (ten hues). Printed by Kunstanstalt J. Miesler, Berlin, Germany.

Photography came into its own during this period, and more and more black-and-white photographs were produced to serve the postcard industry. The highest quality of the international printing press view-cards produced in the golden era were based on the work of professional photographers. These skilled artisans were capable of sensitively framing a subject, determining a photograph's lighting requirements, developing images to match appropriate printing processes, and creating prints with sharp details and well-defined dark and light forms. Cards were rated "excellent" if they showed many details and numerous subtle tones. "Good" ones have several distinct, clear details, while "average" and "poor" ones present few or limited details.

Salespersons under contract with postcard companies were trained to use field cameras so they could take new pictures when they obtained an order. They submitted these original pictures using postcard-size negatives and prints along with the postcard contract. In this way these cosmopolitan photographers influenced the final appearance of international postcards and introduced a coherent format not found in other types of postcards or general photography. Commercial photographers welcomed this outlet for their work, since most newspapers and printed media used few pictures before 1910. Of course, the development of new, inexpensive cameras permitted amateur photographers around the world to make their own photographic (photoprint) postcards. In these instances, smaller pictures were sent in with mail-order postcard contracts and were rephotographed at the factories so they would conform to the standard size of postcards.

Both developments—the widespread use of photography and the growing acceptance of the correspondence card—coincided with the development of better presses, inks, and printing techniques that could produce a quality product at a competitive price. Improvements in the lithographic and collotype processes in the late nineteenth century made both processes key to postcard production.[3] The development of halftone screens around 1888 permitted the production of both common quality newspaper pictures and more refined small-screen issues. While photoprint postcards remained available in limited editions of hand-printed issues, the development of the rotary process and presses around 1900 allowed photoprint postcards to be mass-produced.

Initially, *Gruss aus* picture layouts began as decorative, multiview designs with limited note space on the front and only the address on the verso. The effusive writer often wrote around and over the pictures. After the demand for more correspondence space reduced the popularity and sales of multiview designs, they were replaced with a single image view with larger note space.

PRINTING PROCESSES

One of the first printing processes utilized in the postcard industry was the monochrome collotype process, also known as Albertype, Lichtdruck, Phototype, and Heliotype. This planographic type employed a plate coated with a photosensitive gelatin and treated with fine resin powder to produce a grainy, non-halftone image. A fine, irregular granular pattern appeared when a collotype image, such as "Hindo Temple and Nauch Girls, Ceylon" (fig. 6), is viewed through a strong magnifying glass. Very sharp details can be seen when excellent photographs were used for these cards. In preparation for printing, a layout of thirty to forty different images was photographed on a photosensitive plate. Printing the cards required a single pass through the press to print the images and often a second one to print the caption and electrotype. The printer could select black, sepia, and colored inks, different hues and textures of paper stock, and a variety of finishes to create a broad range of products.[4] Printed sheets were individually covered with protective tissue paper. After the stacks were cut, the postcards were sorted into individual series. To make colored cards, transparent watercolor washes were hand-stenciled over scenes in predetermined color schemes.

The lithographic process relied on the natural antipathy of grease to water. Initially, heavy lithographic stones made of

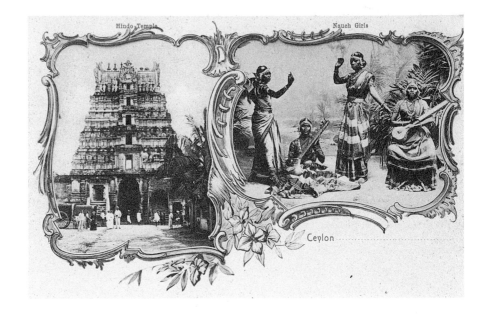

FIGURE 6. "Hindo Temple and Nauch Girls, Ceylon," ca. 1898. Collotype. Printed by Stengel and Company, Dresden, Germany.

Bavarian limestone were employed to produce finely grained images. This slow, limited process was followed by asphaltum, in which sheets of glass, and later metal (zinc) plates, were coated with asphalt. Early horizontal, flatbed cylinder presses could print about 250 sheets per hour in the 1890s. This number increased significantly when rotary presses were developed at the turn of the century and offset presses came into use around 1908. Newly developed transparent and opaque inks allowed for a wide variety of subtle differences in hue and tone. Dots of colors, so small that a strong magnifying glass is needed to see them, were applied in overlapping layers and stippled patterns to create a spectacular range of colors. "Vue De Port Au Prince" (see fig. 5) is a bright yet delicately colored composition that resulted from a costly lithographic process in which small details were artistically drawn to describe the subjects.

Scenes on view-cards evolved from hand-drawn details to high definition photographic images reproduced as collotypes or halftones enlivened with descriptive color. For these polychromatic issues, each black-and-white image was subdivided into individual areas to which particular colors were applied. Most processes used four to ten hues, which in effect fractured an image into successive arrangements of color shards. For mass printing, thirty to forty different postcards were combined in a single unit. Irregular patterns of each color were grouped together in a layout, which was then photographed on photosensitive surfaces using carefully controlled registers. Sheets of card stock were then sent through the presses repeatedly to print each color in the sequence until every hue, the caption, and electrotype were added. The finished sheets were covered with tissue paper, stacked, and cut, and the postcards were grouped into individual series.

Chromo-collotype processes combined both lithography and the collotype process without the drawn details. A series of transparent and opaque colors was printed in sequence over a collotype to create an image colored by lithography. In "Mohamedan Woman" (fig. 7), a "Chromo-Lichtdruck" issue by Knackstedt and Näther Company, the lithographic colors highlight the subtle collotype imagery of the costume of a woman in British India.

In chromo-halftone processes, drawn details are replaced by color lithographic formulas of shades and tints combined with a black ink halftone screen. "Japanerinnen beim Briefschreiben" (fig. 8), a postcard from the Louis Glaser Company in Leipzig, was produced using the "Auto-Chrom" process, which placed a subtle halftone screen over the lithographed hues. Stengel's "Autochrom" and Pinkau's "Heliocolorkarte" processes also utilized these same combinations.

The halftone process, invented around 1888, used two plates of glass with horizontal gratings of forty to four hundred lines per inch. These plates were then placed at right angles to create a grid screen. The photograph was next projected through the screen to create a dot pattern on a photosensitive plate, with the number of dots varying according to the tones in the original image. Then, as today, a coarse 60-line screen was used to print newspapers; a 120- to 150-line screen was utilized for ordinary black-and-white commercial prints; and a screen of 150 to 200 lines was employed for fine color reproductions.[5]

On the verso of postcards appeared the so-called electrotype, the most obvious, unique, and significant feature of the postcard layout. Electrotypes were the precise raised-letter arrangement and spacing of the word "postcard" (or its equivalent in foreign languages) and other embellishments that were added using cast metal facsimile printing plates.

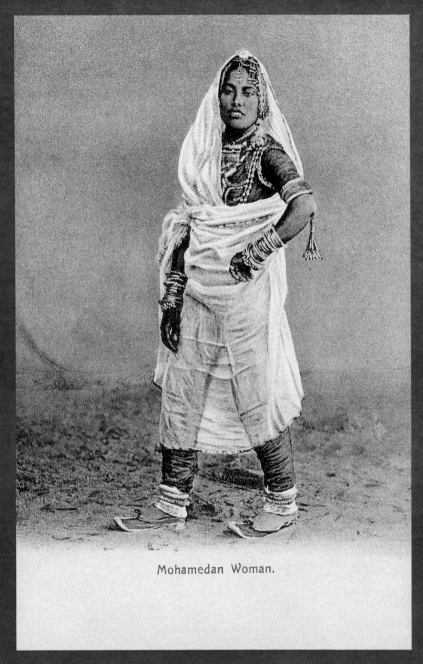

Mohamedan Woman.

FIGURE 7. "Mohamedan Woman," India, ca. 1900. "Chromo-Lichtdruck,"
chromo-collotype, color lithograph (ten hues). Printed by Knackstedt and Näther
Company, Hamburg, Germany.

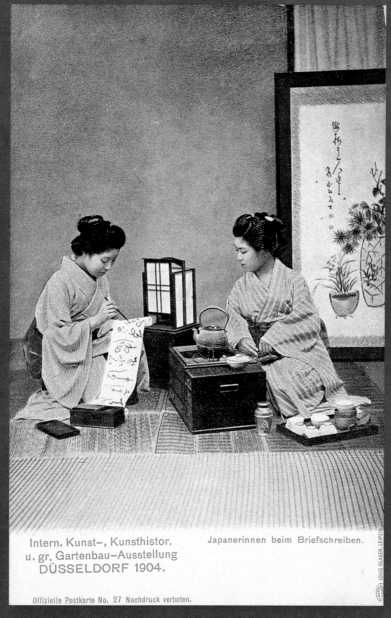

Intern. Kunst-, Kunsthistor.
u. gr. Gartenbau–Ausstellung
DÜSSELDORF 1904.

Japanerinnen beim Briefschreiben.

Offizielle Postkarte No. 27 Nachdruck verboten.

FIGURE 8. Japanese women writing letters, ca. 1904. International Exhibition, Dusseldorf, Germany. "Auto-Chrom," chromo-halftone, color lithograph (six hues). Printed by Louis Glaser Company, Leipzig, Germany. Published by Schmitz and Olbertz, Germany.

On one card in the uncommon style of the Rotograph Company (see fig. 16), advertisement data is printed over the electrotype (see fig. 17). (Messages were not permitted on the verso of United States postcards until 1907.)

Many companies included a sequential job code number on their postcards to indicate the card's position in their production cycle.[6] A string of four to six digits was usually the printer's code, while figures in the low thousands indicated the distributor or importer. Groups of digits in the hundreds or below were the sponsor's numbers. Some issues had two or three codes, and they often carried the same code identifier when reordered.

Normally when more than one postcard series and electrotypes were printed on a large sheet of card stock, the code numbers, if used, were sequential. The issues, that is, single postcards, on each sheet naturally shared the same coding system, process, colors of ink, and paper. Provenance imprints were used only once or twice per printed sheet. This could mean that one or more series on a sheet might not have had origin imprints. Finally, different technical procedures, complexities, and time problems were associated with each printing process.

DATING AND IDENTIFYING POSTCARDS

The complex process of dating postcards begins by analyzing an individual electrotype, the stamp box, printing series codes, caption styles, ink colors, and the position of all features on the verso, or address side, of a card. Each printing detail found on a postcard can be significant, because every variation creates a distinct layout that potentially identifies an issue's provenance and time period. Most companies mixed the interchangeable features of the cards' design to produce a variety of layouts. It is not unusual for a company to have more than fifty different unique examples. Cards using the same postal regulations and a factory's preferred layout can be found in both European domestic issues and those issues made for their distant colonies. This verifies that factories normally used a preferred electrotype unless the distributor or sponsor requested a unique one.[7] Some peripheral, limited production electrotypes, however, mimicked the prominent ones of established companies.

Equally important to identifying a provenance are the color schemes of a card's picture. Principles used to analyze these pictures are similar to methodologies applied in the study of art. Each view-card has a distinct point in its manufacturing cycle, usually during printing, at which artisans created unique color formulas that can be distinguished, isolated, grouped, and compared. Understandably, factories used different color formulas, processes, and finishes. "The Shwe Dagon Pagoda, Rangoon" (fig. 9), for example, was printed by the Otto Leder Company using its "Photo-Iris" chromo-collotype process, which lends an easily recognizable hue of luminous pale blue to the sky and other surfaces.

Since postcards were seldomly imprinted with a date, determining a postcard's age begins by reviewing the evolution of postal regulations and the general postcard industry. Definitive periods in U.S. postal regulations and postcard development can be divided as follows:

Pioneer era (before 18 May 1898)
Private Mailing Card (PMC) period (19 May 1898 to 24 December 1901)
Undivided Back period (25 December 1901 to 28 January 1907)
Divided Back period, during which messages were permitted on the back (1 March 1907 to 1915)
White Border-style period on the picture side (1916 to 1930)
Linen-style period (1931 to 1945)
Modern Chrome-style period (1946 to today)

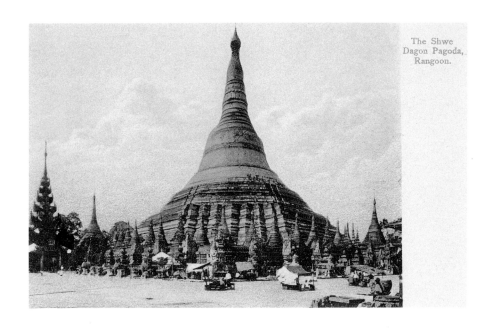

The Shwe
Dagon Pagoda,
Rangoon.

FIGURE 9. "The Shwe Dagon Pagoda, Rangoon," Burma, ca. 1904. "Photo-Iris," chromo-collotype, color lithograph (six hues). Printed by Otto Leder Company, Meissen, Germany. Distributed by Watts and Skeen.

A review of U.S. publications on international postal stamps and stationery, such as Higgins and Gage's Postal Stationery, can indicate the dates when international changes of stamp design, postage, and related features occurred.

To date each layout, I make a chart to document individual time frames by recording the earliest postmark information and city directory data from both the site of provenance and that of distribution during the relevant years. A circulation span for each layout can be traced through clusters of postmarks and inscriptive dates, the caption, and data found on other copies of that example, related cards from the same series, or examples using various coding systems. Scattered postmarks after the main cluster(s) might be the result of slow-moving holdover stock. Consequently, individual dated specimens do not necessarily indicate when these issues were printed or when they began their sales cycle. A similar

method has been employed to date photoprint cards by surveying the verso layouts of commercial photographic paper stock.[8]

Surprisingly, postcards were not considered historically significant during their golden age, and most of the information on this novelty item was not collected, cataloged, or housed like other historical materials. Researchers reviewing the postcard industry have encountered the dual problem of records being discarded when businesses closed and data being destroyed when factories and industrial cities in central Europe and England were devastated by war during this century. Thus, recorded data on the postcard industry is sorely lacking. In addition, because postcards fail to be printed with the publishing industry's normal data, scholars, curators, and catalogers have had a difficult time in dating, identifying, organizing, and confirming relationships among research samples.

THE PRODUCTION CYCLE

Much of the behind-the-scenes production information that remains comes from a wide variety of sources. One such source includes sample cards produced for postcard jobbers (figs. 10 and 11). Also called drummers, postcard jobbers served as the traveling salespersons for regional, national, or international postcard distributors or manufacturers. The jobbers' employers were often only collection and distribution agents for one or more domestic or international printers. Although many of these distributors may have called themselves publishers, some were little more than entrepreneurs with post office boxes. They acted like conduits, funneling contract orders to and from manufacturers.

Some manufacturers were able to combine printing, publishing, and distribution activities. In the United States the Detroit Publishing Company and the Albertype Company managed all these functions in one factory. The Hugh C. Leighton Company obtained a postcard factory in Frankfurt, Germany, where it could print, publish, and distribute issues from a stock of forty million cards. Leighton accepted individual orders for unique issues (fig. 12), printed

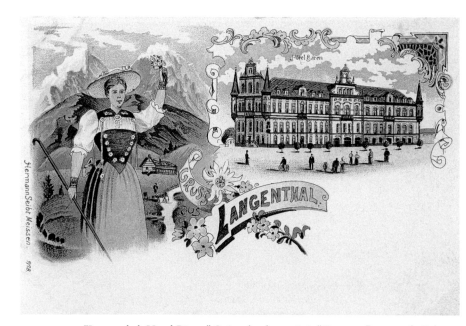

FIGURE 10. "Langenthal, Hotel Bären," Switzerland, ca. 1898. "Gruss aus" postcard. Color lithograph (eight hues). Printed by Kretzschmar and Schatz, proprietor Hermann Seibt, Meissen, Germany.

FIGURE 11. Verso of "Langenthal, Hotel Bären," ca. 1898.

FIGURE 12. Verso of a manufacturer's receipt card, 1908. Distributed and imported by Hugh C. Leighton Company, Portland, Maine

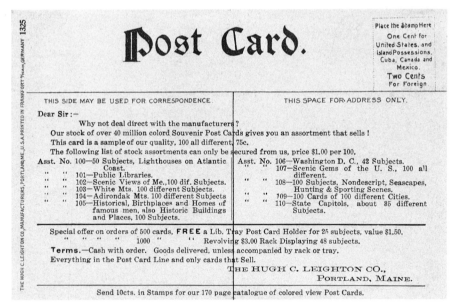

FIGURE 13. Verso of a sample card, advertisement, ca. 1908. Distributed and imported by Hugh C. Leighton Company, Portland, Maine.

catalogs of its stock, and sold sets of one hundred cards for one dollar (fig. 13). Later Leighton sent printing contracts to other factories. In London the company of Raphael Tuck and Sons printed, published, and distributed much of its own product. Tuck's extended product line was so large that it subcontracted overflow view-card orders to factories in Germany and The Netherlands in order to meet customer deadlines. Stengel and other German firms also printed, published, and distributed their own cards. Some factories, operating as contractual printers, made annual consignment agreements with other printers or publishers, who may have already reached their facility's capacity, to print a set volume at unscheduled times for a predetermined price within a certain time span.

Jobbers served as the liaison through which clients, or so-called sponsors, could commission postcards to be produced according to set specifications. In doing so, jobbers acted as the main sales contact between the wholesale and the retail side of the industry. Often they mailed sample cards to alert merchants of their upcoming sales trip. One example features the halftone portrait of L. A. Wilkinson, a jobber for E. F. Branning and Son, a New York importer of German issues (figs. 14 and 15). Wilkinson's

stock could have included hundreds of sample cards from different companies to show the full range of processes, styles, and types available (see figs. 28–33). For the jobbers' sample card (sales card), the company selected an example from its standard stock to illustrate the superior printing qualities of its presses. On the message side manufacturers or distributors described the details of the postcard contract, identified the printing process, listed prices per unit for each image, and gave other instructions about photographic and caption requirements and details on ordering. A Rotograph sample card illustrates a German issue from the Knackstedt and Näther factory (figs. 16 and 17). Details on the verso indicate a three-to-five-month delivery period for the chromo-collotype process and lists prices per units of one thousand.[9]

Other sources of information about the postcard industry include interior and exterior views of factories and work stations (figs. 18–21), published descriptions of activities observed during visits to postcard factories,[10] insights gathered from reviewing background materials, and of course, large samples of cards. Such research samples have been assembled by searching through the limited range of postcards that are still available and by obtaining representative examples from each factory that was active during the postcard era. The depth and breadth of the international industry can be extrapolated from this information and data from each provenance can be catalogued.[11]

Recognizing a potential for profit, some printers acquired presses to manufacture this small-image specialty. Around 1890, J. Miesler Company in Berlin, an early lithographer of pictures, added postcards to its product line. C. G. Röder Company in Leipzig, a printer of sheet music and other commercial items, expanded into producing postcards around 1904.[12] The picture and framing shop of Raphael Tuck and Sons began its postcard line around 1898. In the United States, the Albertype Company produced small picture books in the early 1870s and began manufacturing postcards around 1897.[13] During this period the Detroit Photographic Company (later called the Detroit Publishing Company), which manufactured photographic educational products around 1888, secured the "Photochrom" process and made its initial postcards in 1898.[14] Other manufacturers of calendars and posters or companies specializing in engraving and halftone processes bought the special presses and equipment that were required to produce these cards profitably. In this way, established printers could rather easily expand into postcard production by buying rights to patented processes or by purchasing small factories that were already successful.

Before proprietors could open a new postcard factory, they had to decide whether to establish a collotype or a lithographic printing plant. They had to compare processes, equipment, facility constraints, expenses, the availability of a skilled labor force, market trends, and sales potential. This decision of collotype versus lithograph determined the firm's initial niche in the postcard industry. If the company was profitable, however, the factory could expand its facilities and add other processes. Most companies built their reputation on one process or the other.

During the golden era, the postcard industry included hundreds of companies that employed millions of skilled workers. A major factor in a company's success was the ability of its artisans to create attractive yet cost-effective products with unusual color schemes. To this end, each factory developed unique color formulas that were closely guarded as trade secrets and often were protected by patents[15] and trademark[16] registration and use. For example, the Photo-Glob Company in Zurich patented a postcard process called

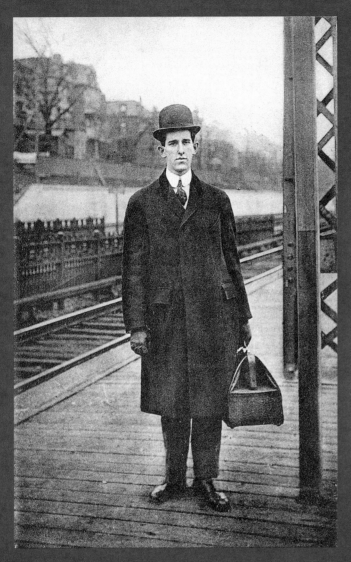

FIGURE 14. Portrait of L. A. Wilkinson (jobber's sample card), 1910. Halftone. Distributed and imported by Edwin F. Branning and Son, New York.

POST CARD

Printed in Germany.

This Space may be used for message.

The Address only to be written here.

Gentlemen.

I am on my way with samples to get your order.

Will call on you about
We sell a full line of such goods as you handle - Dry Goods, Notions &c, our speciality is POST CARDS, we have a complete stock, and make 'em to order from your Photos.

Sincerely Yours

L. A. WILKINSON

Representing Edwin F. BRANNING & SON, Cedar Ave. and West 177 St., New York City.

B 7893

FIGURE 15. Verso of a portrait of L. A. Wilkinson (jobber's sample card), 1910. Distributed and imported by Edwin F. Branning and Son, New York.

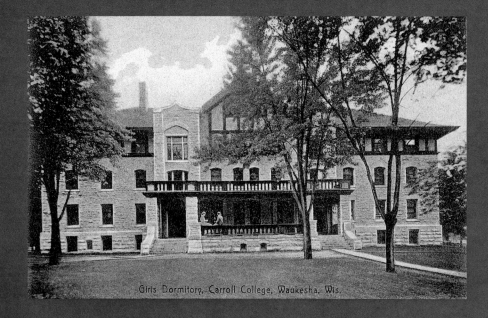

FIGURE 16. "Girls Dormitory, Carroll College, Waukesha, Wis.," Wisconsin, ca. 1907. "Machine Colored Chromo," chromo-collotype, color lithograph (six hues). Printed by Knackstedt and Näther Company, Hamburg, Germany. Distributed by Rotograph Company, New York.

FIGURE 17. Verso of "Girls Dormitory, Carroll College, Waukesha, Wis.," ca. 1907.

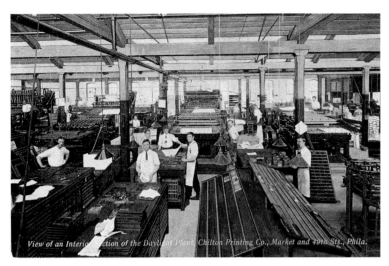

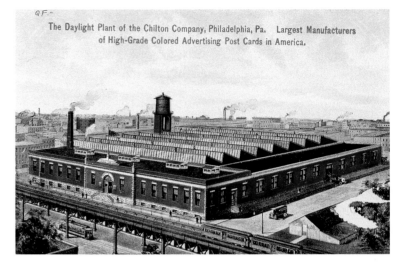

FIGURE 18. "View of an Interior Section of the Daylight Plant, Chilton Printing Company, Market and 49th Sts., Phila.," ca. 1910. Chromo-halftone, color lithograph (four hues). Printed by Chilton Printing Company, Philadelphia.

FIGURE 20. "The Daylight Plant of the Chilton Company, Philadelphia, Pa. Largest Manufacturers of High-Grade Colored Advertising Post Cards in America," 1910. Chromo-halftone, color lithograph (four hues). Printed by Chilton Printing Company, Philadelphia.

FIGURE 19. Verso of "View of an Interior Section of the Daylight Plant, Chilton Printing Company, Market and 49th Sts., Phila.," ca. 1910.

FIGURE 21. Verso of "The Daylight Plant of the Chilton Company, Philadelphia, Pa. Largest Manufacturers of High-Grade Colored Advertising Post Cards in America," 1910.

"Photochrom" in 1895 and sold the North American rights to the Detroit Photographic Company and the British rights to the Photochrome Company in London (Lowe and Papell 1975, 17). Some large companies registered their unique processes. Among them were the German factories of Louis Glaser Company (registered its "Auto-Chrom" process about 1898), Knackstedt and Näther Company (registered its "Chromo-Lichtdruck" process about 1899), and Stengel and Company (registered its own "Autochrom" process about 1905). About 1898, Stengel also patented a three-dimensional "Reliefkarte," which featured raised surfaces under the images. Competition was fierce among postcard factories, and industrial spying was commonplace. Security became a major concern, with factory workers sworn to secrecy and visitors kept to a minimum. Many of the smaller or more financially insecure factories were not in business long before they closed or merged with stronger and more successful companies.

Many postcards appear to be anonymous issues because they carry few, if any, imprints or trademarks, which creates problems in identifying their provenance. In contrast, some postcards display trademarks that manufacturers placed on their domestic and export issues. Raphael Tuck and Sons, a British manufacturer, publisher, importer, and distributor of view-cards, applied its trademark on all domestic and export issues. Most manufacturers placed the imprints of the distributors, dealers, or sponsors on their postcards.

Those who sponsored view-cards were largely retail merchants, promotional agents, or hobbyist publishers. The largest percentage of sponsors were retail merchants who placed orders for view-cards of their communities. For most of these retailers, postcards were little more than a novel souvenir that occupied a small amount of space and added a few pennies to their income. Their selection of stock was largely influenced by the interests of their clientele. Merchants with a fashionable resort trade typically handled the expensive lithographic or specialty cards, while those who catered to tourists and to professional and business customers stocked the "better" issues. Smaller retail shops carried an "average" product obtained from regional sources or visiting jobbers. Rural stores often relied on amateur photographers and mail-order firms that advertised inexpensive cards and fast service, which frequently resulted in cards of "poor" quality.

Subjects on view-cards sponsored by local merchants ranged from interior and exterior scenes of their own establishments to locations and events of interest to tourists and local residents. Images were selected, composed, and manufactured as commercial products that the public hopefully would be willing to buy. If a certain card sold slowly, it most likely was replaced the next time an order was placed.

Placing orders for cards occurred seasonally or at least four times a year. International companies required three to five months to produce and deliver lithographic and collotype cards (see fig. 17). National companies that received an out-of-region order generally required four to five weeks for delivery, while nearby national companies promised delivery in two to three weeks, and smaller regional companies needed three weeks. If the subject related to local events or disasters that were of immediate, short-term interest, photoprints or local issues were used instead. In larger communities a photographer could take pictures of special occasions, give the photos to a local printer, and have halftone issues printed in a week. Photoprint cards were taken, developed, and ready for sale in a day's time.

Time was less important if the contract was to replenish or expand the range of subjects in a merchant's stock or to or-

der seasonal issues. Reorders were less expensive to produce than new issues, since the printing plates were not remade unless excessive wear had damaged the surfaces. The printer usually retained master impressions in case of reorders, but sponsors occasionally requested that the master negatives or plates be returned with the finished product. Reorders using master impressions could be given to either the same printing company or to a different one, and cards have been found that were reprinted by more than one firm. Another problem for researchers is being aware of "generic" postcards, which are mass-produced, generalized scenes without specific, unique details of a particular site.

Sponsors for promotional issues were frequently entrepreneurs, not merchants, who saw an opportunity for large volume sales and high profit in special issues for tours and expositions. For the small Alaska-Yukon-Pacific Exposition, held in Seattle from 1 June to 26 October 1909, Rowe and Martin of Portland acquired the exclusive concession for postcard sales. In turn, Rowe and Martin sold those rights to thirty postcard stands on the exposition grounds. With an average daily attendance of twenty thousand visitors to the fair, fifty thousand copies of the two hundred exposition views were sold, which totaled more than ten million cards being sold during the first two months.[17] Issues of popular expositions can be divided into four types: pre-opening promotional examples; views of buildings, sites, and events; advertisement issues for exhibitors; and photographic documentation. "Japanerinnen beim Briefschreiben" (see fig. 8), an exposition card from 1904, exemplifies this last type.

Entrepreneurs also signed contracts for issues related to special occasions, such as royal visits, local or national celebrations, or special political, religious, or entertainment events. These cards were produced as souvenirs for these occasions, as

lottery issues, or as a way to fund special projects for hospitals, orphanages, missionary societies, and other worthy causes. For missionary issues, photographs were sometimes taken at the site and sent to sponsors for printing as inexpensive collotype or halftone series for local promotions.

Among hobbyist sponsors were the publishers of "Vue De Port Au Prince" (see fig. 5). The exceptional quality of this card indicates that it was directed toward avid postcard collectors. Its artistic layout suggests that the card was designed with color schemes that would make attractive group arrangements suitable for framing or display in an album. Such issues were often sold in postcard shops.

As the fad of collecting postcards circled the globe, postcard specialty shops opened in most major cities. Thousands of view-cards of local, state, national, and international interest were stocked, along with hundreds of topical issues. The qualities and types of stock ranged from international polychromatic sets to local photoprint series of entertainments or natural disasters. To ensure that avid collectors would always find new stock in their stores, merchants placed orders for new series as quickly as they were introduced by jobbers or in new catalogs. Interior views of these stores show wall-to-wall glass cases and racks filled with postcards (fig. 22). The diversity of products stocked in these shops reflects the enormity of the industry's structure and global network.

To assist in interpreting the postcard industry's vast international networks, production coverage has been divided into generational groupings: first generation, 1880–90; second generation, 1891–95; third generation, 1896–1900; fourth generation, 1901–5; fifth generation, 1906–10; sixth generation, 1911–15; and seventh generation, 1916–20. This coverage is also organized into a series of distribution patterns that be-

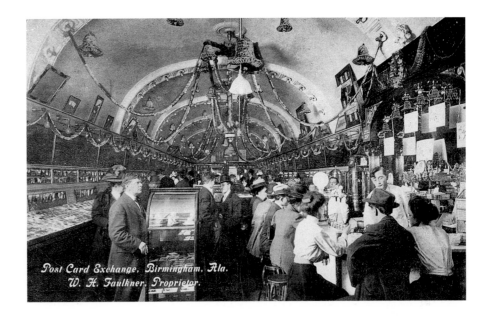

FIGURE 22. "Post Card Exchange, Birmingham, Ala. W. H. Faulkner, Proprietor," 1913. Chromo-halftone, color lithograph (five hues). Printed by Curt Teich Company, Chicago. Sponsored by the Postcard Exchange, Birmingham, Alabama.

gins with a worldwide scope and scales back to cards with only a local perspective. First-layer factories, such as Stengel and Company (see fig. 27), exported postcards to every region of the world, while second-layer ones, including Albertype Company in North America, limited their coverage to a single geographical region. Third-layer firms, for example, Raphael Tuck and Sons in London, sold their issues in the country of origin or to adjacent trading partners and overseas colonies, whereas fourth-layer ones, including Hugh C. Leighton Company of Portland, Maine (see fig. 13), restricted their production to domestic issues only. Fifth-layer companies covered sections of a country, while local entrepreneurs, photographers, and printers comprised the sixth layer.

A company's position within the postcard industry depended largely upon the effective arrangement of international offices and jobbers' regional territories as well as a united affiliation with distributors who shared an equally am-

bitious attitude toward exports. Once a distribution system was established, contracts and finished products were channeled back and forth between distant sponsors and the manufacturer. A contract network might lead directly from the retailer through a postcard jobber to the manufacturer. A more complex network might follow an extended pattern from a merchant, such as a rural hotel in a distant country, signing an order that passed to a territorial wholesaler, then to an affiliated supplier in the colony's home country, a national postcard importer and distributor in that country, the export postcard distributor in the country of origin, and finally to the printer. Once the cards were made, they returned through the system to the sponsor. This complicated network was employed for only select, "better" postcard products due to the extended cost and time needed to complete the contract cycle. Cheaper products and those needed quickly eliminated one or all of the third, fourth, and fifth steps.

Networks flowing to destinations in Latin America, Africa, the Pacific islands, and Asia were directly affected by the European nation that governed each colony; by the international or local status of the ports of entry; by the country of registration of the steamship lines—both international trunk lines and coastal feeder boats—that stopped at those ports; and by the nationalities of the traveling salespersons who brought supplies of postcards to local merchants. In turn, territorial merchants were influenced by the governing structure of their community or colony as well as by their overseas affiliations. Their clientele were the commercial, governmental, military, professional, and religious personnel of their area, as well as the local residents and the tourists who traveled through the territory.

GERMAN POSTCARD PUBLISHERS

German issues dominated most postcard markets during the first decade of the twentieth century. Hundreds of companies in Germany were producing billions of cards each year, with about thirty of these firms expanding into the international market. Many of these large factories employed as many as fifteen hundred workers to run 112-cylinder printing presses to produce millions of cards (Lowe 1982, 17). Low labor and production costs permitted a complex, polychromatic lithographic image to be printed and distributed at a minimal export price. This situation continued until strong industries in other countries and restrictive tariff rates removed the German advantage.

Stengel and Company of Dresden (figs. 23 and 24) stood out as the leading European printer of prime export viewcards. Its three hundred fifty workers produced eighty million cards annually. This dominance resulted from Stengel's greater potential for production, with its main printing plant in Dresden and other plants and affiliations in Berlin and Vienna. This versatility enabled Stengel not only to meet the growing number of contracts it received but also to maintain its wide circulation across the Continent. In addition, its London office gave it broad coverage in the British Empire, and its New York one provided it with a prominent distribution position in the United States.

Stengel began to print collotypes before 1895, using flatbed cylinder presses. By 1898 the company had export cards on sale from China to the United States. Its earliest color issues were hand-painted watercolor tints on collotypes, yet both limited and multihue lithography processes were added before the end of the century. By 1899 the company expanded its product line by putting an embossed "Reliefkarte" issue on the market. Stengel also began making reproductions of artworks in museums, printing them with an extended range of more than twenty hues.

The tonal appearance created through this distinct collotype adaptation made Stengel's cards easily recognizable. Adding to their easy identification was the printer's idiosyncrasy of marking a production code number on the bottom corner of the photographic negative. The collotype issue "Fijian Village" of circa 1900 (fig. 25) was one of a series that portrayed indigenous cultures. This issue, number 56,805, was from a documented code that ranged from 417 to 89,653. A second one, indicated with the letter A, ranged from A4,715 to A94,744, while other ones had prefix letters of B, C, E, and R. This distinctive marking was sometimes replaced with a printed font code number positioned elsewhere on the card.

Local girls posed in dance positions or holding musical instruments are teasingly presented alongside a ceremonial

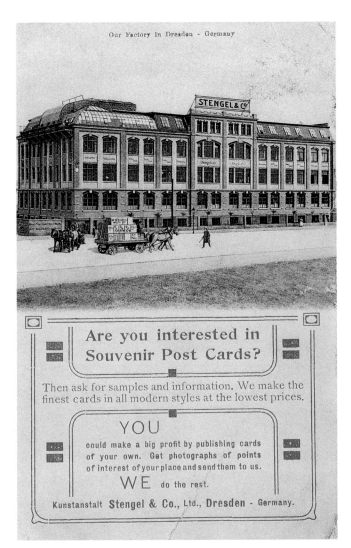

FIGURE 23. "Our Factory in Dresden - Germany," ca. 1907. External view of Stengel and Company. Chromo-collotype, color lithograph. Printed by Stengel and Company, Dresden, Germany.

FIGURE 24. Verso of "Our Factory in Dresden - Germany," ca. 1907.

Fijian Village

A. M. Brodziak & Co., Suva - Fiji

FIGURE 25. "Fijian Village," Fiji, ca. 1900. Collotype. Printed by Stengel and Company, Dresden, Germany. Sponsored by A. M. Brodziak and Company, Suva, Fiji.

site in "Hindo Temple and Nauch Girls, Ceylon" (see fig. 6), a collotype dating from 1898. The diverse images on the card are visually united by the embellishments and flowers that nicely form an attractive frame around them. Unfortunately, the irregular outlines created by such design elements often obscured the negative's code number and allowed only a limited amount of writing space. Other images in the series documented scenes of harbors, cities, and rural areas in decorative single and multiview issues as well as in unadorned full-image views. This series on the former Ceylon (now Sri Lanka) was reprinted several times, with this particular card being made between 1901 and 1905. Series using this format could be found from tourist sites in Egypt and North Africa to port cities along the trade routes that circled Africa, India, and the Far East. While such collotype cards formed the mainstay of Stengel's production, their lithographic products proved to be popular issues as well.

Luxury resorts in Tanger (Tangier), Cairo, and throughout the Mediterranean often stocked both the basic collotype lines and Stengel's elegant lithographic cards printed in ten colors. "Tanger (sud) 1 Maroc" (fig. 26), with its rich layering of lush, moody color under a golden sky, typifies the company's multicolored product of the late 1890s. Unlike the stippling application of the early *Gruss aus* cards, this printing process used a simplified scheme of broad, irregular patches of tones to produce luxuriant colors. Stengel's artists could thus enhance the company's premiere issue by emphasizing features of interest with heightened color and dramatic highlights. Higher production costs were partially offset by requiring a minimum order of three thousand cards per subject. Stengel produced a less-expensive lithographic product as well.

To stay abreast with evolving market demands for cards with limited color, Stengel developed its own version of the chromo-collotype process. This simplified printing method, introduced between 1901 and 1905, is illustrated in "South African Ricksha Boys" (fig. 27). It started with a dark and light collotype image and overlapped irregular shapes and layers of transparent and opaque hues to indicate landscape and sky features. This step was followed by the careful placement of color accents to highlight details. This six-color specimen has the negative code number 8232 in the lower right and a standard Stengel caption font.

The C. G. Röder Company in Leipzig was an international contract printer active from 1904 into the 1930s. Its

FIGURE 26. Tangiers, Morocco, ca. 1899. Chromo-collotype, color lithograph (ten hues). Printed by Stengel and Company, Dresden, Germany. Sponsored by Hell, Tangiers, Morocco.

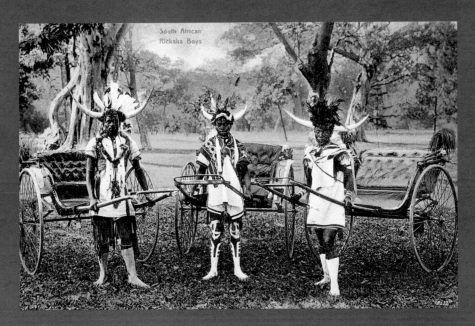

FIGURE 27. "South African Ricksha Boys," ca. 1904. Chromo-collotype, color lithograph (six hues). Printed by Stengel and Company, Dresden, Germany. Sponsored by A. Rittenberg, Durban, South Africa.

imprints appear only on sample cards. "Art-Photo," an attractive early Röder chromo-collotype, had a code range from 38,484 to 119,288 (Leonard 1991, 21–23). A pale bluish green was used for its captions and in its sky coloring. Over time numerous other processes were developed under the Röder imprint. "Tiberias from the Lake," a selection of sample cards dating from the period of 1911 to 1915, appears in several jobbers' folders (see figs. 28–33). It represents only six of the many different color formulas (code level 625,000) produced by Röder at that time.[18] These formulas ranged from a standard collotype that Röder called "Platinotype" (black ink on white paper; fig. 28), to "Collotype-Antique" (brown ink on off-white stock; fig. 29) and "Doubletone-Crystal," which used both pink and black inks (fig. 30). This last process required two press runs and was available in editions of brown (sepia), blue (Delft), and green (malachite). Three other printing formulas incorporated variations of the general chromo-collotype format that was popular between 1911 and 1915. The "Heliodore" process placed a decorative ocher (yellow) sky defined with linear patterns over a collotype image (fig. 31). Ocher, green, brown, and black hues cover the landscape and seascape, while a subtle halftone screen defines the water area. In another card a pale iris blue sky distinguishes the "Bromo-Iris" process. Pale halftone screens of pink, red, yellow, tan, and black are barely visible in the sky and water areas (fig. 32). The "Photochrome-Substitute" process is similar to "Bromo-Iris" except for the application of a deeper hue of cobalt blue (fig. 33). These chromo-collotype variations are actually simplified substitutions of earlier patented color formulas, a step that seemed necessary as market economics required reduced production costs.

Numerous postcard distributors in the United States, such as the American News Company in New York, a newspaper agency that stocked postcards and premiums, handled Röder's later issues, judging by postmark dates that range from 1910 to 1913. These distributors sent their contracts through importers on the East and West Coasts. On several of these cards Röder's preferred electrotype layout was printed in green ink, and its production code was placed in the lower right corner or stamp box. Codes for these simplified processes range from 350,000 to 700,000.

The worldwide scope of German postcard circulation also can be understood by reviewing companies located in the major industrial port city of Hamburg. Regional cargo arrived at the port via trains or coastal and river steamers. From there it was placed on German or other international trunk lines and sent to distant ocean ports, such as Singapore, where smaller feeder steamers traversed the archipelagoes, coasts, and rivers carrying cargo to and from European ports.[19] Jobbers for Hamburg postcard companies used local shipping lines, including the trading and shipping company C. Woermann and the Hamburg-American Line,[20] to organize distribution networks along the numerous trade routes, which enabled them to sell German products around the world. M. Glückstadt and Munden Company, Knackstedt and Näther Company, and H. A. J. Schultz and Company, all postcard producers in Hamburg, exported their German products over a wide area. Other postcard exporters with a base in Hamburg distributed issues to Africa and more distant regions. Among them were Albert Aust in circa 1898 (Cameroon, Mozambique, Togo, Tanganyika and Zanzibar, and the United States) and Otto Körner (Mozambique). These and other exporting jobbers probably represented multiple German products.

Among the prominent Hamburg factories of the pre-1895 period was the Knackstedt and Näther Company, an international printer noted for its outstanding "Lichtdruck" collotypes for view-cards and shipping issues. The com-

FIGURE 28. "Tiberias from the Lake," Palestine, ca. 1911. "Platinotype," collotype. Printed by C. G. Röder Company, Leipzig, Germany.

FIGURE 29. "Tiberias from the Lake," Palestine, ca. 1911. "Collotype-Antique," collotype. Printed by C. G. Röder Company, Leipzig, Germany.

FIGURE 30. "Tiberias from the Lake," Palestine, ca. 1911. "Doubletone Crystal," collotype. Printed by C. G. Röder Company, Leipzig, Germany.

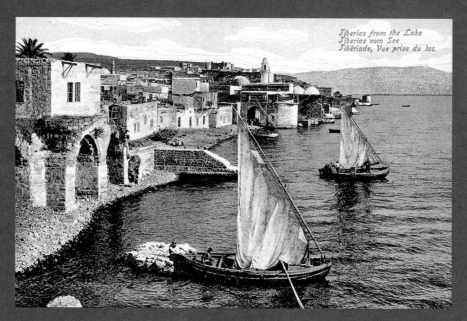

FIGURE 31. "Tiberias from the Lake," Palestine, ca. 1911. "Heliodore," chromo-collotype, color lithograph (six hues). Printed by C. G. Röder Company, Leipzig, Germany.

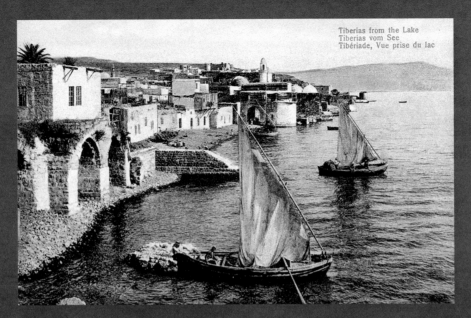

FIGURE 32. "Tiberias from the Lake," Palestine, ca. 1911. "Bromo-Iris," chromo-collotype, color lithograph (six hues). Printed by C. G. Röder Company, Leipzig, Germany.

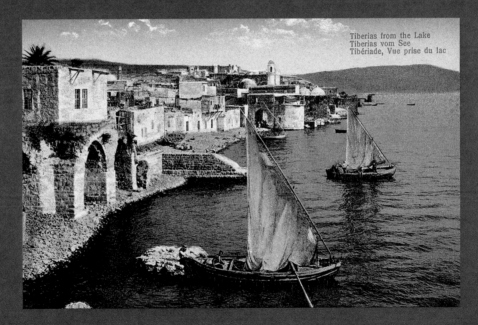

FIGURE 33. "Tiberias from the Lake," Palestine, ca. 1911. "Photochrome-Substitute," chromo-collotype, color lithograph (six hues). Printed by C. G. Röder Company, Leipzig, Germany.

pany's subtle yet exquisite definitions reflected its superb craftsmanship and set a high standard for the collotype process. Each delicate variation of color tones, resulting from black, sepia, green, or blue inks, gave dark and light definitions to the collotype images. After the initial collotype processes were established, hand-colored issues were added to the product lines. Lithographic formulas were also developed at the same time.

A group of Knackstedt and Näther collotypes printed between 1898 and 1900 documents the route along the West African coast and the diverse paths that Aust's jobbers traveled. The cards show steamers off Cape Palmas in Liberia, villagers of the Gold Coast (now Ghana and Côte d'Ivoire), market scenes in Dahomey (now Benin), dancers in Togo, Africans in dance costumes in Nigeria, and a wrestling match in Cameroon. Examples from Togo are unusual in that they carry both the exporter's imprint (Aust) and the factory's imprint (Knackstedt and Näther). Collotype examples that were printed between 1901 and 1905 and were sent to the Caribbean include two cards of Santo Domingo with Hamburg-American Line imprints, Port au Prince views, and scenes from Jamaica, Curaçao, Antigua, and Bermuda. Other steamer companies carried Knackstedt and Näther cards to Brazil, Chile, Ecuador, and Peru.

Routes of the Hamburg-American Line visited Damascus and Palestine before passing through the Suez Canal to reach Aden, the Arabian Sea, and the Far East. Collotypes printed between 1898 and 1900 document a path from Ceylon (with hotel issues) to Calcutta (with port scenes) and on to the major Asian crossroads of Singapore. The route then either shifted to Java (with views of indigenous life) or moved to Hong Kong and then changed to a river steamer going up the Pearl River to Canton (as seen in views of flower boats and river fronts). Passengers to Singapore could purchase postcards of the bustling port and city, and of course, of the indigenous culture. One image shows a market scene with local produce defined by the subtle greenish black tones of the collotype. "Singapore. Variety of Fruits" (fig. 34) features both excellent photography and superior collotype craftsmanship that demonstrate the delicate modeling that is possible with this process.

Knackstedt and Näther expanded its product range around 1900 by creating a delicate lithographic chromo-collotype process called "Chromo-Lichtdruck." This was used to make the reprint of "Mohamedan Woman" (see fig. 7) between 1901 and 1905. The "Chromo-Lichtdruck" process was created by printing a basic collotype image in a compatible color of ink on a yellow card. Sheer layers of transparent and opaque stippled inks in red, pink, tan, medium and pale blue, gray, yellow, brown, and black were then added to highlight the image. In this image, light hues accent the woman's layered costume and create an attractive, luminous image that contrasts with the muted background. By changing the color and texture of the paper stock, different color schemes could be fashioned to convey the appearance of foggy waterfronts, rich sunset vistas, and moody night scenes. Those collectors who were enticed by such seductive color palettes considered these issues to be some of the best chromolithographs produced between 1896 and 1905, and they often recognized the cards at first glance.

Economic competition led Knackstedt and Näther to develop yet another printing process between 1901 and 1905. This resulted in a machine-colored chromo with beautifully marbleized patterns in the sky areas. Its characteristic middle spectrum of airy, pale shades is evident in "Girls Dormitory, Carroll College, Waukesha, Wis." (see fig. 16). The Roto-

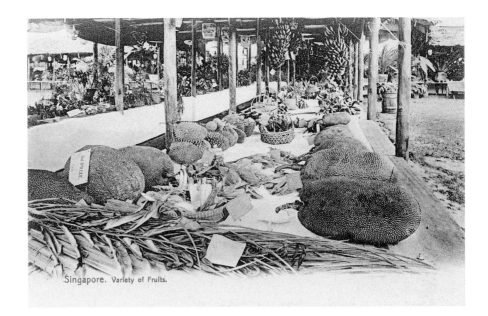

FIGURE 34. "Singapore. Variety of Fruits," Malaysia, ca. 1907. Collotype. Printed by Knackstedt and Näther Company, Hamburg, Germany.

graph Company in New York was the main importer of this product in the United States.

Like many of the issues produced by its rival companies, Knackstedt and Näther's postcards were represented by distributors and exporters in the British Empire, such as the Pictorial Stationery Company and J. Davis Company of London. For the Photographie Artistique Ed. Nels in Brussels, Knackstedt and Näther printed its domestic and export colonial issues for the Belgian Congo (formerly Zaire, now Democratic Republic of the Congo). Knackstedt and Näther did not use code numbers on issues with its imprint but instead assigned distributor codes.

My research into the international distribution of viewcards indicates that the German postcard industry ranked as the leading producer and exporter to continental Europe. Its extended British distribution network was documented

when German cards carrying the imprints "made at our 'works'" in Leipzig, Hamburg, Berlin, etc. were found and added to my research sample. This imprint indicates that this product became the preferred choice of many British distributors and exporters. The skills of the German printing industry were also dispersed when many young printers, upon learning the printing trade, emigrated to Great Britain, the United States, and elsewhere for better employment opportunities. Such movement helped improve the overall quality of international postcards.

In this way German postcards represented the dominant benchmark for issues in the United States, the British Empire (with its extensive maritime trade), and the German colonies. Indeed, the worldwide view-card factories were all German, and single-region printing plants in Europe were mainly German. Pre-1910 North American postcards were

mostly German. After the restrictive Payne-Aldrich Tariff Act was passed in 1909, however, printers in the United States shifted from playing a supplemental role to becoming major producers of postcards. Spanish and Portuguese shipping services were limited to Latin America and the West Indies, so the German shipping network filled the void and delivered German products to those areas. British shippers supplied both German and British issues to British colonies and ports of call. Consequently, the combination of the two major maritime networks of Germany and Great Britain lent an unparalleled distribution system to German postcards.

In Africa most of the postcards sold in the German colonies and the Belgian Congo were German issues, and a large portion of the Portuguese colonies' postcards had German origins. The British colonies stocked both German and English products, while the French colonies printed and distributed their own national cards. Egypt, a tourist-oriented country under British control, offered postcards manufactured by all the industrial nations.

Asia was divided into several contiguous areas. Scenes of the Near East were documented in cards from many European industrial countries. The British colonies of India and adjacent areas distributed primarily German and British issues, while the Indochina territories in Southeast Asia were dominated by French products. Postcards in China came from Germany, Britain, and France. Japan, with its own strong domestic industry, limited the number of European issues circulating in that country.

Australia and New Zealand, the large landmass areas of Oceania, sold British and German as well as their own domestic products. Scenes of the East Indies were depicted in Dutch, German, and some British postcards, while exotic views of the Philippines appeared mainly in issues from Germany and the United States. The numerous islands in the Pacific Ocean maintained ties with both their national

sources and those countries whose shipping routes used their ports. Their postcards illustrated that diversity, with French territories largely handling national issues with the limited participation of German companies. Several European industries shared the scattered distribution network among the remaining Pacific territories. Naturally, pipelines and sources of postcards for all these regions changed from time to time.

At the height of the industry's boom, postcards were virtually everywhere in the world. The international use of postcards can be interpreted by the sale of one-cent stamps in 1909: 833 million in Great Britain; 668 million in the United States (1908); 400 million in India; 398 million in Austria; 280 million in Belgium; 210 million in Russia; 160 million in Germany; 110 million in Hungary; 76 million in The Netherlands; 74 million in Sweden; 71 million in Italy; 28 million in Romania; and 18 million in France (at a two-cent rate) (Lowe 1982, 77). This volume continued to increase until the collecting craze peaked in 1912. Of course, the above data does not include the countless cards that were mailed in letters or carried home in person.

As differences in the production of postcards equalized across international boundaries and as competition for postcard contracts with national chains of stores began around 1910, production costs were forced down. Since labor constituted the greatest expense, color schemes were reformulated and fewer hues were used to reduce press time and costs per printed sheet. Substituting fewer colors and utilizing cheaper materials resulted in more garish products, which were nevertheless bound into perforated booklets of ten to twenty cards to encourage volume purchases. Due to the changing economic structure of the postcard industry, issues in the second decade of the twentieth century lost much of their inherent visual beauty.

By 1912 the golden era of postcard production was coming to an end. Quality had declined and new images and sub-

jects had decreased. Consequently, sales abated, postcard clubs were less active, and collectors developed different hobbies. By then the marketplace was glutted with cards. With profits disappearing, entrepreneurs closed their postcard firms and shifted their focus to other merchandise. In turn, factories closed and millions of workers lost their jobs. Also, postcards no longer were the primary vehicle for distributing photographic images to a large cross section of the population. Publishers of popular magazines and newspapers were now willing and able to include photographic images in their publications. Finally, by 1914 shortages of paper and ink, and restrictions caused by war preparations blocked the easy flow of needed supplies. Since postcards were largely an nonessential novelty item, their production was stopped as war-related products were printed. By the time World War I was over and peacetime trade resumed, most postcard companies were out of business. Only a few printers returned to full-time postcard production.

Although the postcard era was essentially finished, a number of major factories continued to print a reduced volume of international cards. The Tuck and Valentine companies produced a steady volume for the British Empire, while Knackstedt and Näther, Röder, and Stengel all remained active in Germany during the next decade. Unfortunately, numerous factories, including Tuck in London and several ones in central Europe, were destroyed during World War II and their records lost. Today's researchers are valiantly trying to piece together the history of this fascinating industry from the scattered information that remains from the golden era of postcard production.

NOTES

1. This collection is now in the Special Collections and Preservation Department, Suzzallo-Allen Library, University of Washington, Seattle. It was assembled by Caroline Ober (1866–1929), a professor at the University of Washington from 1897 to 1929, during a period that overlapped with the major postcard era. The collection of 67,000 cards covers most American states and many countries. Ober joined several national and international postcard exchange clubs and developed a vast network of worldwide contacts, which were documented in brief notes written on the exchanged cards. The collection was donated to the University Library by Myra Ober More and inventoried in 1972. Professor Ober's documentation was researched by Richard Engeman of the Photographs and Graphics Collections, Suzzallo-Allen Library, University of Washington, Seattle.

2. J. R. Burdick, *Pioneer Post Cards* (reprint, New York: Nostalgia Press, n.d.), p. 7.

3. J. Kainen, "Lithography," *Encyclopedia Britannica,* vol. 14 (Chicago: University of Chicago, 1965), pp. 111–16.

4. According to W. Morris, *The American Heritage Dictionary of the English Language* (New York: Houghton Mifflin Company, 1973), the platin, platino, or platinotype collotype or photographic process uses both a finely precipitated platinum salt and an iron salt in the sensitizing solution to produce photographic prints in platinum black (p. 1004). A sepia print uses a dark brown ink originally prepared from the secretion of a cuttlefish (p. 1182).

5. E. Epstean, "Photo-Engraving, Halftone plates," *Encyclopedia Britannica,* vol. 17 (Chicago: University of Chicago, 1965), pp. 793–96.

6. Codes on view-cards can be described as identification numbers for each image and its position either in the factory's printing cycle or in the distributor's contract cycle. Rotograph and Company in New York modified its codes with prefix letters for processes—A for black ink, D for Delft blue, H for hand-colored collotypes—and for lithographic factories—G for Knackstedt and Näther Company in Hamburg and E for Rosenblatt Lithographic Company in Frankfurt. R was used for Stengel and Company's embossed cards. Factories such as Rosenblatt assigned special codes for individual product lines, while others used different codes for each distributor or for domestic and export issues. Curt Teich Company in Chicago and others discontinued initial code structures and began new ones at various points in their business cycle. Production codes, of course, could be deleted upon the request of the sponsor. Codes of each provenance should be cautiously studied for irregular patterns.

7. Each factory could change the verso layout upon the request of a distributor or sponsor. Factories such as Raphael Tuck and Sons in London, for example, subcontracted its overflow orders for view-cards and required contracted printers to duplicate Tuck's logo, electrotype, and the ink colors used on the verso of its cards. Importers in the United States, such as the International Postal Card Company, Rotograph Company, and Souvenir Post Card Company, all in New York City, required factories printing their cards to use the distributors' distinctive logos, electrotypes, and ink colors. Ornate electrotypes often had small differences in letter shapes, spacing, or details that permitted differentiation among

cards from various factories. Many resorts, historical sites, and expositions required each contracting factory to use special and sometimes elaborate verso designs. Many colonial countries demanded that verso designs of early issues resemble their postal stationery, complete with heraldic coats of arms and decorative designs. Some of these countries are Mexico, San Salvador, Costa Rica, Chile, Venezuela, Cuba, Dominican Republic, Egypt, Ethiopia, Zimbabwe (then Southern Rhodesia), South Africa, Iran, India, Ceylon, Thailand, China, Australia, New Zealand, and Fiji. Factories such as Leder, Knackstedt and Näther, and Stengel filled these orders using special verso designs. Today they can be identified only by the picture-side features of caption fonts, negative codes, and the printer's unique color schemes.

8. Arnold Pilling, "Stock Dating and Mount Dating of Early Photographs" (paper presented in Detroit, 1978). Also see A. Pilling, "Dating Photographs," *Ethnohistory: A Researcher's Guide, Studies in Third World Societies* 35 (1986), pp. 167–226.

9. Prices for German color lithographic (chromo-halftones) issues of *Gruss aus* multiview cards from circa 1900 can be inferred by noting the price structure of Emil Pinkau's "Special Designs": 2,000 cards for $25; 5,000 for $45; 10,000 for $70; and 25,000 for $150. The same "Special Designs" in a one-color process cost $8 per 1,000 cards and $12 per 2,000. Popular with exposition sponsors, these "Special Designs" were used in 1904 at the World's Fair in St. Louis and in 1905 at the Lewis and Clark Exposition in Portland, Oregon.

Around 1907, German postcard pricing structures for single-view images often required a minimum order of 3,000 copies per image. Color lithographs (chromo-collotypes) by Knackstedt and Näther in Hamburg cost $9 per thousand for 3,000 or $7 per thousand for 5,000 cards. In Leipzig, Dr. Trenkler's color lithographs (chromo-halftones) required a minimum order of 5,000 cards at a price of $8 per thousand and $6.50 per thousand for 10,000 cards.

For its color lithographs (chromo-collotypes with halftone screens used in the sky), Valentine and Sons in Dundee, Scotland, had a minimum purchase of 1,000 cards at a price of $10 per thousand, with a reduction to $9 per thousand if the order included 1,000 copies each of six or more subjects. Around 1910, Alfred Holzman in Chicago offered machine-colored (chromo-halftone) issues at $10 per thousand for 3,000 cards; $7.50 per thousand for 5,000 cards; or $5.50 per thousand for 10,000 cards. American postcards in the early twentieth century often used four-color chromo-halftone processes. Prices for hand-colored collotypes hovered around $10 for an order of 1,000 cards: Knackstedt and Näther at $12.50 per thousand, with a minimum order of 1,000; an anonymous factory in Berlin at $10 per thousand; and the Albertype Company in Brooklyn at $11.50 per thousand for five to ten different subjects, $10.75 per thousand for twenty to thirty different subjects, and $10 per thousand for fifty or more subjects. Prices for collotypes ranged from Knackstedt and Näther at $5 per thousand, with a minimum order of 1,000 per subject, to Albertype at $8 per thousand for five subjects,

$7.50 per thousand for ten subjects, and $7 per thousand for twenty subjects. Albertype also offered smaller minimums of 250 and 500 copies per subject. Domestic halftone prices ranged from $5 to $7.50 per thousand, and some printers were willing to print smaller minimums of 250 or 500 copies.

10. D. B. Ryan, *Picture Postcards in the United States 1893–1918* (New York: C. N. Potter, Inc., 1982), pp. 15–32.

11. My own research began in 1985 with the identification of American and German factories, such as Stengel, Knackstedt and Näther, and Pinkau. Since then I have surveyed over one million cards and hundreds of pre-1920 city directories from major cities across the United States and Germany. To reach my goal—to document each American and international postcard printer and publisher in operation from 1890 to 1920—my research sample exceeds twenty-five thousand cards and photocopied specimens.

12. A. Leonard, "F. G. O. Stuart's German Printer (Jack Foley Research on C. G. Röder)," *Picture Postcard Monthly* (Great Britain), (July 1991), pp. 21–23.

13. Albertype history statement, Wittemann Collection, no. 782, Prints and Photographs Division, Library of Congress, Washington, D.C.

14. J. L. Lowe and B. Papell, *Detroit Publishing Company Collectors' Guide* (Newtown Square, Penn.: Deltiologists of America, 1975), p. 10.

15. Around 1905, patented color formulas for view-cards were not limited to standardized selections of red, yellow, and blue plus a flesh pink tone on a black collotype or halftone image. Instead, they included various shades of each primary color to create specific results. Unusual secondary or tertiary shades could be created by placing two, three, or four layers of colored ink one over the other. Often German issues expanded the color range by including tones of pink, teal, tan, or gray for complementary or analogous color harmonies that resulted in intricate color schemes and superior products with six to ten color combinations. Each factory's unique color formulas were named. "Photo-Iris," for example, was registered and protected by international patent conventions.

The International Convention for the Protection of Industrial Property, held in 1883 in Paris, set international regulations on "new and useful processes" and the "composition of matter" in the manufacture of products. These standards went into effect on 7 July 1884 and were revised at the convention held in Brussels in 1900. See P. J. Federico, "Patent," *Encyclopedia Britannica,* vol. 17 (Chicago: University of Chicago, 1965), pp. 370–76.

16. Governmental acts on industrial trademarks were passed in Great Britain (1862), the United States (1870), and Germany (1874, revised in 1894). These trademarks indicating the origin of a product not only acted as a company's guarantee of quality, but they also distinguished its product from that of other businesses. The United States and Great Britain required the adoption and use trademarks, while Germany required only their registration. These business marks, logos, or trade names could be "devices," "figures," "letters," "fancy or descriptive words," etc. See

R. Callmann, "Trade-marks and Names," *Encyclopedia Britannica,* vol. 22 (Chicago: University of Chicago, 1965), pp. 356–60.

17. J. L. Lowe, *Walden's Post Card Enthusiast Revisited* (Ridley Park, Penn.: Deltiologists of America, 1982), pp. 12, 14, 17, 29, 49, and 77.

18. A large assortment of a jobber's sample cards illustrating fourteen printing processes and dating from circa 1911 to 1914—they contain correspondence from the C. G. Röder Company from 1914—was uncovered in a Toronto estate sale in 1994 and added to the collection of Chris McGregor. This discovery documents the distribution pipeline beginning in Leipzig, with the samples being exported out of Hamburg by Albert Aust's jobbers using the Hamburg-American Line. The cards were shipped to Montreal to expand the range of products ordered by clients in Canada. Aust's jobbers may have met with representatives of the Montreal Importing Company, which sold German postcards, and other importers in the city. Either Aust's jobbers or other salesmen traveled inland to Toronto and elsewhere to show examples of the Röder line to regional wholesalers, distributors, or suppliers to the tourist industry. As McGregor points out, both the Novelty Manufacturing and Art Company in Montreal and Rumsey and Company in Toronto used Röder cards, so wholesale jobbers must have traveled across the provinces to obtain the merchants' orders. Contracts and finished cards then followed various pipelines between the central importer and the factory. These jobbers' materials also indicate that Canadian tariff laws did not restrict the flow of German cards into Canada to the same degree as similar laws did in the United States during the period of 1910 to 1915.

19. J. R. Smith, *The Ocean Carrier* (New York: G. P. Putnam's Sons, 1908), p. 155.

20. A map of the worldwide services of the Hamburg-American Packet Company illustrates the major ports it serviced through its international trade routes of sixty-eight lines and services.

> [It] connected with Montreal, Portland, Boston, New York, Philadelphia, Baltimore, Newport News, New Orleans and Galveston in the eastern United States. It sent steamers to Mexico, Central America, Panama, Columbia, Venezuela, and the Lesser and Greater Antilles. They go to the Amazon, to the ports of central and south Brazil, to Uruguay and the Argentine Republic, to Chili and Peru. . . . In Africa it touches at Alexandria and down the whole west coast as far as the mouth of the Congo (Rufisque, Monrovia, Grand Bassam, Axim, Accra, Lagos, and Banana). In Asia it serves Aden, the ports of Arabia, Persian Gulf, Ceylon, Calcutta, Singapore, Hongkong, Shanghai, Korea, Siberia, Japan and across the Pacific to Portland, Oregon [Smith 1908, 159].

The Hamburg-American Line and other German trunk lines that traveled to distant colonial ports, such as Singapore, were fed by lines of smaller German steamers. Traversing coasts, isolated gulfs, bays, and rivers, these smaller steamers collected cargo for the trunk lines bound for German ports.

CARTE POSTALE

Ce côté est exclusivement réservé a l'adresse

Monsieur et Madame Aubert

Mecanicien

Bourbonne les bains

Hte marne

JCB

2 ROBERT W. RYDELL

Souvenirs of Imperialism

World's Fair Postcards

Much has been written about the world's fairs that lent form and substance to the modern world between London's Crystal Palace Exhibition of 1851 and the New York World's Fair of 1939–40. We know rather less about world's fair postcards, although it is common knowledge that fairs, especially the World's Columbian Exposition held in Chicago in 1893 and the Exposition Universelle held in Paris in 1900, transformed this medium of business communication into a massive industry serving and representing multiple cultures.

World's fairs and the postcard industry were equally important parts of the emerging "exhibitionary complex" that characterized Europe and the United States in an era of rapidly expanding Western control over the regions that have been referred to as the "Third World." What made these fairs such important cultural institutions was their powerful ability to represent the world by putting people and their cultures on display and thus build public support for na-

tional imperial policies. Beginning in 1893, postcards propelled images of race and empire to an audience far beyond the fairgrounds. Even today, postcard images of African, Asian, and Oceanic displays at world's fairs can be misread as authentic reflections of these cultures. Despite the supposedly noble intentions of their sponsors, world's fairs were rife with contradictions, and so were the images transmitted by postcard manufacturers.[1]

ARSENALS OF EMPIRE: WORLD'S FAIRS

From the beginning, world's fairs were intended to be much more than showcases of technological advancements. At the Crystal Palace Exhibition, officially titled the Great Exhibition of the Works of Industry of All Nations, the industrial

and artistic wares of many countries were put on display within the larger context of promoting nationalism and imperialism. Three years earlier, Europe had been swept by political revolutions. The Chartist movement, through which British working classes demanded political and economic reforms, seemed to be gathering momentum. Just a year before lending his endorsement to plans for the 1851 exhibition, Prince Albert, Queen Victoria's husband, confessed his nervousness. "We have Chartist riots every night, which result in numbers of broken heads," he wrote in a letter in 1848. While confident of the "loyalty of the country on the whole," Albert nonetheless feared for the stability of England's political order and saw the Crystal Palace as a vehicle for impressing "millions of British workers" with the essential rightness of the nation's political, social, and economic systems.[2]

In addition to stabilizing the domestic social order, expositions were organized to rally public support for national imperial objectives. This facet of the exposition movement became increasingly apparent at world's fairs organized after 1851. For example, at the 1878 Paris exposition the reconstruction of colonial villages led to the creation of a new international exhibition genre. In 1883 the Dutch organized an exposition devoted primarily to promoting the benefits of colonization both for the colonizing country and for the members of the colony. Following the Dutch example, organizers in Great Britain held the British Colonial and Indian Exhibition three years later. The success of both the Dutch and British colonial expositions in turn inspired the French. For the 1889 Exposition Universelle, which featured the Eiffel Tower, the French government combined nationalism and imperialism with technological utopianism. In so doing, the French set a new standard for expositions and provided a new set of standard bearers, namely, anthropologists.[3]

The convergence of the scientific practice of anthropology and the popular entertainment of world's fairs was anything but fortuitous. Since the eighteenth century, anthropologists had been basing the credibility of their endeavors on their ability to define and measure racial differences. From Georges Cuvier's dissection in 1815 of Saartje Baartman, an African woman who was known as the "Hottentot Venus" because of her enlarged buttocks and genitalia, to the involvement of the anthropological establishment in recreating supposedly authentic villages in the Jardin d'Acclimatation in 1877, French anthropologists, like their counterparts in England, Germany, and the United States, had attested to the truth of categories of "savagery" and "civilization." After the publication of Charles Darwin's findings, they took it upon themselves to apply Darwinian ideas about evolution and natural selection to human beings. To popularize their findings, anthropologists turned to expositions, a vehicle that, perhaps next to the Church, had the greatest capacity to influence a mass audience. They converted these world's fairs into showcases for educating people about the significance of racial differences, especially for determining the meaning and direction of human progress.[4]

Given their determination to transform the 1889 Exposition Universelle into a grand display of French imperial power, organizing authorities were only too happy to accommodate the overtures of French anthropologists. They hoped the anthropologists would bestow a large measure of scientific authority on their undertaking, especially on their efforts to define French nationality and civilization. This would be accomplished, they reasoned, by introducing fair visitors to anthropological concepts of "racial otherness," which would be reinforced by the colonial displays set up around the base of the Eiffel Tower.[5]

French anthropologists, guided by the Société d'Anthropologie de Paris, exceeded the expectations of exposition authorities. By the fair's opening day, several hundred people from French colonies in Africa, Asia, and the Middle East were arranged in fake habitat settings that leading anthropologists certified were authentic. Indeed, when the Tenth International Congress of Anthropology and Archaeology met in conjunction with the fair, prominent French anthropologists conducted tours of this "colonial city" and attested to the critical importance of the displays for measuring racial differences.[6]

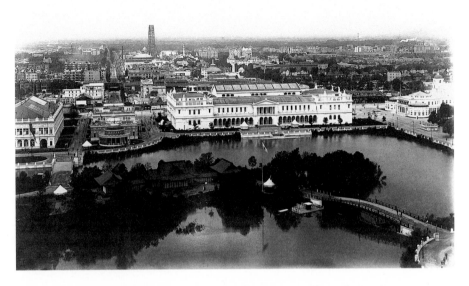

FIGURE 35. "World's Columbian Exposition," Chicago, 1893. Silver gelatin print.

The effect of the colonial and anthropological features of the 1889 exposition registered immediately on the organizers of the next major international fair, the 1893 World's Columbian Exposition in Chicago (fig. 35). For the purposes of their fair, the American organizers included a department of anthropology headed by the renowned Harvard ethnologist Frederic Ward Putnam. A mile-long Midway Plaisance, the first midway ever constructed for a world's fair, was built as a living ethnological museum replete with Chinese, African, Native American, Pacific Island, and Middle Eastern villages. Listed in the exposition's official guidebook as part of Putnam's anthropology display, these villages on the Midway Plaisance confirmed popular stereotypes of "savagery," especially when they were contrasted with the picture of "civilization" conveyed by the neoclassical palaces of the exposition's White City. On this midway, as historian Curtis M. Hinsley writes,

the "world as marketplace" was proposed as the solution to the American economy's propensity to overproduce and thus depress domestic prices. Hinsley emphasizes: "It is but a short step in such an ideological construction of the world to an Open Door policy, gunboat diplomacy and banana republics."[7] Future fairs underscored precisely this point.

The 1900 Exposition Universelle, which boasted attendance figures of nearly fifty million visitors, and the 1904 Louisiana Purchase Exposition, which was held in St. Louis and occupied the greatest amount of acreage of any world's fair, carried these imperialistic notions to new heights. The Paris fair included a formal Colonial Department that featured one of the largest colonial exhibitions ever mounted. This method of promoting French colonial policy was deemed so successful that the French government decided to build a smaller version the next year in Hanoi to endorse its

policies in Southeast Asia. Not to be outdone, managers of the St. Louis exposition, aided by anthropologists working for major universities and the United States government, organized their own colonial display of nearly twelve hundred Filipinos to emphasize America's recent acquisition of overseas territories (fig. 36). Called "the overshadowing feature" of the fair by the exposition's president, this enormous presentation confirmed America's willingness to take up the "white man's burden" on the world stage.[8]

Ethnological and colonial villages remained mainstays of world's fairs through World War II and into the Cold War period. Those world's fairs that were held in those years are usually remembered for their celebration of technological advances and architectural modernism, yet fully half of them were colonial expositions. Culminating this movement was the massive 1931 Paris Colonial Exposition, the single-year attendance figures of which surpassed those of the New York World's Fair. Like their predecessors in the Victorian era, these fairs propagated faith in specific national and imperial policies. When the United States government represented its overseas territories next to a full-size replica of Mount Vernon at the 1931 exposition, the move foreshadowed the creation of an American version of such European colonial spectacles at the San Francisco Golden Gate International Exposition in 1939.[9]

From 1851 to 1939 the dominant trope of world's fairs was imperialism. Just as fairs mirrored European and American efforts to colonize the world, they also reflected patterns of resistance to those efforts, especially by the colonized people who were put on display and expected to perform. At the World's Columbian Exposition, for example, around sixty Inuits agreed to participate in the Eskimo village in exchange for foodstuffs, guns, ammunition, and a small amount of cash. By all accounts, sanitary conditions were deplorable, and the Inuits suffered from an outbreak of measles after

FIGURE 36. "A Native Dance by the Wild Tribe of Igorrotes, in the Philippine Village. St. Louis World's Fair," 1904. Stereograph. Silver gelatin print. Photographed by T. W. Ingersoll.

they arrived in Chicago. When exposition managers insisted that the Inuits wear their sealskin suits even on the hottest summer days, several of the Inuits resorted to physical resistance. Others hired an attorney to secure release from their contract. Following suit, many others tried to force the organizers and anthropologists to agree to contract concessions. Despite their degrading surroundings, several Native Americans managed to persuade concessionaires to bargain with them as individuals.[10]

Probably more typical was the response of women from the kingdom of Dahomey, located in what is now the Republic of Benin in West Africa. They were part of a troupe of nearly seventy Africans who were put on display by the French showman Xavier Pené. Generally unpaid for their performances and subject to an immense amount of public ridicule, these Dahomean women evidently derived great pleasure from chanting in their native language, "We have come from a far country to a land where all men are white. If you will come to our country we will take pleasure in cutting your white throats."[11]

That these responses were not completely out of the ordinary is emphasized by the story of Ota Benga, an African pygmy put on display at the 1904 fair. Taken to the fair by a missionary-adventurer who filled a "shopping list" of African "types" wanted by exposition authorities, Ota had decidedly mixed reactions to being on view. On one occasion he and other pygmies attacked a photographer who surprised them; at another time they threatened a crowd who tried to poke and prod the Africans. Like his fellow Africans, Ota insisted on returning to his native country. Unlike them, however, he then demanded to return to the United States, where he was put on display at the Bronx Zoo and the American Museum of Natural History. At the museum Ota expressed his frustration over his treatment by throwing a chair at museum benefactor Florence Guggenheim.[12]

What was it like for the people on display? In her suggestive reading of the 1895 Exposition Ethnographique de l'Afrique Occidentale, art historian Fatimah Tobing Rony asks readers in the late twentieth century to identify with an African woman in one of the fair's cultural villages.

> You are a Wolof woman from Senegal. You have come to Paris in 1895 with your husband as a performer . . . because of the promise of good pay. You have been positioned in front of the camera, and you are thinking about how cold it is: you can't believe that you have to live here in this reconstruction of a West African village, crowded with these other West African people, some of whom don't even speak Wolof. Every day the white people come to stare at you as you do your pottery. You make fun of some of them out loud in Wolof, which they don't understand.[13]

Also insightful is *The Couple in the Cage,* a modern film that parodies these turn-of-the-century "anthropology" shows. Two performing artists, Coco Fusco and Guillermo Gomez-Peña, put themselves on display as "savages" in contemporary anthropology museums and fairs to challenge the legitimacy of such presentations and to show how those on view can manipulate audiences. If these contemporary readings of living ethnological villages offer any indication, the performance dimensions of these spectacles, with their intention of inscribing meanings of "otherness" and inferiority on colonized people, were imperfectly realized—at least from the perspective of those on display.[14]

And what did the overwhelmingly white American and European audiences think? As George Brown Goode, a

Smithsonian Institution scientist and a prominent world's fair authority, answered succinctly in 1897, "To see is to know." Goode explained the basis for his observation.

> In this busy, critical, and skeptical age each man is seeking to know all things, and life is too short for many words. The eye is used more and more, the ear less and less, and in the use of the eye, descriptive writing is set aside for pictures, and pictures in their turn are replaced by actual objects. In the schoolroom the diagram, the blackboard, and the object lesson, unknown thirty years ago, are universally employed.[15]

To an age increasingly accustomed to learning through "object lessons," colonial villages, authenticated by leading anthropologists, seemingly offered visible and scientific proof of racial difference and hierarchy, thus making imperialism seem right and natural.

Imperialistic intentions and efforts by colonial subjects to give meaning to such conditions of outside control shaped the central drama of world's fairs. Not surprisingly, this struggle was played out in pictorial representations of "village types" reproduced in souvenir publications, guidebooks, and postcards.

IMPERIAL AMMUNITION: EXPOSITION POSTCARDS

From their beginnings in 1851, world's fairs generated memorabilia of its buildings and exhibits. Paperweights, linens, dinnerware, advertising cards, and even furniture carried memories of these international experiences into homes. The popularity of miniature Eiffel Towers at the 1889 Exposition Universelle and small spoons at the World's Columbian Exposition in 1893 even led to the widespread acceptance of the word *souvenir* to describe the phenomenon of collecting

knickknacks to commemorate trips to expositions and other excursions. Of all these keepsakes, none surpassed the communicative power of illustrated picture postcards. By the time the 1900 Exposition Universelle closed its gates in Paris, picture postcards had become as deeply ingrained in the exposition experience as Ferris wheels, the Eiffel Tower, and ethnological villages.

In his *Modular America: Cross-Cultural Perspectives on the Emergence of an American Way,* John G. Blair calls attention to a fundamental characteristic of modernity, namely, the importance of "modularity," or "conceiving a whole in such a way that its parts are open to replacement by or recombination with other parts that are compatible and systemically equivalent to each other."[16] With this rests the inventiveness of postcard manufacturers. Their graphic representations of noteworthy buildings, exhibits, and artwork at the world's fairs made it possible for visitors to put their exposition experience in order. Some did so by collecting postcards, while others inscribed their own interpretations on postcards that were then sent through the mail. Precisely because they were open for all to read and because they allowed fairgoers to communicate their own experiences to the folks back home, illustrated postcards seemed quintessentially democratic. They achieved enormous popularity at the World's Columbian Exposition in 1893, where vendors sold them for a nickel each. The openness of the postcards, however, belied the fact that they were instilled with meanings selected by photographers and illustrators and, in the case of "official" cards sold on the exposition grounds, tacitly approved by exposition sponsors. World's fair postcards, in other words, should now be regarded as part of the same "set of cultural technologies" as the international expositions themselves, technologies that, according to Tony Bennett, were "con-

cerned to organize a voluntarily self-regulating citizenry" (Bennett 1995, 63). Individuals might pen their own messages on postcards, but those messages were framed by images carefully chosen to represent the underlying principles of the fairs.

Nowhere were these "representational containments," to borrow a concept from literary critic Frederic Jameson, in sharper relief than in images of splendid buildings designed and constructed for the world's fairs.[17] Like the expositions themselves, these architectural wonders emphasized balance, symmetry, grandeur, and order, concepts that contrasted with the social and political upheavals that were occurring in England and Europe or the violent fluctuations that shook the American economy between 1873 and the close of the 1930s. Postcards magnified several times over these sentiments of escape and enchantment, particularly the multicolored "hold-to-lights" cards that were developed for the 1900

Exposition Universelle. Most, like the reproduction of the bird's-eye view of the 1901 Pan-American Exposition, presented idealized cities or immense buildings without people. Indeed, when exposition crowds were shown at all, the apparent orderly behavior of the masses silently confirmed the civilizing capabilities of the fair (fig. 37).

Postcards further reinforced the expositions' values by promoting national emblems and ideas of patriotism. Sometimes these symbols were as discreet as the American flags flying atop a hotel on the grounds of the Panama-Pacific International Exposition held in San Francisco in 1915. More often they were representations of bald eagles holding pennants or flags in their beaks or the figures of Columbia or Uncle Sam acting out their respective roles as guardian angel or official greeter to the fair. Rarer still, but just as revealing in its eccentricity, was a densely packed card published by the Koehler firm for the St. Louis fair of 1904. Based on a

FIGURE 37. "Marseille - Exposition Coloniale - Grand Palais de la Côte Occidentale d'Afrique," France.

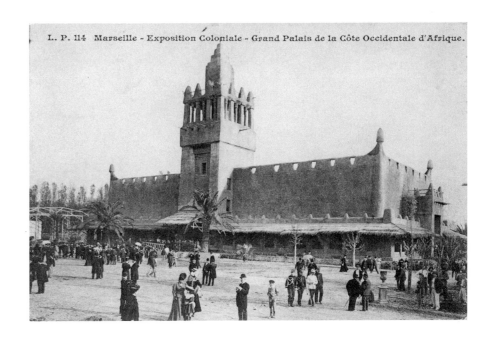

L. P. 114 Marseille - Exposition Coloniale - Grand Palais de la Côte Occidentale d'Afrique.

FIGURE 38. "Cascade Gardens," St. Louis World's Fair, 1904. Published by J. Koehler, New York.

poster designed for the exposition, one card, inscribed by a fairgoer with "Greetings from Mother," presents a thicket of patriotic icons—the U.S. Capitol Building, the American flag, and a bald eagle—surrounding an inset view of the fair's Cascade Falls (fig. 38).

No less nationalistic in their iconography were postcards produced for European fairs. Souvenir cards featured political leaders and exposition officials, as well as a full range of symbolic regalia. The clever manipulation of these symbols is evident in cards generated for the 1908 Franco-British Exhibition, which in part celebrated the Entente Cordiale. One card featured King Edward VII of England and President C. Armand Fallières of France strolling across the exposition grounds. British and French flags formed the border of another card. During this period, postcards complemented efforts of exposition sponsors in England and France to construct national identities that would embrace specific national colonial projects as a central component of modernity.[18]

In addition to generating nationalistic sentiments, postcards revealed and transmitted the commercial ambitions of fair organizers and exhibitors. Oil companies, mining corporations, railroads, banks, hotels, hosiery manufacturers, automobile firms, house builders, and many, many others published illustrated postcards and business cards that featured their products as part of the world's fair phenomenon. They obviously sought to expand their markets by advertising their commodities within the context of fairs. The Singer Sewing Machine Company, for example, generated a series of cards showing "primitive" people using their products. By identifying themselves so closely with expositions, these businesses and commercial interests endeavored to make their products seem essential for the progress of Western civilization. For this ideologically charged concept to be accepted

within the imperial context of the fairs, representations of racial "otherness" were needed against which to measure the accomplishments of the colonial powers.

Publishers happily obliged by incorporating images of "ethnological types" and colonial villages into their postcard inventory of featured architectural fantasies, nationalistic symbols, and the latest innovations in science and technology. Driven by their growing recognition that fairgoers wanted to document their experiences at world's fairs, postcard publishers contributed to this "commodification of the exotic," a process by which non-Western people were displayed and "imagined and evaluated in terms of the market and its functions" (Hinsley 1991, 362). Why were nonwhites so overly represented in exposition postcards when human beings in general were so underrepresented? By affixing images of colonial people onto their cards, postcard publishers quite literally framed nonwhites as commodities to be collected, traded, and recombined in modular fashion with other marketable goods on display at the fairs.

The process of framing "others" on exposition postcards followed conventions common to photography generally and colonial photography specifically. As numerous scholars, including Christraud Geary, Mick Gidley, Virginia-Lee Webb, Laura Mulvey, John Tagg, and Alan Trachtenberg, have made clear, photographic representations of reality are best regarded as re-presentations or constructions rather than as accurate depictions of reality.[19] Instead of insisting on the verisimilitude of photographs and assuming a one-to-one correspondence between image and reality, scholars trained in visual anthropology argue that photographic representations are themselves artifacts and that photographs of nonwhites "incorporate, reflect or respond to, perhaps justify, the assumptions of the dominant" (Gidley 1992, 2). When re-

produced on postcards, these photographs not only reflected the assumptions of the socially powerful groups that organized these world's fairs, but they also refracted "fair" ways of seeing to a mass audience.

Central to those ways of seeing was the transformation of subjects into objects through a variety of photographic and anthropological conventions that emphasized the "otherness" of people who were displayed at fairs as ethnological specimens. As Catherine Lutz and Jane Collins, following Tagg's insights, have persuasively argued, class position often influenced photographic perspectives. "The civilized classes, at least since the nineteenth century, have traditionally been depicted in Western art turning away from the camera and so making themselves less available." In contrast, people deemed inferior by virtue of racial or class attributes have been portrayed frontally, "isolated in a shallow, contained space; turned full face and subjected to an unreturnable gaze; illuminated, focused, measured, numbered and named; forced to yield to the minutest scrutiny of gestures and features."[20] Just as exposition visitors could roam freely among the ethnological displays and, on occasion, prod "villagers" with sticks, so postcard photographs of these "living exhibits" offered opportunities for surveillance, study, and erotic pleasure (fig. 39).

The way postcard publishers presented nonwhites echoed the anthropological basis of the exhibits. By the turn of the century anthropologists commonly organized college-level summer school courses around ethnology displays at world's fairs, referring to these "living specimens" as proof of their theories about human and cultural evolution. Publishers readily produced postcards that could easily serve as visual aids in such classroom instruction. While it is not known how many were used in this fashion, it is clear that such depictions of colonial people made seemingly knowledgeable

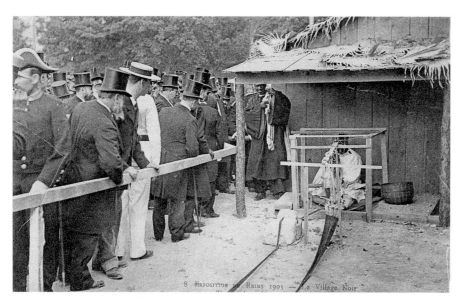

FIGURE 39. Ministerial visit to the black village at the Exposition at Reims, France, 1903. Photographed or printed by L. B. R.

were displayed in various states of undress. By the 1890s, souvenir publications generated for parlor room display included photographs of seductively posed Samoan women and of Dahomean women arranged into pyramids of bosoms. Such displays had become utterly routine at world's fairs and colonial expositions by the 1920s and 1930s. No one has better summarized the significance of "colonial nudes" than Raymond Corbey. Women featured on postcards were "categorized as something 'other,' what we are not, something mysterious and exotic, personifications of a different space, an imaginary world that only was what it was made to be" (Corbey 1988, 90).

claims about the importance of measuring the distance between savagery and civilization.[21]

Several cases in point are found in the twenty postcards that were produced by Foster and Reynolds of the Philippines Reservation for the Louisiana Purchase Exposition in 1904. With their depictions of "Natives at Home," "Negritos Shooting," and "Igorrote [Igorot] Women Weavers" (fig. 40), photographers at this and other fairs scrutinized the daily life of Filipinos (see also fig. 36). This approach to documenting scenes was also utilized by European postcard publishers, who routinely distributed views of missionary activities and families at work and play in fake native habitats.[22]

Just as surveillance was one way of replicating and reinforcing imperial power relations, stimulating the erotic gaze was another. Beginning with the 1878 Exposition Universelle in Paris, if not before, indigenous people, especially women,

Stripped of their identity as individuals both while on display and on postcards, colonial women were cast as sexual objects waiting to be possessed. If, as Corbey has insisted, "taking pictures was indeed another means of taking possession of native peoples and their lands" (Corbey 1993, 362), erotically inflected picture postcards at once facilitated and legitimized that process (fig. 41).

Amidst these explicit impressions of racial differences and primitivism few cards showed whites and nonwhites together. If they did appear in the same photograph, the "savage" behavior of the indigenous people stressed their distance from the civilized white European or American. In "Igorot War Dance," a card produced for the 1909 Alaska-Yukon-Pacific International Exposition in Seattle, the white audience forms the scene's horizon line. A card occasioned by the 1930 Antwerp colonial fair projects the same message about

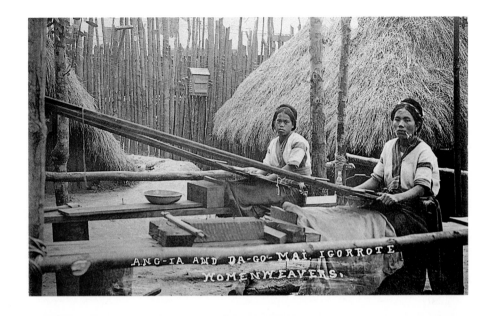

FIGURE 40. "Ang-Ia and Da-Go-Mai. Igorrote Women Weavers," Seattle, 1909. Published by Park, 1909.

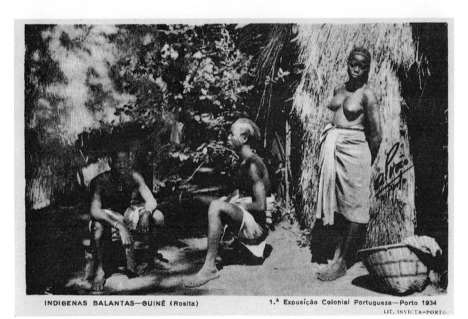

FIGURE 41. Balante peoples from Guinée Bissao at Portuguese Colonial Exposition in Porto 1934. Published by Lit. Invicta, Porto, Portugal.

the distance between savagery and civilization by emphasizing the space between natives dancing on a makeshift platform before a crowd of white onlookers.

Measures of distance in both spatial and temporal terms, which, as Johannes Fabian has noted, was vital to the imperial enterprise, animated many postcard representations of colonies and colonial people.[23] Illustrations of Nyasaland (present-day Malawi) produced for the British Empire Exhibition of 1924–25 idealized the natural environment and working conditions of this British colony in eastern Africa, yet these scenes also managed to underscore the primitive qualities of both land and labor. Two other postcards in this series—"A Native Goatherd" and "A View from Zomba Plateau" (fig. 42)—explicitly convey the great geographical, cultural, and racial distances that existed between the presumably civilized possessors of the cards and those being depicted.

In a veritable sea of exposition postcards that are generally devoid of crowds and portraits of individual fairgoers, postcards featuring indigenous people made compelling viewing. Undoubtedly, postcard representations of colonial people, like the ethnological displays themselves, reflected strategies of control and domination. Postcards transmitted the very ideological messages that were embedded in the expositions about the essential rightness of imperialism and the importance of mass consumption to the continued progress of Western civilization (fig. 43). As one component in the broader set of "cultural technologies" that included fairs, museums, and zoos, mass-produced exposition postcards aided in the campaign to make "empire as a way of life" on both sides of the Atlantic.[24]

Postcards, however, should also be considered in light of the subversive possibilities they posed. While postcards were definitely sent home by white, middle-class fairgoers, they were also quite feasibly mailed overseas by performers on display as ethnological "types." Did their postcard inscriptions read, "Greetings, wish you were here?"[25]

Such information about messages sent home to family and friends is largely speculative. We can quickly surmise, however, that reactions to being on display, whether angry, fearful, defiant, or embarrassed, would have been tempered by the amount of relative control that the "villagers" had over the conditions of their exhibition. Were they free to leave their villages? Did they have any privacy? Could they maintain some semblance of human dignity? For now, postcard photographs provide some provocative clues about the ability of these ethnological specimens and colonial subjects to use the medium of the photograph to turn the world imagined by fair organizers upside down.

Of all the arresting images presented by postcard manufacturers, few raise more interpretive problems than photographs of Columbia. The life of this Inuit woman had been intertwined with international fairs ever since she was born at the 1893 World's Columbian Exposition, a fair that provided the inspiration for her name. By 1909, when she was featured in the Eskimo village at the Alaska-Yukon-Pacific International Exposition in Seattle, her life story had captured the attention of postcard manufacturers. (They were already well acquainted with the publicity surrounding the Eskimos' arrival in Seattle and the fact that they had been forced to live in cold storage vaults prior to the exposition's opening [Rydell 1984, 199].)

On one level, Columbia's smile utterly negated reports of the harsh treatment that the Inuits had received (fig. 44). Indeed, the "smile plays an important role in muting the potentially disruptive, confrontational role of this returned gaze. If the other looks back at the camera and smiles, the

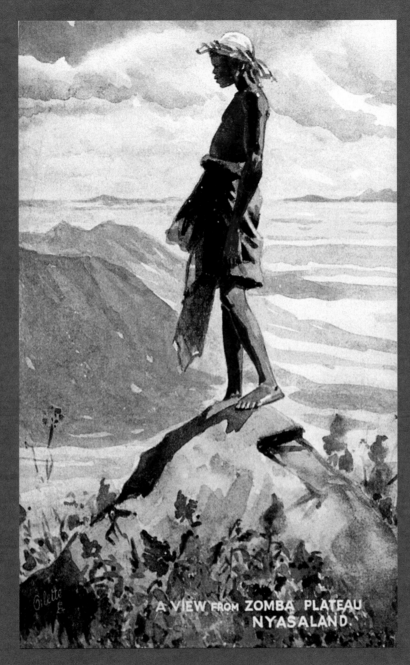

FIGURE 42. A View from Zomba Plateau, Nyasaland."

EXPOSITION COLONIALE INTERNATIONALE — PARIS 1931

LIN MUSÉE DES COLONIES

Loprade & Jaussely, Archs.

FIGURE 43. Museum of the Colonies at the International Colonial Exposition in Paris, France, 1931. Printed by Braun & Cie, Imp., France.

combination can be read by viewers as the subject's assent to being surveyed" (Lutz and Collins 1993, 198). Furthermore, within prevailing photographic conventions, only children could be properly photographed smiling. This image thus reinforced contemporary impressions of the Inuit as childlike human beings.

On another level, this photograph doubles back on the viewer. Columbia looks squarely into the photographer's camera lens. Conceding that she was posed as a type, a gem of the frozen tundra, her smile can also be read as a "weapon of the weak."[26] Her welcoming expression is so disarming that it forces the viewer to acknowledge the presence of another—not merely an "other"—human being.

Other postcard representations of colonized people convey implicit messages of varying degrees of resistance. For instance, exposition officials and photographers in Seattle routinely portrayed the Igorots as savages, but no one looking at postcards bearing the caption "Igorot War Dance" or featuring images of Igorot spear throwers could conclude that Filipino acquiescence to American rule was widely accepted. Similarly, hundreds of illustrations of "native craftsmen" reflected their ability to "make do" in adverse circumstances amid obvious manifestations of imperial power.[27] In one instance, a photograph of a young man from the Kuba kingdom in central Africa was circulated as a postcard during the 1958 Brussels Universal Exposition (fig. 45). For all its stereotypical inscriptions of social inferiority (ranging from frontal portraiture to the inclusion of a local dwelling in the background), his portrait registers the pain and defiance that would explode a short two years later in the Belgian Congo (formerly Zaire, now Democratic Republic of the Congo).

World's fair postcards, like the fairs themselves, were mass-cultural products that became enmeshed in the struggles for cultural and political control stemming from efforts to build empires around the globe. When considering the implications of this argument for fairs or their postcards, it becomes readily apparent that the intentions of the manufacturers of power and culture—then as now—were imperfectly realized.

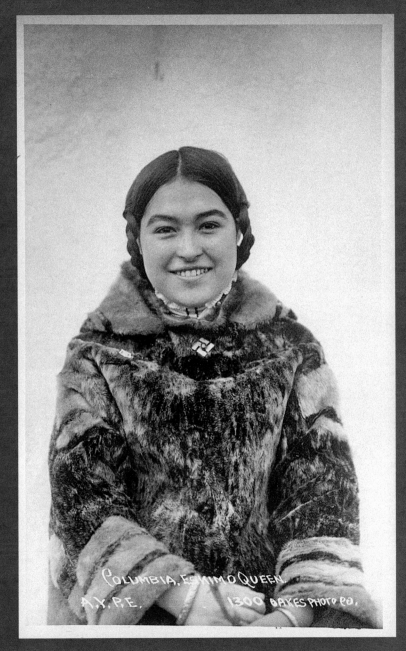

FIGURE 44. "Columbia. Eskimo Queen. Seattle Alaska-Yukon-Pacific International Exposition," 1909. Published by Oakes Photo.

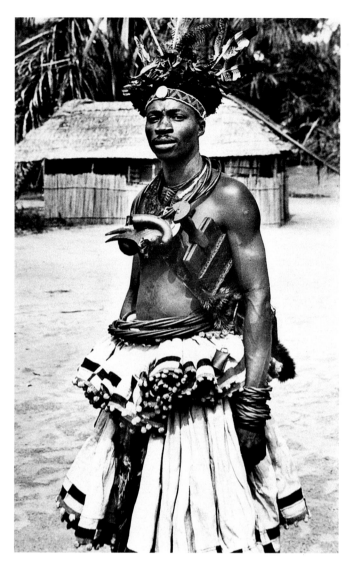

FIGURE 45. Mweka, Belgian Congo. Young Kuba man, 1958.

NOTES

1. I am grateful to Christraud Geary and Virginia-Lee Webb for their insightful critiques and for sharing images of postcards from collections at the National Museum of African Art and the Metropolitan Museum of Art. Thomas Klubock also provided useful criticism. I am also indebted to Frederic H. and Mary S. Megson both for their assistance with images and for their terrific compendium, *American Exposition Postcards, 1870–1920* (Martinsville, N.J.: privately printed, 1992).

Literature about world's fairs is growing. Useful introductions are provided by Burton Benedict et al., *The Anthropology of World's Fairs* (London and Berkeley: Scolar Press, 1984); John E. Findling and Kimberly D. Pelle, eds., *Historical Dictionary of World's Fairs and Expositions, 1851–1988* (Westport, Conn.: Greenwood Press, 1990); Brigitte Schroeder-Gudehus and Anne Rasmussen, *Les Fastes du progrès* (Paris: Flammarion, 1992); and my introductory essay to *Books of the Fairs* (Chicago: American Library Association, 1992). On world's fair postcards, consult Marian Klamkin, *Picture Postcards* (New York: Dodd, Mead, 1974), pp. 58–66, and Frederic H. and Mary S. Megson, *American Exposition Postcards, 1870–1920* (Martinsville, N.J.: privately printed, 1992). Imperialist forms and functions of fairs are detailed by William H. Schneider, *An Empire for the Masses: The French Popular Image of Africa, 1870–1900* (Westport, Conn.: Greenwood Press, 1982); Robert W. Rydell, *All the World's a Fair* (Chicago: University of Chicago Press, 1984); Robert W. Rydell, *World of Fairs* (Chicago: University of Chicago Press, 1993); John M. MacKenzie, *Propaganda and Empire: The Manipulation of British Public Opinion, 1880–1960* (Manchester, England: Manchester University Press, 1984); Paul Greenhalgh, *Ephemeral Vistas: The Expositions Universelles, Great Exhibitions and World's Fairs, 1851–1939* (Manchester, England: Manchester University Press, 1988); and Annie E. Coombes, *Reinventing Africa: Museums, Material Culture and Popular Imagination* (New Haven: Yale University Press, 1994). The phrase "exhibitionary complex" is taken from Tony Bennett, "The Exhibitionary Complex," *New Formations* 4 (Spring 1988), pp. 73–102. For a more extended treatment of this theme, see Tony Bennett, *The Birth of the Museum* (New York: Routledge, 1995).

2. Prince Albert to Baron von Stockmar, 30 March 1848, in Kurt Jagow, ed., *Letters of the Prince Consort, 1831–1861* (New York: E. P. Dutton, 1938), pp. 141, 176.

3. Burton Benedict, "Rituals of Representation: Ethnic Stereotypes and Colonized Peoples at World's Fairs," and Aram Yengoyan, "Culture, Ideology and World's Fairs: Colonizer and Colonized in Comparative Perspectives," both in *Fair Representations: World's Fairs and the Modern World,* eds. Robert W. Rydell and Nancy E. Gwinn (Amsterdam: VU University Press, 1993), pp. 28–83. Also see Coombes 1994, pp. 187–213.

4. Robert D. Altick, *The Shows of London* (Cambridge, Mass.: Harvard University Press, 1978), pp. 268–72; Joy Dorothy Harvey, "Races Specified, Evolution Transformed: The Social Context of Scientific

Debates Originating in the Société d'Anthropologie de Paris, 1859–1902," Ph.D. diss., Harvard University, 1983; and Greenhalgh 1988, pp. 82–111.

5. Greenhalgh 1988, pp. 66–67.

6. See Rydell 1984, chap. 2.

7. Ibid. Curtis M. Hinsley, "The World as Marketplace: Commodification of the Exotic at the World's Columbian Exposition, Chicago, 1893," in *Exhibiting Cultures: The Poetics and Politics of Museum Display,* ed. Ivan Karp and Steven D. Lavine (Washington, D.C.: Smithsonian Institution Press, 1991), pp. 344–65.

8. Rydell 1984, chap. 6; William M. Schneider, "Colonies at the 1900 World's Fair," *History Today* 31 (1981), pp. 31–34; and Eric Breitbart, *The World on Display* (Albuquerque: University of New Mexico Press, 1997). Attendance figures were taken from Findling and Pelle 1990, p. 378.

9. Herman Lebovics, *True France: The Wars over Cultural Identity* (Ithaca, N.Y.: Cornell University Press, 1992), pp. 51–97, and Rydell 1993, chap. 3.

10. Robert W. Rydell, "A Cultural Frankenstein? The Chicago World's Columbian Exposition of 1893," in Neil Harris et al., *Grand Illusions: Chicago's World's Fair of 1893* (Chicago: Chicago Historical Society, 1993), pp. 158–59, and Lester G. Moses, "Indians on the Midway: Wild West Shows and the Indian Bureau at World's Fairs, 1893–1904," *South Dakota History* 21 (1991), p. 220.

11. Gertrude M. Scott, "Village Performance: Villages of the Chicago World's Columbian Exposition of 1893," Ph.D. diss., New York University, 1990, pp. 312–29.

12. Phillips Verner Bradford and Harvey Blume, *Ota Benga: The Pygmy in the Zoo* (New York: St. Martin's Press, 1992), passim.

13. Fatimah Tobing Rony, "Those Who Squat and Those Who Sit: The Iconography of Race in the 1895 Films of Félix-Louis Regnault," *Camera Obscura* 28 (January 1992), pp. 262–89, quote from Bradford and Blume 1992, p. 263.

14. *The Couple in the Cage: A Guatinaui Odyssey* (New York: Authentic Documentary Productions, 1993), 30 minutes. Also see Rydell 1993, pp. 142–70.

15. George Brown Goode, "The Museums of the Future," in *Annual Report of the United States National Museum: Year Ending June 30, 1897* (Washington, D.C.: U.S. Government Printing Office, 1898), pp. 243–62. The full implications of Goode's ideas are developed by Raymond Corbey, "Ethnographic Showcases, 1870–1930," *Cultural Anthropology* 8, no. 3 (1993), pp. 338–69.

16. John G. Blair, *Modular America: Cross-Cultural Perspectives on the Emergence of an American Way* (New York: Greenwood Press, 1988), p. 3. A good introduction to the history of postcards is found in Paul J. Vanderwood and Frank N. Samponaro, *Border Fury: A Picture Postcard Record of Mexico's Revolution and U.S. War Preparedness, 1910–1917* (Albuquerque: University of New Mexico Press, 1988), pp. 1–14.

17. Frederic Jameson, "Modernism and Imperialism," in *Nationalism, Colonialism, and Literature,* ed. Terry Eagleton, Frederic Jameson, and Edward W. Said (Minneapolis: University of Minnesota Press, 1990), pp. 43–66.

18. For postcards of the 1908 Franco-British Exhibition, see A. D. Brooks and F. A. Fletcher, *British Exhibitions and their Postcards, Part One, 1900–1914* (Holborn, England: Fleetway Press, 1978). For a good account of this exposition, see Coombes 1994, pp. 187–213.

19. Christraud M. Geary, *Images from Bamum: German Colonial Photography at the Court of King Njoya, Cameroon, West Africa, 1902–1915* (Washington, D.C.: National Museum of African Art and Smithsonian Institution Press, 1988); Mick Gidley, *Representing Others: White Views of Indigenous Peoples* (Exeter, England: Exeter University Press, 1992); Virginia-Lee Webb, "Fact and Fiction: Nineteenth-Century Photographs of the Zulu," *African Arts* 25, no. 1 (January 1992), pp. 50–59, 98–99; Laura Mulvey, *Visual and Other Pleasures* (Bloomington: University of Indiana Press, 1989); John Tagg, *The Burden of Representation: Essays on Photographies and Histories* (Amherst: University of Massachusetts Press, 1988); and Alan Trachtenberg, *Reading American Photographs* (New York: Hill and Wang, 1989). See also Julie K. Brown, *Contesting Images* (Tucson: University of Arizona Press, 1994), p. 63.

20. Catherine A. Lutz and Jane L. Collins, *Reading National Geographic* (Chicago: University of Chicago Press, 1993), p. 200. Also see Tagg 1988, p. 64.

21. Rydell 1984, p. 197. On measuring the distance between "civilization" and "savagery" by postcard manufacturers see Raymond Corbey, "Alterity: The Colonial Nude," *Critique of Anthropology* 8, no. 3 (1988), pp. 75–92, and Alloula 1986.

22. In addition to Megson 1992, examples of these postcards can be found in the Department of Special Collections, Henry Madden Library, California State University, Fresno; the Metropolitan Museum of Art; and the Eliot Elisofon Photographic Archives, National Museum of African Art, Smithsonian Institution.

23. Johannes Fabian, *Time and the Other: How Anthropology Makes its Object* (New York: Columbia University Press, 1983), cited in Corbey 1993, p. 361.

24. William Appleman Williams, *Empire as a Way of Life* (New York: Oxford University Press), 1980.

25. For some sense of the level of anger felt by Filipinos, in this case Filipino elites, over the Philippines Reservation, see "Filipinos Are Preposterously Misrepresented," *St. Louis Post Dispatch,* 19 July 1904. I am grateful to Penee Bender for this reference.

26. James C. Scott, *Weapons of the Weak: Everyday Forms of Peasant Resistance* (New Haven: Yale University Press, 1985).

27. On the concept of "making do," see Michel de Certeau, *The Practice of Everyday Life* (Berkeley: University of California Press, 1984), passim.

Carte Postale.

Adresse

ATH
22-23
29
9 12

Mademoiselle Aquiline Poin...
Rue Brantignies
Ath
Belgique

Ma chère amie Aquiline,

Je m'empresse vivement de répondre à votre aimable carte du 12 avril, datée de Renaix, ayant répondu un peu tardivement à la précédente correspondance, comme je sais que vous avez un petit cœur charmant, je compte bien être pardonnée. J'ai... également reçu une carte de votre petite sœur Robert. Est-il collectionneur de timbres? Envoyez-moi... à votre bonne Maman, à vous un meilleur souvenir, je vous embrasse de tout cœur...

3

PATRICIA C. ALBERS

SYMBOLS, SOUVENIRS, AND SENTIMENTS

Postcard Imagery of Plains Indians, 1898–1918

When the picture postcard was at the height of its popularity, roughly from 1898 to 1918, it was one of the most common formats for the mass reproduction of images of American Indians. Tribal nations from all areas of North America were well represented by this medium, but by far the largest and most popular selection of cards depicted peoples from the tribes of the Great Plains. Plains Indians appeared on thousands of different postcards, representing virtually every type of card manufactured in the pre-1918 era. They were featured in collectible and commemorative series; they were caricatured on greeting, advertising, and comic cards; and they were included in a wide range of views issued as subjects of local interest or as souvenirs of travel. Many of these postcards conveyed a highly romanticized and stereotypical image of Plains Indians as legendary figures in an epic yet bygone struggle over the frontier West. Many other cards based upon the lived experience of Plains Indians reveal more nuanced views of their lives in the early decades of the twentieth century.

How early postcards promoted images that made Plains Indians into icons and symbols while they simultaneously represented them in ways more faithful to their actual lives provides a central theme to this essay. Some of the different processes by which pictures of Plains Indians were selected for and issued as early postcards will be examined, as will ways this process changed when postcards were produced for different audiences and uses. A critical look will be taken at the multiple, and often contradictory, roles these postcards played in fostering and perpetuating stereotypic imagery.

LEGENDS AND ICONS

When the picture postcard first appeared at the end of the nineteenth century, only a few decades had elapsed since the United States had been at war with American Indian nations in the Plains and neighboring Rocky Mountains. The feats

and exploits of the Lakota, Cheyenne, Ute, and Nez Percé were still fresh in the public mind. Once these tribes were subdued by the military and confined to reservations, however, their history of battle and fighting was recreated as spectacle for international exhibitions and popular Wild West shows that toured Europe, Canada, and the United States.[1]

Although vanquished, Plains Indians were hailed as spirited and courageous foes who bravely challenged their Euro-American enemies and thus deserved a heroic place in history. Through such glorification, they were accorded some of the same pomp and ceremony reserved for European nobility and heads of state.[2] Notwithstanding the poverty and hardship that marked much of their everyday experience on reservations, the legendary image of the Plains Indians persisted and achieved immortality through paintings and photography.

From 1898 to 1918, postcards became a critical part of the ennobling discourse that surrounded popular understandings of Plains Indians. In addition to serving as commemoratives of the spectacles at which Plains Indians performed for international audiences, postcards were manufactured as collectible images and sold as sets in a worldwide marketplace.[3] Along with British royalty, American presidents, and Dutch children, American Indians were one of the most popular subjects on postcards issued in a serialized format. Nearly every major manufacturer in the United States and Europe issued at least one set of postcards with Plains Indian subjects. And even though American Indians from the Great Lakes, Southwest, and Northwest Coast regions were also featured in collectible series, their representation was small compared to the dominating presence of Plains Indians.[4]

In these early collectible sets, pictures of Plains Indians were drawn from the work of some of America's most famous frontier, expeditionary, and exposition photographers.

David Berry's portraits of Lakota taken at Fort Yates in Dakota Territory during the 1880s constituted an early series that was issued by the E. C. Kropp Company of Milwaukee a decade later.[5] William Soule's photographs of the Kiowa, Osage, and Comanche, taken during the 1860s and 1870s, appeared on a set released by A. C. Bosselman and Company of New York in 1904.[6] Around 1902 portraits of the Cheyenne taken by John Hillers of the U.S. Geological Survey when he accompanied the Powell Expedition in 1875 were reproduced as cards by New York's Franz Huld Company.[7] The Wannamaker Department Store of Philadelphia released postcard pictures of the Crow from the photographic expeditions of Joseph Dixon in 1908 and 1909.[8] F. A. Rinehart of Omaha issued a postcard series in 1904 and 1905 that was dominated by Plains Indian subjects he had photographed at the Trans Mississippi Exposition in 1898.[9]

Performing exhibitions were another source of pictures for collectible sets. Lakota performers in Buffalo Bill's Wild West Show were included in sets issued not only in the United States by both Illustrated Postal Card Company and John F. Byrnes and Company, but also in Europe by Raphael Tuck and Sons and Weiner Limited.[10] In addition, the work of various studio photographers residing in the West also ended up in serialized issues. Around 1915 the Fairman Company of Cincinnati released a set of Lakota pictures drawn from the work of John Anderson of Rosebud, South Dakota,[11] and between 1902 and 1908 Adolph Selige of St. Louis reproduced some of Fred A. Miller's photographs of the Crow.[12]

Whatever their origin, the appearance of Plains Indian pictures in postcard sets destined for national and international audiences was carefully orchestrated to recreate familiar understandings of a noble, proud "race" of warriors and chiefs. Many of the conventions for representing Plains Indi-

ans, however, were established well before the advent of the picture postcard.[13] Compositions already prevalent in painting, lithography, and photography were adapted to the postcard format with little change. In certain respects, the postcard only served to perpetuate older and widely accepted standards of visualization. Whatever innovations occurred primarily reflected stylistic trends that were taking place in pictorial production worldwide, and none of them was especially peculiar to the ways in which Plains Indians were depicted on postcards.

In creating suitable and saleable visual images, postcard manufacturers followed several different strategies to select, stage, and even alter American Indian photographs to fit popular conventions.[14] And again, many of these approaches were not unique to the visual medium of the postcard.[15]

One of the most obvious strategies was to emphasize portraiture. Of the collectible or commemorative examples from my own research collection,[16] more than 70 percent are portraits of Plains Indians identified as "chiefs" or "warriors." A significant characteristic of these portraits is that their subjects are decontextualized when they are shown in pictures devoid of concrete historical markers and settings. By not showing people engaged in common activities or posed in the settings in which they lived, it is easy to manipulate images to fulfill public fantasies and stereotypes. Such pictures can be readily put to uses and meanings that have little to do with the historical realities of their subjects (Albers and James 1984b, 87).

In the case of collectible postcards, the historical authenticity of the images and their subjects was largely irrelevant. What mattered most was inventing a symbol through which the Plains Indian became the quintessential "noble savage." To recreate an ennobling ambience, publishers carefully selected paintings and photographs to be reproduced in postcard format. Typically, Plains Indian subjects appeared in war bonnets, war shirts, and other types of "regalia," and they carried pipe bags, shields, staffs, weapons, and emblems associated with distinguished status. Most of them were photographed using epic styles of posing (figs. 46 and 48). Commonly placed in the picture's foreground at or above camera level, subjects were usually depicted against a largely empty background or one decorated with special effects (e.g., backdrops with majestic landscapes). Reminiscent of portraits of European nobles and dignitaries, these images presented Plains Indians as regal figures who transcended the bounds of historical time and space.

Epic styles of posing, although most commonly associated with portraits of prominent Europeans, were also employed for "foreign" ethnic groups who were exalted by Euro-Americans.[17] Besides Plains Indians, Maori and Bedouin "warriors" and "chiefs" of regal bearing commonly appeared on picture postcards. This contrasts with the more commonplace, and even ignobling, modes of posing found in many early ethnic postcards not only from Mexico and Singapore but also of American Indians from the Great Basin and Great Lakes regions of North America.[18]

Some of the most popular epic-style pictures of Plains Indian "chiefs" were simultaneously reprinted by several different publishers and embellished in a variety of artful ways. One studio photograph of Tall Man Dan, a Sichangu Lakota, appeared on different color-lithographed cards, including one bespeckled with fanciful glitter and another rendered as an oil painting (see fig. 46). In the latter image, the painted backdrop tries to connect symbolically the chiefly figure with the natural majesty and transcendent quality of the mountains behind him.

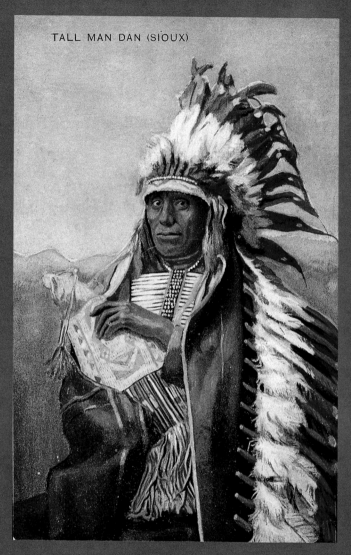

TALL MAN DAN (SIOUX)

FIGURE 46. "Tall Man Dan (Sioux)," South Dakota, ca. 1900. Published by Valentine and Sons, Great Britain.

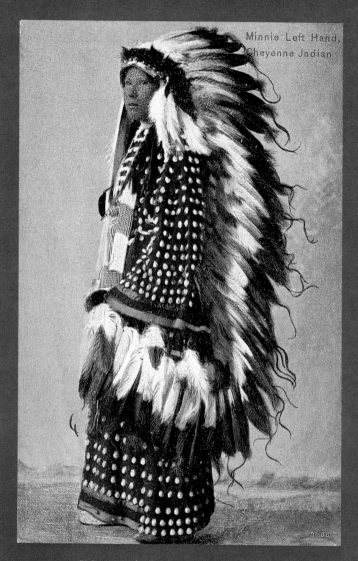

Minnie Left Hand, Cheyenne Indian

FIGURE 47. "Minnie Left Hand, Cheyenne Indian," Oklahoma, before 1908. Published by American News Company, Buffalo, New York.

Not surprisingly, most of the images of Plains Indians offered in popular sets at the turn of the century were of men. This kept with the popular idea that Plains Indians lived in hunting and warrior societies dominated by men.[19] In the few pictures in which women do appear (figs. 47 and 49), they were typically cast as "maiden" or "madonna" figures.[20] And like their male counterparts, females were mythologized and largely severed from any connection to actual reality.

Exceptions to this romanticizing process were typically associated with postcard pictures of well-known American Indian personages. Famous individuals, such as Chief Joseph, Sitting Bull, and Red Cloud, were sometimes depicted in more neutral or even ignobling compositions. In these cases, the overpowering strength of their legendary fame was sufficient to compensate for the image's nondescript character. Yet even here, most postcard pictures favored an epic style of posing.

Consistent with the epic manner of posing Plains Indians was the common practice of using proper names in captions. Unlike many other ethnic-type postcards from the same period, in which subjects are identified only by typecast labels such as "Femme de Tahiti," "Machaco Lechero," or "Cornish Fisherman," most collectible postcards of Plains Indians assigned a proper name to the subject, even if it was incorrect. Just as titles for European royalty rarely stood alone, so the honorific designation of "chief" was typically accompanied by a proper name. Name recognition became so important that in some cases the identities of well-known Plains Indians were attached to figures who bore no likeness to the persons they supposedly represented. Conversely, the designation of chief was applied indiscriminately to portraits of Plains Indians, whether or not they actually held positions of leadership and privilege in their tribes. In fact, this practice became so common that men shown in war bonnets were routinely identified as chiefs.

As with collectible postcards of ethnic groups from other parts of the world, those picturing Plains Indians were textually impoverished.[21] Understated captions identified subjects only by title, proper name, or tribal affiliation. Without accompanying biographical texts, Plains Indian subjects were frequently disengaged from any concrete attachment to time and place. Instead, Plains Indian people became nebulous abstractions susceptible to various and sundry meanings, including ones that obscured and mystified the historical conditions they actually faced (Albers and James 1983, 140). The sheer generality of these postcard images and identities privileged the viewer's interpretation. Lacking solid narrative guidelines, viewers had considerable opportunity to project their own incomplete and often false understandings onto the picture and subsequently onto its subject (Albers and James 1988, 153–54).

When collectible postcards offered more elaborate captions, their texts were rarely precise or even accurate, as found in the lofty hyperbole of an Omaha News Company postcard from 1898: "Red Cloud was King over all the Northwest from the Missouri to the Columbia and during the Black Hills excitement gave frequent evidence of his powers and magnanimity." At the other extreme, captions entirely deflected attention away from the subjects by focusing on a property of their status, dress, or accoutrements. A postcard of Stranger Horse in Raphael Tuck and Sons' "Indian Chiefs" series 2171 states, "A well-known chief is shown holding a pipe bag which constitutes a particularly fine example of Indian bead-work. The peace pipe is an Indian's most significant possession and he therefore provides for it a case or bag in the adornment of which much time and labor are expended." Here, the figure of Stranger Horse is almost incidental to the avowed purpose of the picture, which was to illustrate and document the importance of material ob-

jects. In either case, the subject's identity as a person with a true life history has been largely lost.

In combination with nondescript captions, portraits made it easy to sever subjects from a historically concrete and culturally authentic body of meaning as well as to manipulate their images graphically in completely alien ways. Indeed, postcard manufacturers frequently went to great lengths to invent pictures by "doctoring," "faking," or "reconfiguring" photographs to create suitable postcard images (Albers and James 1984b, 74–77).

One of the best examples of this process is a pair of postcards from a set issued by Weiner Limited as commemoratives for Buffalo Bill's Wild West Show (see figs. 48 and 49). The two cards were actually derived from a single photograph, which also appeared on a postcard (fig. 50), that was taken on the occasion of Alexandra Olive Standing Bear's birth in England in 1903. In the Weiner versions, the isolated, regal figure of Luther Standing Bear conforms to conventionalized images of the Plains Indian chief. His spouse Laura also appears in the Weiner rendition, but now she holds a different infant. In the original photograph, her baby daughter is wrapped in a blanket, while the larger infant in the color lithograph is swaddled in a cradleboard. Indeed, the infant transposed onto the Weiner issue initially appeared on a Detroit Photostint postcard (no. 6885). Obviously, the image of this child, an Ojibwe from Walpole Island in Ontario, replaced that of Alexandra Standing Bear in order to give the Weiner postcard a more exotic and culturally suitable look. Another analogous change was the substitution of a fringed buckskin wrap for the plaid, wool shawl on Laura Standing Bear's lap.

Divorced from the original contexts of their making or the lives of the people depicted, popular pictures of Plains Indians

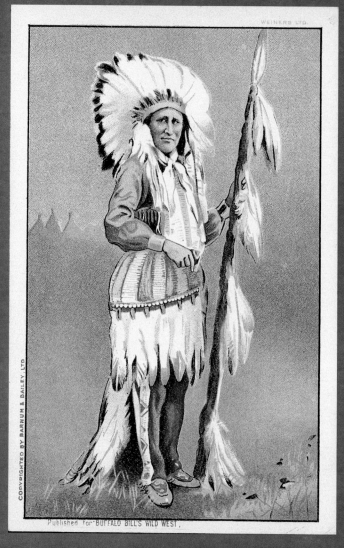

FIGURE 48. Luther Standing Bear, a Sichangu Lakota from the Rosebud Reservation in South Dakota, ca. 1905. Distributed by Barnum and Bailey.

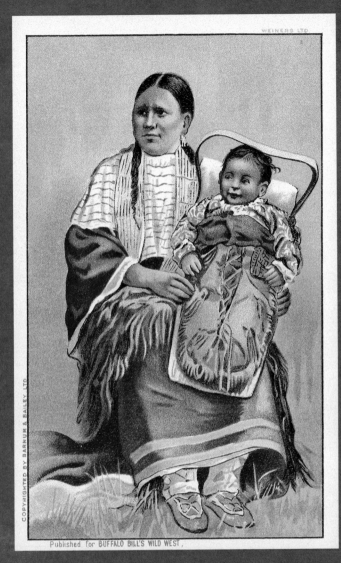

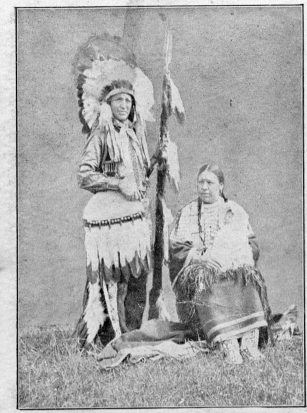

FIGURE 49. Laura Standing Bear, a Sichangu Lakota from the Rosebud Reservation in South Dakota, ca. 1905. Distributed by Barnum and Bailey. Printed by Weiner, Great Britain.

FIGURE 50. "Chief Standing Bear, Laura Standing Bear and Alexandra Pearl Olive Birmingham England Standing Bear, June 7, 1903." Printed by Weiner, Great Britain.

were easily reinvented to cross a variety of iconographic terrains and to fit a range of media. They were further objectified and then transformed into relics embellished with glitter and silk, transposed onto leather pouches, and even reconfigured as ceramic curios. Through this process Plains Indians no longer seemed like real people, or even strangers or foreigners, but were instead abstract artifacts that were completely assimilated by the postcard medium and its commodified interests. One picture of a Kiowa infant was issued in several different formats, including a silk appliquéd version (fig. 51) by the Illustrated Postal Card Company of New York from about 1904 to 1914. Particularly noteworthy is the bizarre caption imprinted on the verso of some issues: "I am sending you on today's train a little Indian Papoose that I picked up out here. Take him in and treat him as one of your own. Stick pins in him and he will not squeal. Be on the lookout for him." Similar captions on postcards issued by the H. H. Tammon Company of Denver illustrate one of the tragic consequences of pictorial decontextualization. Besides reinforcing the stereotype of American Indians as stoic figures who are immune to pain and suffering, the caption transforms the picture's subject into a depersonalized object vulnerable to racist and even sadistic interpretation (Albers and James 1984b, 80–82).

The objectification of Plains Indians on collectible postcards is also revealed in some of the messages that senders wrote on the front or back of their cards. In examples from my own collection, a fairly typical message addressed to children implied that they might not only "become" but also "have" or "possess" the subject pictured on the postcard. On an Edward Mitchell card (no. 1534) captioned "Standing Wolf" is inscribed the message, "Hello Boys, how'd you like to be these Indians?" An H. H. Tammon example (no. 5708)

entitled "Chief Wolf Robe" reads, "Here is an Indian for you and tell grandad I'll be home tomorrow."

Messages written by those who sent Plains Indian postcards sometimes contradicted the ennobling intent of the picture. Some senders described the subjects in hostile terms. "Rather fierce looking Indian don't you think so!" is written on the front of an E. C. Kropp postcard (no. 272) captioned "Black Eagle." "You may scare people with this one" is found on the back of Curt Teich's "White Wolf" card (no. X16). These represent, of course, the other side of the stereotyped Plains Indian as a wild, brutish savage. While that kind of interpretation may not have been the dominant, or even the manifest, intent of those who published collectible cards, it was certainly construed this way by some viewers.

As the twentieth century progressed, Plains Indians increasingly became a generic stand-in for all Indians, and postcards helped to seal that fate (Ewers 1968; Albers and James 1984a). This occurred because images of Plains Indians were most likely to appear on collectible cards, and they became a popular model for Indians on other types of cards. Postcards issued as comics, advertisements, holiday greetings (fig. 52), or political propaganda typically caricatured their subjects in the stereotyped image of war-bonneted, equestrian, tipi-dwelling Plains Indians.[22]

So powerful was the identification of American Indians with Plains Indian imagery that tribes from other regions of North America started to adopt their traditional style of dress in an effort to communicate the legitimacy of their own ethnic identities (Albers and James 1985, 240, and Albers and James 1990, 363). From Maine to California, American Indians were photographed in the guise of Plains Indians, wearing war bonnets, riding horses, and standing by

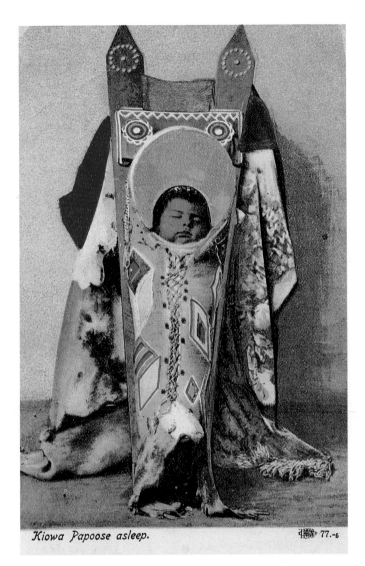

Kiowa Papoose asleep.

FIGURE 51. "Kiowa Papoose asleep." Published by the Illustrated Postal Card Company, New York.

tipis. The process by which a homogenized image of the Plains Indian grew in popularity and came to dominate postcard representations of other tribes, even those whose indigenous appearance had no connection with Plains Indians, has been reported elsewhere in considerable detail.[23]

SCENES AND SOUVENIRS

Beyond the scores of postcards produced as collectibles or as commemoratives of exhibitions and Wild West Shows were countless others made primarily for tourists and travelers. Often manufactured by companies working on behalf of the transcontinental railways, these cards were intended for passengers who journeyed to the Great Plains and Rocky Mountain regions for vacation or who crossed vast stretches of the country en route between Eastern cities and the Pacific Coast.[24] Usually based on motifs grounded in the history and landscape of the West, such cards emphasized the "scenic," "picturesque," and "colorful" qualities of the "sights" travelers would encounter, and many featured the distinctive and ever-popular cultures of Plains Indians.[25]

Travel-oriented postcards contain many examples of the ennobling styles of portraiture that were so common in collectible sets and series, but such cards are also heavily vested in scenes that exhibit and even recreate Plains Indian life as part of the West's romantic landscape. Numerous postcard pictures are based on what Brian Street identifies as a process of "recontextualization," by which staged photographs imitate life as performance.[26] A prime example of this comes from a series published by the H. H. Tammon Company of Denver for the Great Northern Railway (fig. 53). It includes the work of the well-known photographic pictorialist Roland

To My Valentine
Oh, if I were only an artist
Who paints things
sweet and true,
I'd want no better subject
Than just the heart
of YOU!

FIGURE 52. "To My Valentine," ca. 1915.

Reed, who, like Edward Curtis, staged scenes to create a pristine vision of the American Indian (Fleming and Luskey 1993, 100–126). Epic styles of visualization dominated these postcards, but unlike the collectible sets just described, these subjects were clearly contextualized and symbolically associated with the scenic and natural "wonders" of the places in which they were pictured. The Blackfeet Indians seen in the H. H. Tammon series, arranged along with their horses, travois, tipis, and even paraphernalia that had been borrowed from museums, were artfully juxtaposed against the beauty and majesty of Glacier National Park, an area of Montana where they had never lived, even in pre-reservation times (Fleming and Luskey 1993, 100–101). As William E. Farr writes in a historical study of photographic work undertaken among the Blackfeet, these highly romanticized yet aesthetically pleasing images were completely contrived and had nothing to do with the actual lives of the Blackfeet at the time these photographs were taken.[27] Ultimately, viewers came to understand and judge the cultural authenticity of these images of the Blackfeet, largely in response to such carefully designed and highly romantic depictions appearing in the popular format of postcards.

In addition to the scenic travel destinations with which Plains Indians came to be associated were special exhibitions or events in the West at which American Indians were featured attractions. In the Dakotas and Montana, Indian exhibits were often situated near railway stations to entertain passengers on their long transcontinental journeys. Indians from the Ponca, Lakota, Osage, and Otoe tribes encamped at the famous 101 Ranch in Oklahoma and performed off-season with Pawnee Bill's Wild West Shows. Members of various Plains Indian tribes also held central performing roles in big rodeos, such as Frontier Days in Cheyenne, Wyoming, and the Calgary Stampede in Alberta.

FIGURE 53. "Following the Old Travois Trail, McDermott Country, Glacier National Park, Montana. See America First," 1915. Published by H. H. Tammon, Denver, for the Great Northern Railroad Company

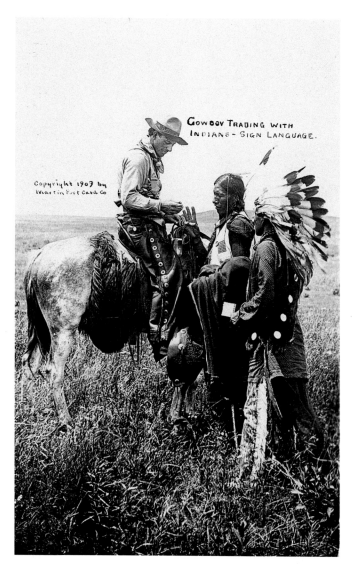

FIGURE 54. "Cowboy Trading with Indians - Sign Language," 1909. Published by the North American Postcard Company, Kansas City, Missouri.

All these attractions served as sources of postcard pictures for the traveling public, and most involved various degrees of selection, staging, and contrivance. Among the most popular motifs were rows of equestrian riders "on parade," scenes of tipi encampments with women, but especially men, dressed in "ceremonial outfits," and war or grass dancing. Some of the more manipulated pictures featured mock battles, the smoking of peace pipes, and the butchering of buffalo. Here, also, pictorial backgrounds were rarely "empty." Instead, the subjects were carefully positioned in relation to objects that represented Plains Indian culture, most notably horses, travois, and tipis. These kinds of purposeful compositions lent a false air of cultural authenticity to the images by reinforcing the sense that what is seen, although actually an imitation of reality, is "genuine" after all.

Other travel postcards offered photographs taken of community places or events in which Plains Indians really did live and celebrate. These pictures, however, were selectively chosen to emphasize the most distinctive and exotic aspects of Plains Indian life. The Herbert Coffeen Studio of Sheridan, Wyoming, issued a wide range of postcards that featured the Crow in this manner, and Sumner Matteson released similar kinds of photographs of Atsina, Cree, and Assiniboine Indians on postcards distributed by firms in Great Falls and Chinook, Montana.[28] In some respects, these pictures were hardly different from those taken in performance contexts, emphasizing as they did equestrian figures, grass dancers, and tipi habitations (fig. 55). Even though they may have been more "true to life," such photographs hardly represented the totality of experience for Plains Indians in the early twentieth century.

Another common practice was reprinting photographs long after they originally had been taken. Several photo-

graphs of Cree and Sarcee Indians from the Canadian prairies, for example, were taken in the nineteenth century and reproduced on postcards into the 1930s, without any reference to their historic provenience. These pictures were no doubt chosen over more modern ones because they conveyed the pristine, foreign look of a mythical West. The practice of reissuing photographs on postcards over many decades virtually perpetuated the illusion that American Indian cultures were locked forever in a time outside the passage of history (Albers and James 1987b, 41–42).

Messages written on tourist postcards reveal some of the different and on occasion contradictory ways in which the traveling public "saw" Plains Indians. Like the vast majority of messages inscribed on collectible and commemorative issues, many objectify the subjects and distance the viewer through demeaning or hackneyed ploys. "Should have seen him doing a small hula this morning. Nothing Lazy about him" was written on the back of a Glacier National Park postcard that featured a portrait of Lazy Boy, a Piegan. Another conveyed the dissonance that tourists sometimes experienced in Indian country when they did not find Indians who conformed to their stereotypes. The message "Altho we have not seen any Indians since our arrival I thought you might like to see how they move" appears on a postcard, mailed in 1912, that reproduces a photo taken in the late nineteenth century of a Piegan woman with a horse-drawn travois. In contrast to many collectible cards, the handwritten messages on tourist

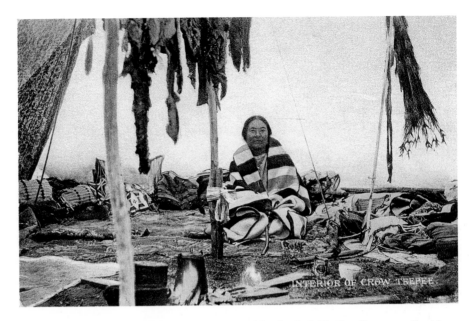

FIGURE 55. "Interior of Crow Teepee." Sponsored by the C. S. Trading Company, Sheridan, Wyoming.

views often attempted to make some direct experiential connection with the subjects pictured. In this respect they more closely resemble messages written on postcards intended for local audiences. Here, the Plains Indians are not simply legendary icons: they possess a degree of actual presence, even if their pictures serve only as a souvenir of some transient or expected encounter.

In this context it would be tempting to press the exotic qualities of travel postcards and to argue that their pictorial and narrative representations played into racial/ethnic ideologies that depicted Plains Indians as romantic primitives or wild savages. While this certainly occurred in many popular images of American Indians, it must also be made clear that exotic and culturally distancing motifs did not apply exclusively to Indians. They also extended to other peopled landscapes of the West, including Euro-American "cow-

boys" and "cowgirls" who were deemed curiosities and novelties by travelers touring the region. These figures were covered pictorially by much of the same legendary veneer as Plains Indians. In fact, many of the most popular postcard sets and series published for tourists in the western United States sequenced their pictures of cowboys and cowgirls with those of Indians or included them both in the same picture (see fig. 54).

VIEWS AND MEMENTOS

Far different from postcards sold as collectibles and travel souvenirs were those produced locally for sale at drugstores, variety stores, stationers, and photographic studios in many of the small towns that dotted Indian country from Alberta to Oklahoma. As elsewhere, resident commercial and amateur photographers inserted neighboring Indian people in their selections of postcards that featured people, places, and events of local interest (Albers and James 1983, 131–34, and Albers and James 1990, 348–54). Most of these views were printed in small quantities on photo stock, but many were published as lithographs by manufacturers in Europe and the eastern United States.

Although these views contained many of the same motifs found in other types of postcards, they tended to do so with different intentions and modes of representation. Generally speaking, they presented Plains Indians in ways that were not divorced from what they or their neighbors experienced on a sporadic or day-to-day basis. In the vast majority of these views, Plains Indians were pictured either in their everyday dress, often fashioned after styles popular among their Euro-American neighbors, or in ethnic-style attire customarily worn at celebrations and festive occasions within their own communities. Settings ranged from places where Plains Indians actually lived, worked, shopped, and celebrated, to local photographic studios.

Dominant styles of posing American Indian subjects did not radically differ from the ways in which their Euro-American neighbors were photographed. In most studio and outdoor portraits, subjects faced the camera in the formal, full-frontal poses that were so popular in this era. If not, they posed in the unpretentious and candid manner of a "snapshot," nestled against the background at or below camera level. In addition to involving more neutral, unaffected styles of posing, these photographs tended to include "filled" backgrounds dominated by ordinary landscapes (fig. 56) or everyday domestic, working, and commercial environments. And in studio portraits, American Indians were frequently posed with similar props and against the same types of backdrops that were used in photographing Euro-Americans.

Locally issued postcard pictures also included a much more diverse range of people. Tribal nations not commonly seen in the collectible sets or travel cards of the era, such as the Hidatsa, Osage, and Comanche, were well represented in local views. Women were pictured nearly as often as men (fig. 57), and children as well as the elderly were also commonly photographed.

Although local postcards likely presented more nuanced and accurate views of the worlds in which Plains Indians lived, they still did not reflect the entire spectrum of the Indians' experience in the early twentieth century. Only those aspects of life that photographers deemed noteworthy, or that Plains Indians allowed to be photographed, appeared on postcards. And here, as in other areas of postcard production, it was the more exotic and distinctive aspects of

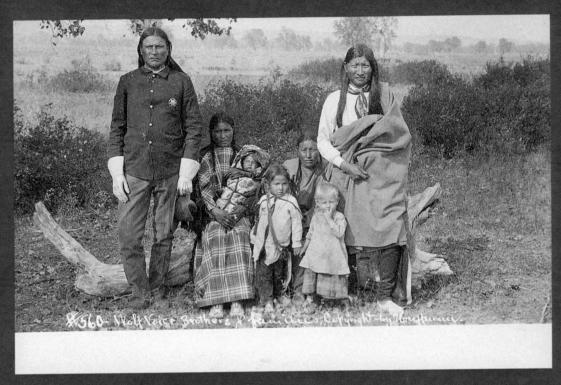

FIGURE 56. "Wolf Voice Brothers and Family," ca. 1905. Photographed by E. L. Huffman, Miles City, Montana.

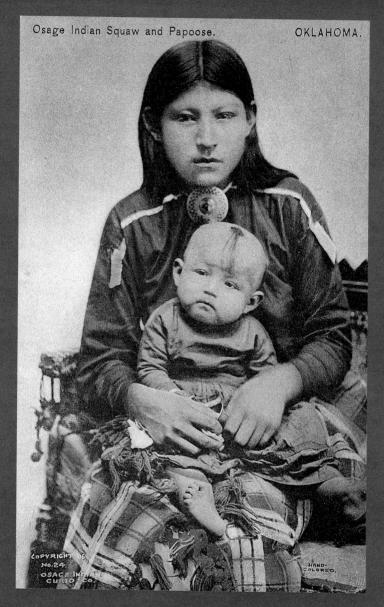

Osage Indian Squaw and Papoose. OKLAHOMA.

FIGURE 57. "Osage Indian Squaw and Papoose. Oklahoma." Printed by the Albertype Company, New York. Sponsored by the Osage Indian Curio Company of Pawhuska, Oklahoma.

their lives that became the focus of commercially manufactured postcards.

A common type of scene depicted Plains Indians set against the backdrop of a campsite made of tipis or A-frame tents, and even horses and sideboard wagons (fig. 58). Other pictures showed them situated by their log homes or wood-frame houses. Unlike most of the photographs issued on postcards for mass distribution to travelers, little effort was made to avoid, remove, or cover up influences from the outside world.

By far the most numerous views illustrated scenes of Indian ceremonies and dancing. Sun Dances and Peyote Meetings were two of the religious ceremonies repeatedly pictured, but the largest selection focused on war and grass dancing. In the Dakotas, for example, such dancing was typically shown as part of the celebration activities associated with rodeos, chautauquas, parades, county fairs, and Fourth of July festivities held in neighboring Euro-American towns (fig. 59). Other views depicted feasts and celebration dancing at Indian agencies and at reservation communities in which Plains Indians lived. Here again, such pictures were less likely to edit out appearances of acculturation. Instead, they clearly located subjects within their own time and place.

In addition to more typical views, postcards carried pictures of Plains Indians farming and ranching, shopping at general stores and trading posts, securing their rations at reservation agencies, attending mission and government-run boarding schools, meeting with federal officials, and participating in community picnics. They included scenes of tribal baseball teams, church parishioners, drill teams, and school bands (fig. 60). Unlike the images that dominated collectible and travel postcards, these local views were not completely distanced from the daily lives of Plains Indians. Indeed, some of them offered fairly telling views of what life was like in this era.

A minority of the local postcards, however, did involve staged forms of image-making, with subjects posed in contrived ways, or pictures labeled with hackneyed captions that fed on local prejudices. "Indian Aristocrats of Mellete County" or "Good Indians" (a caption on a view of burial scaffolds) fit into this order. Far more often, captions were neutral and nondescript, merely giving the subject's tribal identity, the place where the photograph was taken, or some other noteworthy feature of the scene.

Handwritten messages found on local postcards can also be instructive. Like the vast majority of cards from the Great Lakes and Great Basin regions, those from the Plains say little about the subject pictured, but instead convey personal news and gossip.[29] Those messages that mention the picture sometimes reveal that the sender was personally acquainted with the subjects or knew something about them from direct experience. Some describe general aspects of Indian life in the area, but only a few provide specific details about the personal identity of the subjects.

Other messages suggest empathy or friendship, despite a paternalistic air, with the subjects. One card, entitled "Osage Indian Braves," was mailed from Pawhuska, Oklahoma, in 1908.

This is a true representation of a party of young Osage braves or warriors, with their usual costume, they were not fixed up for the occasion. I am personally acquainted with every one in this picture except the papoose and the pony. Such gatherings as you see here will be soon a thing of the past. They dance here now occasionally. They are a peculiar people, sad silent, reflective. Poor people, they know their days are numbered. I am their friend.

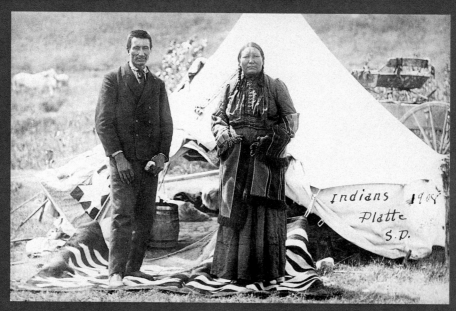

FIGURE 58. "Indians. 1908. Platte. S.D.," South Dakota.

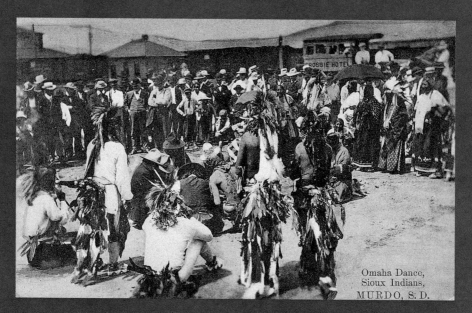

FIGURE 59. "Omaha Dance, Sioux Indians, Murdo, S.D.," South Dakota, ca. 1910.
Distributed by Irwin, the Druggist of Murdo, South Dakota.

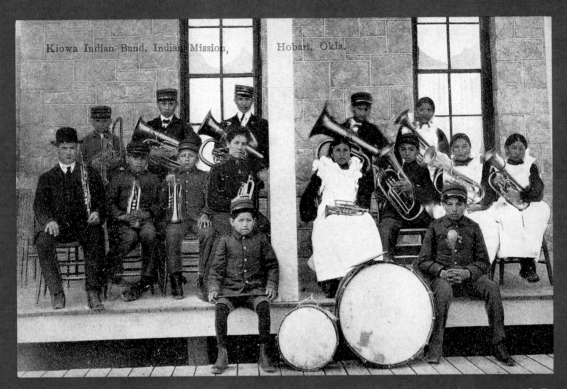

FIGURE 60. "Kiowa Indian Band, Indian Mission, Hobart, Okla." Produced in Germany under contract with C. E. Wheelock and Company, Peoria, Illinois, for the H. H. Johnson Post Office Bookstore in Hobart, Oklahoma.

This communication reveals a notion, widely held at the time, that Plains Indians were vanishing, poised on the verge of cultural extinction. Unlike Edward Curtis and other romantic photographers who attempted to reconstitute and rescue a mythical pictorial past (Lyman 1982), local postcard producers were more likely to record the transitions that were unfolding through continuity and change. This premise held true, even when their choice of subjects and scenes was highly selective and stereotyped.

Certain messages on early postcards reveal all too well the antagonism, prejudice, and hostility Euro-Americans felt toward and directed at Plains Indians. Many such cards were written by settlers who were occupying lands that had been wrestled from Plains Indians only a few decades earlier, and their commentaries aptly reflect the rhetoric needed to justify the dispossession of Indian homelands. One postcard published by Irwin, the Druggist, pictured Lakota Indians on the main street of Murdo, South Dakota. Its message reads:

> These devils are working day and night trying to make the whites get out so they can have the country and do as they want to. We are allowed to shoot them on sight now. They have their war dances most every night and [the] country is not safe here at all now. Women and I guess children are carrying guns to protect themselves.

Whether the messages on locally produced cards were friendly or hostile in their intent, they indicate that the Plains Indians pictured were not total abstractions but people with whom the sender related as part of a personal experience. Through such messages it becomes apparent that Indian people were an active presence in the locations pictured. They were the neighbors of the Euro-Americans who saw Plains Indians' photographs on postcards and purchased them as mementos of local life to keep or to mail to others.

In contrast to postcards sold as collectibles and travel souvenirs, those aimed at local audiences were less likely to sever pictorial imagery from real life, so to speak, and to attach it to some mythical abstraction. Despite the obvious biases and stereotypes they reveal, local cards were generally more authentic reflections of the times and places in which Plains Indians lived than were those postcards intended for other audiences.

Significantly, in the early twentieth century the greatest variety of postcards picturing Plains Indians were issued in these local contexts. After the 1920s, postcards catering to small town audiences began to decline in number, as other formats, including newspapers and magazines, started to publish pictures of local interest. As postcards became increasingly focused on the specific interests of tourists, "true-to-life" pictures also declined in number. And in subsequent decades, postcards of Plains Indians were centered, almost exclusively, around the stereotyped appearance of war-bonneted "chiefs," tipis, riders on horseback, and grass dancers.

IMAGES AND REMEMBRANCES

In the early decades of the twentieth century, photographs of private remembrance were also printed in the postcard format. Indians often commissioned local studio photographers to take their portrait and reproduce it on postcards for personal use. Some of these cards are still held today by Plains Indian families as keepsakes displayed in photo albums or cherished with other private treasures in trunks, boxes, and "bundles." When I first began to conduct fieldwork in 1968 on the Mniwakan Oyate Reservation in North Dakota, I

learned that several of the elderly women still kept their family postcard pictures carefully protected and wrapped in silk scarfs or calico goods.

Most private postcard pictures of Plains Indians were also taken in settings with the same props and backgrounds used in photographs of their Euro-American neighbors. Like sitters seen on commercial but locally issued cards, Plains Indians were photographed in the dress they customarily wore for everyday or festive occasions, and they were posed in keeping with the era's popular styles of formal portraiture (fig. 61).

Besides the work of professional studio photographers, amateur snapshots were also printed on postcards (fig. 62). Sometimes these photographs were taken by visitors to the area, but usually they were made by neighbors or associates of the Indians, such as teachers and missionaries. To a great extent these pictures tended to depict ordinary aspects of everyday Indian life in the early twentieth century. Most of these cards exude a candid and unpolished quality. Generally speaking, images on private postcards adhered to the observer's own associated conception of Indian people. Thus, resulting images were embedded both in the day-to-day experiences of the observer and in the daily life of the people pictured.

Like locally issued postcards, some private ones that survive from the early twentieth century contain written messages and identify the subject by name or location. Many more of these postcards, however, do not have a caption or even a message, which suggests that their subjects already would have been familiar to those who were most likely to view and keep the card. For those that remain in the possession of descendants, such imagery evokes a special sense of meaning and belonging, and provides a tangible connection to the past.[30]

Taken as a whole, early postcards of Plains Indians display a wide gamut of pictorial possibilities, all of which were open to different and even contradictory readings by those who produced, sold, and acquired them. In some interpretive perspectives, this diversity might call into question the practicality of categorizing and then making general conclusions about the corpus of Plains Indian pictures that appeared on picture postcards before 1918. From another standpoint, however, it is clear that the sorts of pictures printed on postcards were neither totally random nor relative in their appearance. Outside of a few exceptions, their compositions adhered to fairly conventionalized formulas that varied according to their use and the audiences they served.

At one end of the pictorial spectrum, postcards reproduced images as icons and spectacles. The appearances of Plains Indians were distorted, refigured, objectified, and sometimes trivialized through various processes of visual selection and manipulation. In collectible and tourist-oriented postcards, Plains Indian figures were often decontextualized or recontextualized in the interests of cultural agendas far removed from their own life experiences. In the process, highly revered and even sacred elements from tribal cultures, most notably the war bonnet, were appropriated, diminished, and transformed into kitsch or fantasy objects. Here, postcard images operated as simulacra, offering mere likenesses of real people and objects in a mechanically reproduced format whose endless varieties and permutations could be replicated for mass sale and widespread use. In this form, the postcard was clearly a vehicle for outsiders to possess vicariously and to colonize symbolically the exotic cultural identities of Plains Indian people.

At the other end of the spectrum, postcards held traces of visual memory. They served as records and remembrances of

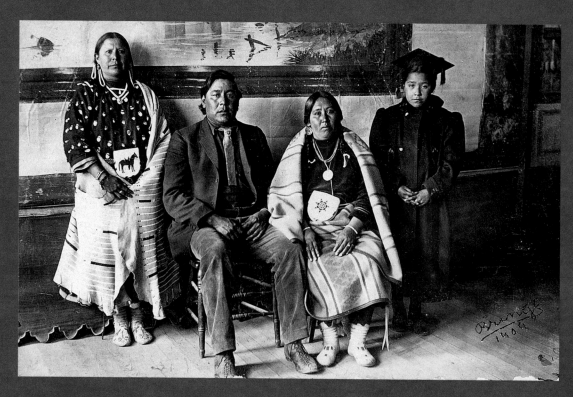

FIGURE 61. Crow Indians, Montana, ca. 1909. Silver gelatin print.

people, places, and shared experiences. Reproduced in small numbers for private use or limited public sale, these cards did not abstract or distance the subjects' appearances, but rather nested and contextualized them within the actual lives of Plains Indians. In these images, photographic conventions did not typically set Indian subjects apart from their Euro-American neighbors. Instead, the pictorial content of postcards, especially the style of clothing and the activities being undertaken by the subjects, often separated the two groups in obvious ways.

Although photographs were manipulated and edited before they were printed onto postcards, their selection was often subtle and identified with interests that were historically specific, not mythic in nature. Pictures were sometimes chosen for postcards because they were grounded in local surroundings, were associated with definite times and places, or conveyed some semblance of fidelity to sights regularly witnessed. This does not mean that the images were objective or even neutral in some naively realistic fashion. Far from this, local postcard manufacturers and their audiences were just as prone to use and abuse photographs to support their own agendas in racially demeaning ways. Although largely subject to interpretations outside the control of those who took or posed for the photographs, most locally issued postcards remained within pictorial confines that allowed for a concrete, personalized reading of their imagery.

This all suggests that early postcards with Plains Indian subjects were not situated in a singular or seamless world of visual motifs and set meanings. Although the stereotyped, romanticized, and mystifying image of a tipi-dwelling, war-bonneted figure astride a horse dominated and largely de-

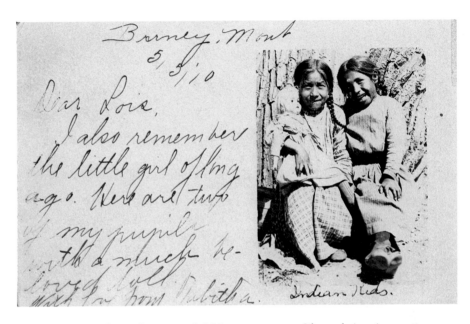

FIGURE 62. "Northern Cheyenne girls," Montana, ca. 1910. Silver gelatin print.

fined public discourse, it did not completely eclipse alternative modes of visualization. In the years from 1898 to 1918, when the picture postcard was in its heyday, its format served many different purposes and functions. Its ability to accommodate a variety of contexts facilitated diverse and at times oppositional styles of visualization that roughly conform to the contrast that John Berger makes between "public" and "private" photography.[31] Conventionalized modes of depict-

ing Plains Indians shifted when postcard iconography moved from the highly stereotyped scenes and sights of spectacle and mass observation to the more versatile but still conventionalized views of actual experience and the visions of familiar audiences.

NOTES

1. William M. and Verla P. Rieske, *Historic Indian Portraits: 1898 Peace Jubilee Celebration* (Salt Lake City: Historic Indian Publishers, 1974), pp. 9-11; Vine Deloria, Jr., "The Indians," in *Buffalo Bill and the Wild West* (Brooklyn, N.Y.: Brooklyn Museum, 1981), pp. 45-56; Richard Slotkin, "The 'Wild West,'" in *Buffalo Bill and the Wild West* (Brooklyn, N.Y.: Brooklyn Museum, 1981), pp. 27-44; Paula Fleming and Judith Luskey, *The North American Indians in Early Photographs* (New York: Harper and Row, 1986), pp. 77-97; and Brenda Child, Introduction, in *Portraits of Native Americans: Photographs from the 1904 Louisiana Purchase Exposition* (New York: New Press, 1994), pp. 1-2.

2. John Ewers, "The Emergence of the Plains Indians as the Symbol of the North American Indian," in *Indians in the Upper Missouri* (Norman, Okla.: University of Oklahoma Press, 1968), pp. 191-98 [originally published in Smithsonian *Report for 1964,* Publication 4636 (1964), pp. 531-44]; Robert Berkhofer, Jr., *The Whiteman's Indian* (New York: Vintage Press, 1978), pp. 86-103; Fleming and Luskey 1986, pp. 20-43; and Brian Dippie, "Representing the Other: The North American Indian," in Elizabeth Edwards, ed., *Anthropology and Photography, 1860-1960* (New Haven and London: Yale University Press in association with the Royal Anthropological Institute, 1992), pp. 132-36.

3. Patricia C. Albers and William R. James, "Postcard Images of the American Indian: Collectible Sets of the Pre-1920 Era," *American Postcard Journal* 7, no. 6 (July 1982), pp. 17-19.

4. Patricia C. Albers and William R. James, "The Dominance of Plains Indian Imagery on the Picture Postcard," in *Fifth Annual 1981 Plains Indian Seminar in Honor of Dr. John Ewers,* eds. George Horse Capture and Gene Balls (Cody, Wyo.: Buffalo Bill Historical Center, 1984), pp. 77-81; and Karl Kreis, "'Indians' on Old Picture Postcards," *European Review of Native American Studies* 6, no. 1 (1992), pp. 42-47).

5. Vine Deloria, Jr., "Warriors of the Tall Grass," *Rocky Mountain Magazine* (June 1973), pp. 33-39; Thomas M. Heski, *The Little Shadow Catcher: D. F. Barry* (Seattle: Superior Publishing, 1978); and Patricia Albers, "E. C. Kropp's American Indian Postcards," *Barr's Post Card News* (5 May 1983), p. 23.

6. Russell Belous and Robert Weinstein, *William Soule, Indian Photographer at Fort Sill, Oklahoma, 1869-1874* (Los Angeles: Ward Ritchie Press, 1969).

7. Fleming and Luskey 1986, pp. 108-109 and 137; and Nancy Hathaway, *Native American Portraits: 1862-1918* (San Francisco: Chronicle Books, 1990), pp. 28-29.

8. Frank A. Reynolds, "Photographs from the Dixon/Wannamaker Expedition, 1913," *Infinity: The American Society of Magazine Photographers' Trade Journal* (1971), pp. 1-30; and Fleming and Luskey 1986, pp. 216-17.

9. Rieske 1974, and Paula Fleming and Judith Luskey, *Grand Endeavors of American Indian Photography* (Washington, D.C.: Smithsonian Institution Press, 1993), pp. 82-86.

10. Patricia Albers, "Raphael Tuck and Sons American Indian Postcards," *Barr's Post Card News,* 2 October 1980, p. 4; Patricia Albers, "The Work of Sumner W. Matteson," *Barr's Post Card News,* 3 June 1982, p. 4; and Kreis 1992, pp. 42-47.

11. Patricia Albers, "Postcards of the Brule Sioux by John A. Anderson," *Barr's Post Card News,* 5 September 1980, p. 4.

12. Jean Castles, "Fred Miller: 'Boxpotapesh' of Crow Agency," *Montana: The Magazine of Western History* 21 (July 1971), pp. 85-92.

13. See Ewers 1968, pp. 191-96; Fleming and Luskey 1986, pp. 20-43; Rayna Green, "The Indian in Popular American Culture," in *Handbook of North American Indians,* vol. 4, *The History of White-Indian Relations,* ed. W. Washburn (Washington, D.C.: Smithsonian Institution Press, 1988), pp. 592-604; Hathaway 1990, pp. 1-13; and Dippie 1992, pp. 132-36.

14. Patricia C. Albers and William R. James, "Utah's Indians and Popular Photography in the American West: A View From the Picture Postcard," *Utah Historical Quarterly* 52, no. 1 (winter 1984), pp. 74-78; Patricia C. Albers and William R. James, "Images and Reality: Postcards of Minnesota's Ojibway People, 1900-1980," *Minnesota History* 49, no. 6 (summer 1985), pp. 230-32; and Barbara Babcock, "Bearers of Value, Vessels of Desire: The Reproduction of the Reproduction of Pueblo Culture," *Museum Anthropology* 17, no. 3 (1993), p. 45.

15. Joanna Scherer, "'You Can't Believe Your Eyes': Inaccuracies in Photographs of North American Indians," *Studies in the Anthropology of Visual Communication* 2, no. 2 (1975), pp. 77-78; Christopher Lyman, *The Vanishing Race and Other Illusions* (New York: Pantheon Press, 1982), pp. 62-78; and Fleming and Luskey 1986, p. 214.

16. This estimate is based on the size of my own research collection, which contains more than forty-three thousand ethnic postcards, including more than sixteen thousand cards of American Indians. Here, I focus attention on an analysis of nearly three thousand pre-1920 postcards of Plains Indians. Most of them are in my own private collection and were gathered randomly over the past forty-five years. Other cards in the sample come from collections studied at the Minnesota Historical Society, Montana Historical Society, North Dakota Heritage Center, San Diego Museum of Man, Western History Collection at the University of Oklahoma, the Denver Public Library, and the Colorado Historical Society. Judging by the holdings I have researched in these and other archives,

my private collection is indicative of the range of cards that were issued with American Indian subjects over the past century.

17. Patricia C. Albers and William R. James, "Travel Photography: A Methodological Approach," *Annals of Tourism Research* 15, no. 1 (1988), p. 150.

18. Patricia C. Albers and William R. James, "Tourism and the Changing Image of Mexico," unpublished paper presented at the Society for Applied Anthropology Meetings, Oaxaca, Mexico (April 1987); Patricia C. Albers and William R. James, "Private and Public Images: A Study of Photographic Contrasts in Postcard Pictures of Great Basin Indians, 1898–1919," *Visual Anthropology* 3 (1990), pp. 147–49; Iskander Mydin, "Historical Images—Changing Audiences," in Edwards 1992, p. 251; Patricia C. Albers and William R. James, "Tourism and the Changing Image of the Great Lakes Indian," *Annals of Tourism Research* 10, no. 1 (1983), pp. 128–48.

The range of photographic conventions used in picturing ethnic groups from various parts of the world follows many of the class-based styles of representation found within Euro-American communities. It indeed can be argued that pictorial compositions follow a hierarchical continuum (from ennobling to ignobling intents), and they are used according to where particular ethnic groups are placed within the viewer's own culturally determined system of visual stratification (Hunter 1987: 115-60; Bourdieu 1990: 73-98; and Albers, "Seeing the Familiar in the Foreign," unpublished manuscript).

19. Patricia Albers, Introduction, in *The Hidden Half: Studies of Plains Indian Women,* ed. Patricia Albers and Beatrice Medicine (Lanham Park, Md.: University Press of America, 1983), pp. 1–3.

20. Patricia C. Albers and William R. James, "Illusion and Illumination: Visual Images of American Indian Women in the West," in *The Women's West,* eds. Susan Armitage and Betsy Johnson (Norman, Okla.: University of Oklahoma Press, 1987), p. 48.

21. Nicolas Peterson, "The Popular Image," in *Seeing the First Australians,* eds. Ian and Tamsin Donaldson (Sydney: George Allen and Unwin, 1985), p. 171; and David Prochaska, "The Archive of *Algérie Imaginaire,*" *History and Anthropology* 4 (April 1990), pp. 379–80.

22. Patricia C. Albers and William R. James, "A 'Real' American Cupid," *Postcard Collector* 4, no. 2 (1986), pp. 22–23.

23. Patricia C. Albers and William R. James, "Wisconsin Indians on the Picture Postcard: A History in Photographic Stereotyping," *Lore* 37 (autumn 1987), pp. 3–19. Also see Albers and James 1983, pp. 134–42; Albers and James 1984a, pp. 80–97; and Albers and James 1990, pp. 362–65.

24. Kirby Lambert, "The Lure of the Parks," *Montana: The Magazine of Western History* 46, no. 1 (spring 1996), pp. 42–55.

25. These types of postcards were also common in the Southwest, where the Santa Fe Railway and the Fred Harvey Company developed a major travel industry based on the commercial exhibition of American Indians and tours to their settlements. See Albers and James 1988, pp. 150–53; Babcock 1993, pp. 43–53; and Patricia C. Albers, "Enchanted, Enduring, and Exotic Images of Southwestern Indians: A View from the Picture Post Card, 1898 to the Present," paper presented in June 1995 at the symposium *Imaging the West,* held at the Autry Heritage Museum, Los Angeles, California.

26. Brian Street, "British Popular Photography: Exhibiting and Photographing the Other," in Edwards 1992, pp. 122–23.

27. William E. Farr, *The Reservation Blackfeet, 1882–1945, A Photographic History of Cultural Survival* (Seattle: University of Washington Press, 1984), pp. 187–201.

28. George P. Horse Capture, "The Camera Eye of Sumner Matteson," *Montana: The Magazine of Western History* 27, no. 3 (1977), pp. 58–70; and Patricia C. Albers, "The Work of Sumner W. Matteson," *Barr's Post Card News* 3 (June 1982), p. 5.

29. Albers and James 1985, p. 234; Albers and James 1987a, p. 12; and Albers and James 1990, pp. 352–54.

30. Joy Harjo, "The Place of Origins," in Lucy R. Lippard, ed., *Partial Recall* (New York: New Press, 1992), pp. 89–94.

31. John Berger, *About Looking* (New York: Pantheon Press, 1980), pp. 50–52.

CARTE POSTALE

Ce côté est exclusivement réservé à l'adresse

Melle
,, J. et S. Bosquet
2-12 rue de la Poste
Bruxelles

4 ELLEN HANDY

JAPONISME AND AMERICAN POSTCARD VISIONS OF JAPAN

Beauties and Workers, Cherry Blossoms and Silkworms

With the invention of photography in the mid-nineteenth century, the photographic colonization of the globe may seem to have been nearly instantaneous and uniform throughout the world. In actuality, the number, type, and influence of photographers varied from place to place. Japan is something of a special case in the history of photography, in that the camera arrived there almost simultaneously with the first major penetration of European/American military, economic, and cultural contact in 1853. The earliest daguerreotypes of Japan were made in 1854 by Eliphalet Brown, a member of the crew commanded by Commodore Matthew Perry that sailed into Tokyo Bay and "opened" the closed port to Western trade with a show of force.[1]

Within a few short years photography was practiced more often (both commercially and as a pastime) by the Japanese themselves than by non-Westerners elsewhere in Asia. As early as 1862 Ueno Hikoma (active 1860–90s) and Shimooka Renjo (active 1850–1914) had each established studios in Yokohama.[2] The existence of numerous Japanese apprentices to European photographers between roughly 1870 and 1890 is well documented, as is the extensive work of Japanese members in the Japan Photographic Society, which was founded in 1889 by William K. Burton, an amateur photographer active in Tokyo from 1887 to 1899. By the 1870s, more than a hundred photographers practiced their trade in Japan.[3]

Felice Beato (1820/25–1906), an Italian-born photographer, was one of the first photographers to work extensively in Japan. In time, he sold his stock to Baron von Stillfried (1839–1911), an Austrian photographer who augmented Beato's collection with many of his own images and then printed and sold both under his own name. Stillfried trained Kusakabe Kimbei (active 1880s–1912), who in 1883 bought out most of his employer's stock of negatives and continued to produce photographs himself. The firm of Farsari and Company purchased the remaining Beato/Stillfried negatives and printed them under its own name. By the end of the nineteenth cen-

tury, just as postcards were becoming a common way to distribute photographic images, Japanese practitioners began to replace Europeans and Americans in the Japanese photographic marketplace, although foreign photographers regularly visited to collect images for their inventories. Japanese craftsmen were also employed to color photographic prints by hand. Many postcards of Japan were printed in monochrome and then manually tinted in this manner. Those produced outside Japan, if colored, had usually been subjected to a photochrome or other photo-lithographic process.

European commercial photographers working in Japan, such as Beato and Stillfried, made and sold stock images that were most often landscapes and genre scenes featuring paid models. In addition, Japanese photographers operated conventional portrait studios where customers commissioned and posed for their own portraits. Such an establishment is described in *Madame Chrysanthème,* a popular diaristic novel by French writer Pierre Loti (1850–1923) concerning his experiences with a temporary Japanese wife. The narrator and Chrysanthème go together to have their photograph taken. Loti explained to the European reader:

> In Japan, there are photographers like ours, only they are Japanese, living in Japanese houses. . . . The entry court [of the photographer's studio] is irreproachably Japanese, with lanterns and dwarf trees. But the studio where one poses could just as well be in Paris or Pontoise: the same "old oak" chairs, the same new couches, plaster columns and cardboard rocks.[4]

The earliest photographs of Japan to exist in any number were made from glass plate negatives in the 1860s by studio photographers like the one Loti describes. These images often depict the treaty ports of Nagasaki and Yokohama, where Westerners were permitted to reside, but few prints could be made of the Japanese interior, which was closed to European visitors. Such geographical limitation and the cumbersome

photographic process itself explain the vast predominance of subjects photographed within a studio setting. These studios were sometimes proper Japanese interiors, but they might also be ornamented with internationally familiar properties and decor, as Loti discovered. Similar mixtures of Japanese and European studio props and conventions also appear in early Japanese postcards, but thus far I have found no instances of postcards recycling images photographed on glass plates during the pre-postcard period.

Deltiological literature affords few accounts of postcard production in Japan. None at all is found in the substantial art historical literature on the nineteenth- and twentieth-century enthusiasms of European and American artists for Japanese fine art, decorative art, and subject matter. Art historians have customarily eschewed consideration of postcards. While turn-of-the-century postcards of Japanese people afford ample points of entry into key issues of cultural history (orientalism, the circulation of mass-produced images, and representations of women, among others), there remains a lacuna in the interpretive fabric of art history. At present the greatest problems hindering the study of Japanese postcards involve the almost complete lack of attribution of the images and the absence of information about postcard production, marketing, and distribution. Since primary research on these topics remains to be done in Japan, the following study concerns only postcards of Japanese subjects in American collections.

THE BURDICK COLLECTION, AMERICAN *JAPONISME,* AND *THE MIKADO*

This case study deals with a group of postcards within the Jefferson R. Burdick collection of printed ephemera, which

is housed in the Department of Drawings and Prints at the Metropolitan Museum of Art in New York. This vast collection reflects the life's work of Jefferson Burdick (1900–1963), a dedicated collector from Syracuse, New York. According to A. Hyatt Mayor, the Metropolitan's curator of prints when the Burdick collection was acquired in 1949, it constitutes "a continuous record of design, and a history of the pictorial media that business has used to present itself to the public."[5] Its 306,353 items include postcards, baseball cards, trade cards of all kinds, and greeting cards. Within the nearly four hundred albums and boxes that hold the collection is a startling range of materials that represent (primarily American) popular culture as expressed through printed media. These are roughly sorted by categories of function before subject matter. The postcard section of the collection alone is vast, and Japanese images are distributed among various subsections of the postcard holdings, such as "Advertising-Institutional" or "Missions."

The Burdick collection offers both advantages and disadvantages for conducting this case study. While postcards of Japanese subjects are plentiful, they nonetheless constitute only a tiny fraction of the whole, which in itself tells a story. To understand fully the scope and nature of Japanese photographic postcards, a wide range of collections in Japan would have to be surveyed. Admittedly, the Burdick collection simply lacks certain important categories of images of Japanese people, but it does afford superb contextual evidence concerning the uses of Japanese postcard images in American mass culture. This is more valuable for Japanese image cards than it might be for cards representing some other peoples. In the United States at the turn of the century, Japanese images occupied a unique niche in the circulation of representations of foreign peoples. The popularity of Japanese motifs generated the proliferation of popular and commercial im-

ages of Japanese people in the United States. Some of these images differ significantly from the ones typically produced in Japan for the tourist market. Since postcards actually printed in Japan are not included in the Burdick collection, it will occasionally be necessary to refer to other bodies of material, such as the postcard file of the New York Public Library Picture Collection.

By the turn of the nineteenth century, European and American artists' enthusiasm for Japanese fine and decorative art was of long standing. Many of the postcards produced for distribution in the United States are therefore second- or third-generation descendants of a complex process of cultural exchange.[6] What began as the cultivation of a taste for all things Japanese on the part of sophisticated Western artists and collectors had, by 1900, become a commonplace fashion, a staple or convention of design (albeit in a very diluted manner), among the middle class. The adoption of Japanese artistic styles and subjects, derived primarily from ceramics, textiles, and *ukiyo-e* woodblock prints of landscape and genre scenes, gave rise to a mass cultural consumption of *japoniste* images and objects. As will be examined here, this *japonisme* was both a product and the cause of the production of inexpensive items such as postcards.

Whereas in many regions of the world early postcards with images of peoples were produced primarily as tourist souvenirs or anthropological curiosities, in Japan other levels of consumption and demand existed. Images of Japanese people (almost exclusively of women) were extremely popular in the United States and functioned within a fictionalized or fantasized mode of representation rather than a documentary one. Many of the postcard images of Japanese people in circulation in this country can usefully be discussed in relation to Japanese and European/American artistic conventions and imagery instead of in terms of visual ethnography. Although

Japanese pictorial designs were often adapted by Western artists and transformed into styles not directly associated with Japanese subjects or motifs (as seen in the work of such late nineteenth-century artists as Edgar Degas, Vincent van Gogh, James Abbott McNeill Whistler, and Mary Cassatt), in large part postcard imagery intentionally retained its Japanese subject matter.[7]

Postcards produced and marketed to tourists in Japan tended to depict landscape scenes more frequently than any other subject. Echoing an eighteenth-century European tradition, these landscape scenes documented way stations on picturesque tours. The picture collection in the library of the American Museum of Natural History contains large holdings of such landscape views, many of which record the increasingly urban and industrial character of Japan in the first two decades of the twentieth century. Although such cards were primarily purchased as mementos and documents of tourist expeditions, they also informed travelers of sites yet to be visited. In 1935 George Watson Cole published *Postcards, The World in Miniature,* a treatise that urged,

> The wise traveler on reaching a stopping place will, therefore, do well to make his first visit to a postcard shop, and there look over views of the place he is in, from which he can select such objects as he may desire to see. Then and then only can he intelligently start out to behold its showplaces and feel assured that in the end he will have seen all that are really worth his inspection.[8]

No doubt many itineraries were arranged and many postcards fondly chosen following this principle, but what of the postcards that were printed, purchased (or received), and sent (or glued into albums) far from the places depicted? What meanings and purposes did Japanese postcard images have for those who never saw Japan for themselves? And most particularly, what was the role of postcards that depict peoples rather than places?

Within the Burdick collection are several groups of postcards of Japanese people. One suite of cards was produced by the Detroit Publishing Company, while another group of advertising cards was manufactured by the Corticelli Silk Company in Florence, Massachusetts. All of these cards were presumably intended for stay-at-home audiences rather than travelers. Like all postcards, these most likely were manufactured for a dual audience of purchaser-sender and recipient, but they are unlikely to have been purchased in Japan, and most were never inscribed or mailed.

Far from the average compendium of postcards that would have filled an album on a parlor table at the turn of the century, the Burdick collection represents the work of a determined collector who began acquiring images in the 1930s. Its vast size results from the fact that Jefferson Burdick collected as broadly as possible for the next thirty years. He was an unusual character, of whom Mayor wrote, "The energy that he might have put into making a home and bringing up a family, he poured instead into studying insert cards. . . . Living in meager lodgings and spending little on himself, he threw his earnings as well as his energy into publishing books and acquiring the finest collection of American cards and ephemeral printing in general."[9] Not surprisingly, Burdick felt strongly about the nature of his collection.

> Like individuals, museums have differing ambitions. Some strive to amass quantity, others seek only the most valuable or attractive items. At the Metropolitan the aim has been to obtain a well rounded showing of various types of art. . . . The Card Collection is much the same. In many card types there are larger collections but to inspect all such would require considerable travel and expense. No attempt has been made to

collect quantity by including every minute difference that is of no particular importance to the vast majority of card students.

In older material, the problem has been to find cards. It is impossible to over-emphasize the extreme scarcity of many old cards. . . . The present collection, through the help of friends and fortune, is better than average in both quantity and quality, and will answer all card questions better than it would be possible to in any one other place. A few of the cards were obtained in about 1910, but most of them have been acquired since 1933 from every corner of the country and several foreign states.[10]

Burdick devoted particular care to representing the stock of the Detroit Publishing Company, a behemoth of American postcard publishing until 1932 (Lowe and Papell 1975). Founded in 1888 as the Detroit Photographic Company (its name was changed in 1905), it soon specialized in producing lantern slides and stock photographs for use in postcards, books, magazines, and calendars. The Japanese image cards date from the period of the company's greatest prosperity, which stemmed in large part from its successes in the nascent postcard market. In 1895 a color photolithographic process called photochrome was perfected in Switzerland; two years later it was brought to the United States by the Detroit Photographic Company.

When the celebrated American photographer William Henry Jackson (1843–1942) joined the firm as a director in 1898, he brought with him several thousand negatives of western American landscape subjects, and this summation of his life's work was soon issued as postcards. According to Jackson, "Our business was the production of color prints, by a process hardly improved today, in sizes ranging from postal cards to the largest pictures suitable for framing. . . . Retail sales rooms were maintained in Detroit, New York, Los Angeles, London, and Zürich."[11] The company's widely distributed inventory not only offers a rough index of the era's popular imagery but also clarifies the context of these Japanese images. The fact that Jackson's glass plate negatives from the 1860s through the 1890s were repeatedly reused is particularly interesting in that it suggests negatives made by his European and Japanese contemporaries who were working in Japan could also have been converted to postcard format in this way. Even so, these Japanese subjects nonetheless look like typical products of the Detroit Photographic Company in their proportions, photochrome printing, and caption format beneath the image. Issued between 1901 and 1907, most depict women wearing bright kimonos and posing idly and indeed a trifle stiffly in staged interiors and garden settings. In 1901 the company also published a series of images taken from Japanese paintings of geishas that is hardly distinguishable from the actual photographs.

Such decorative qualities and a sense of artifice are apparent in a card titled "Three Little Maids from School Are We" (fig. 63). In it, three girls in rickshaws pause to admire cherry blossoms beside a lake. The title derives from William Gilbert and Arthur Sullivan's operetta *The Mikado,* which was first performed in London in March 1885 and has been a perennial favorite around the world ever since. Singing that they are "filled to the brim with girlish glee," the three young women find that "Everything is a source of fun / Life is a game that's just begun." In the complex layering of cultural references in both the operetta and this postcard, the virtually identical Japanese beauties appear as decorative and insubstantial as the cherry blossoms.

In *The Mikado,* the song of the three little maids serves neither to advance the plot nor to develop the satire. Rather, it ornaments the score with local color. Just as Gilbert and Sullivan's three little maids merely serve as stage dressing, the

FIGURE 63. "Three Little Maids from School Are We," Japan, 1901–7. Printed and distributed by the Detroit Publishing Company, Detroit.

postcard offers similarly generalized symbols of Japan—cherry blossoms, girls in kimonos, and rickshaws—yet these symbols bear closer inspection. The cherry blossoms were added during color printing: none of the notoriously short-lived blossoms was on the trees at the time the photograph was taken. The rickshaws, so quintessentially Japanese to the Western eye, were in fact a recent innovation that superseded the traditional palanquin or sedan chair. (They were actually invented by a European to transport an invalid easily.)[12] Indeed, the likelihood that these Japanese girls, who are barely visible because of their distance from the camera, are from families of good standing and would pose for a postcard photographer is even more minimal than would have been true in America. They must be professional models, not genuine school girls, in an image staged for the benefit of a non-Japanese audience familiar with Gilbert and Sullivan's work. In reality, the postcard illustrates the operetta more than it does Japanese culture, and it suits the amiably uninformed *japonisme* of Gilbert and Sullivan. At the same time it stands in stark contrast to the type of cultural depiction that was found in *National Geographic* magazine or in the recently industrialized society of contemporary Japan.[13]

A splendid late Victorian satire, *The Mikado* depicts a hieratic, authoritarian society dominated by slightly eccentric aristocrats and sycophants. Marriage, power (both judicial and personal), and capital punishment form its principal themes. Like all Gilbert and Sullivan operettas, it parodies contemporary British society. Set pieces, such as the famous "I've got a little list," which checks off "society offenders who might well be underground" and who "surely would not be missed," make no attempt to remain in Japanese character. Unfortunates on the list, including "the lady from the provinces, who dresses like a guy / and doesn't think she

dances, but would rather like to try" specifically refer to contemporary England, not to feudal Japan. The operetta's pleasure largely lays in the intersection of genres and its social criticism veiled beneath easily penetrable disguises. As a popular art form, operettas appealed both to solidly middle-class audiences who were unlikely to attend common music hall performances and to lower middle-class audiences which might visit both. Its patrons were precisely those who most avidly collected and sent postcards.

Gilbert and Sullivan expertly exploited the *frissons* that resulted from sudden transitions between cultural categories, as when the emperor's proclamations about his plans for penal reform ridiculously degenerate into music hall patter about specific punishments for hapless malefactors. Mingling high and popular culture as a way to renew the former commonly occurs in nineteenth-century culture and is perhaps best documented in the visual arts. Links between the popular arts of foreign cultures and the peasant or working-class culture at home are particularly significant in relation to postcard imagery, which often combined exotic images with inexpensive production processes to allow wide circulation to a mass audience. Collecting or sending Japanese postcards published by the Detroit Photographic Company thus offered their purchasers or recipients a chance to express their sophisticated taste. Most of the images on these cards are so decontextualized, however, that they seem no more rooted in a historically and topographically specific Japan than do scenes in *The Mikado*.

In addition, these postcards are Japanese in subject matter, not in style. Western artists were largely attracted to Japanese prints for their flat, overlapping forms, sharp disjunctions of scale, colorful patterning, and abandonment of traditional perspective. Although these qualities could be related in pho-

tography, they virtually never appear in photographs or post-cards of nineteenth-century Japan. First, such stylizations of the Japanese aesthetic would have seemed incompatible with the camera's seemingly magical ability to render perspective. Second, including such artistic devices as overall patterning would have interfered with the postcard's informational mission. The standard typology of Japanese postcards, from landscape views to portraits or genre scenes of local inhabitants, were already familiar pictorial subjects due to the Japanese print tradition and the history of European art.[14] Other aspects of Japanese culture, such as its politics, religion, or social caste system, were seldom explored by Westerners in these postcard or Japanese-inspired images. Presumably such subjects were not deemed interesting enough or appropriate to the popular consumption of images.

Visual and musical *japonisme* followed opposite courses of assimilation and dissemination through different forms of high and popular culture. *Japonisme* first entered the musical stage in the popular form, and it was well entrenched in mass culture by the turn of the century, when postcard images began to proliferate. *The Mikado* lightheartedly interpreted Japanese culture while it parodied the high culture of European opera. (It is also noteworthy that it preceded by seventeen years Giacomo Puccini's *Madame Butterfly*, a tragic opera about American imperialism in Japan, which was first performed at La Scala in February 1904.)[15] In contrast to Japanese themes in music, which first appeared in a popular form and were later elevated to a more exalted one, Japanese subjects and styles in the visual arts were avidly imitated in the 1880s by advanced artists but only became generally popular by the turn of the century.

These connections between *The Mikado* and postcards are worth exploring in depth because I wish to suggest that the postcards of Japanese subjects produced by the Detroit Publishing Company and many other firms belong to the Western, middlebrow enthusiasm for all things Japanese, as is typified by the enduring popularity of *The Mikado*. The operetta's comic, ornate, and unreal qualities were also associated with Japan and the Japanese, an idea that was strongly emphasized in the majority of Japanese postcard images that circulated throughout America. While all postcards and images of foreign peoples represent complex constructions of identity and interpretation, these Japanese postcards afford a particular range of meanings.

JAPANESE BEAUTIES FROM DETROIT

Among the hundreds of postcards produced by the Detroit Publishing Company are many that depict Japanese women as "beauties," that is, as objects for contemplation rather than as unique personalities. "A Fair Japanese" (fig. 64), "Miss Pomegranite" [*sic*] (fig. 65), "Queen of the Geisha" (fig. 66), "Wistaria" [*sic*] (fig. 67), "Japan's Fairest" (fig. 68), and "A Tokio Bell" [*sic*] (fig. 69) all belong in this category and most date from 1901. These winsome "bells" are not peculiar to Japanese postcard imagery. Instead, they fall into a universal category of depiction: the "cheesecake" postcard that deploys female attractiveness "in the interest of sex-appeal."[16] Virtually all regions and cultures of the world have contributed to this pictorial category. An extensive body of images of similarly posed women existed in Japan, both as photographs in the pre-postcard era and as prints and paintings in the pre-photographic (hence pre-1854) period. Photographs of geishas dating from the 1860s and 1870s by photographers such as Baron von Stillfried were often more frankly erotic, fre-

quently showing a woman with one breast bared, than were these later postcards. Presumably earlier photographers enjoyed greater license since their prints were less widely circulated than were postcards. Also, photographers could interpret their work as fine art, a category that traditionally legitimated nudity in a way postcards could not do.

Atypical of both those cards produced in Japan and those manufactured by the Detroit Publishing Company is "A Tokio Bell" (see fig. 69). This openly inviting woman, with a wide, lipsticked smile and a kimono opening at her breast, could portray a belle from almost any country. She clutches her robe with one hand over her hip, as if to suggest the folds of her kimono might soon fall open. This boldness poorly accords with prevailing Western fantasies about the sexuality of Japanese women, who, although imagined to be excitingly available, were typically represented as being mysteriously inexpressive, delicate, alien, and submissive.

This characterization culminated in the operatic figure of Madame Butterfly, in whom impassivity and submissiveness reached tragic, grand proportions. With superbly renunciatory stoicism, she witnessed the end of her dream of reuniting with her husband Lieutenant Pinkerton, and she experienced the pain of losing her child to Pinkerton and his new American wife. The opera culminates as she performs a suicide of honor.

An earlier encounter with this fascinating remoteness of Japanese women can be found in Loti's description of the Empress Haruko. "Exquisite and strange, with her air of a cold goddess looking deep within herself, or into the distance, or heaven knows where . . . her little painted face chilled and enchanted me."[17] Such proud and distant women do not resemble the Tokio Bell's smiling engagement and direct eye contact with the camera and eventually with the viewer of the postcard. Indeed, her very boldness renders her virtually indistinguishable from any racial or cultural category of sexually inviting women. It all but erases the racial specificity that is proclaimed in the printed title of the card.

In contrast, "Queen of the Geisha" (see fig. 66) is less forthcoming and thus more typical of depictions of beautiful Japanese women. With pursed lips, the "queen" is considerably more withdrawn than the "bell." Vignetting at the edges creates a haziness that further emphasizes her remote expression to distance the viewer, despite her relatively closer position to the camera.

"Wistaria" (see fig. 67) falls somewhere between "A Tokio Bell" and "Queen of the Geisha." A slightly pouting girl with a yellow parasol stands in a three-quarter length view beside a healthy clump of wisteria blossoms.[18] With her head tilted to one side, she looks past the camera, obviously posing yet not engaging with the photographer or with subsequent viewers. In many of these postcards, it is the colorfully kimono-clad body of the Japanese woman that alone registers the picture's charge of exotic femininity. Apart from "A Tokio Bell," little expression is readily apparent on the women's faces. Roland Barthes has described the whitened faces of traditional Japanese actors, who often play the roles of geishas, as a Mallaméan tabula rasa.

> The actual face is not painted (made up), it is written. . . . The white of the face seems to have as its function . . . exclusively to erase all anterior trace of the features, to transform the countenance. . . . Reduced to the elementary signifiers of writing (the blank of the page and the indentations of its script), the face dismisses any signified, i.e., any expressivity: this writing writes nothing (or writes: *nothing);* not only does it not "lend" itself (a naively mercantile word) to any emotion, to any meaning (not even that of impassivity, of inexpressiveness), but it actually copies no character whatever.[19]

6949, "A FAIR JAPANESE."

Just a token

FIGURE 64. "A Fair Japanese," Japan, 1901–7. Printed and distributed by the Detroit Photographic Company, Detroit.

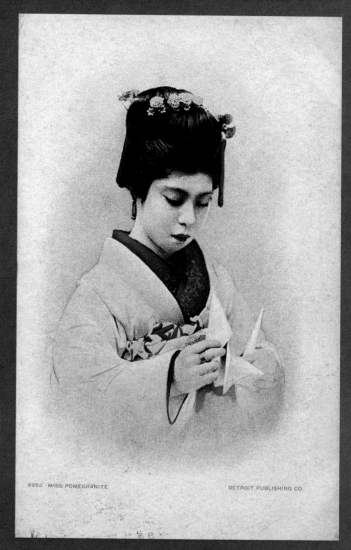

FIGURE 65. "Miss Pomegranite" [*sic*], Japan, 1901–7. Printed and distributed by the Detroit Publishing Company, Detroit.

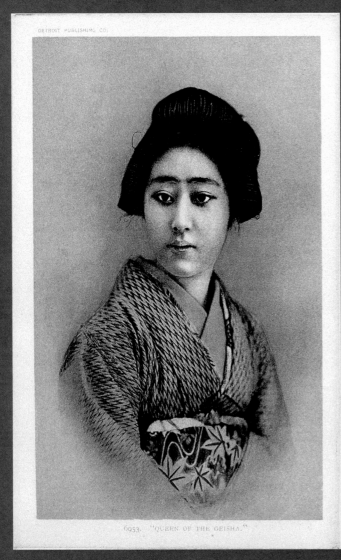

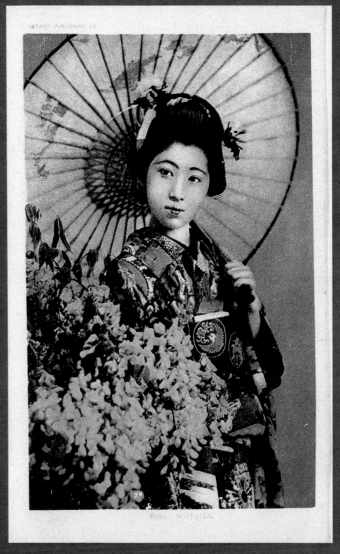

FIGURE 66. "Queen of the Geisha," Japan, 1901–7. Printed and distributed by the Detroit Publishing Company, Detroit.

FIGURE 67. Wistaria" [*sic*], Japan, 1901–7. Printed and distributed by the Detroit Publishing Company, Detroit.

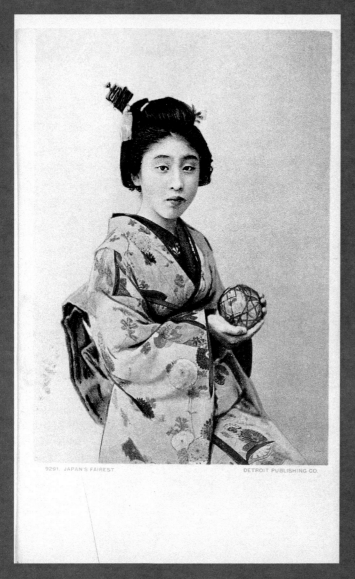

FIGURE 68. "Japan's Fairest," Japan, 1901–7. Printed and distributed by the Detroit Publishing Company, Detroit.

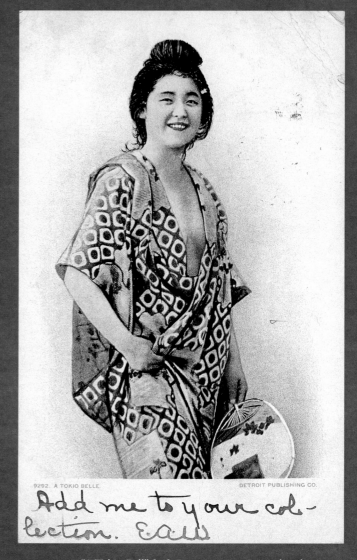

FIGURE 69. "A Tokio Bell" [*sic*], Japan, 1901–7. Printed and distributed by the Detroit Publishing Company, Detroit.

This elegantly updated rendering of the trope of Japanese inscrutability is appropriate to many of these postcard images. Yet it is the postcards, not the faces of the models, that are literally inscribed with several kinds of texts, from the basic photographic image and the coloring applied to it during the printing process, to the cropping, framing, or bordering of the cardstock itself. Of particular interest is the captioning. All of the cards produced by the Detroit Publishing Company are captioned in reddish brown ink on the picture side. "Detroit Photographic Company, Publishers" or "Detroit Publishing Co." normally appears at the upper left of a vertical card (or sideways from the lower left on a horizontal one), with a serial number and a title or caption beneath the image.[20] None of the images fills the entire card.

If, as Barthes would have it, the Japanese face is a signifier of writing and the written, it is also an exemplar of the beauty of artifice. At a time when most European and American women did not use cosmetics, and almost none admitted to doing so, the *maquillage* of the Japanese was part of a fascinating artificiality that seemed to characterize their culture as a whole. From the complex rituals of the tea ceremony to the apparently lacquered hair and heavily powdered faces of its women, Japan was a country of mannered refinement, and Japanese women (unlike European and American ones) could wear cosmetics without implying wickedness. In certain postcard images, however, Japanese women were compressed into the familiar feminine roles of European culture. For example, in a postcard entitled "Vanity," a somber young woman kneels before a mirror that reflects nothing beyond her face. This centuries-old European pictorial convention depicts female frailty while it moralizes about the transience of all earthly things, physical beauty included.

If this was the American interpretation of Japanese feminine beauty, what was the Japanese version? According to

John Dower, "postcards of beauties . . . were often carried to the front by enlisted men" during the Russo-Japanese War of 1904–1905.[21] It is difficult to determine which postcards these were, but within the picture collection of the New York Public Library are a number of postcards of Japanese women that bear Japanese captions in addition to the ubiquitous "POSTCARD" or "Carte Postale" verso. While these images are quite similar to those produced by the Detroit Publishing Company, the cards differ significantly in format in that they generally have neither borders nor titles recto. Groups of geishas engaged in games, musical performances, meals, or merely bowing are often depicted. Single figures are simply shown close up, with head and shoulders. Although they were not so deliberately selected and organized within a given format as were images printed as postcards by the Detroit Publishing Company, these cards still present an image of Japanese femininity that was recognizable to Western viewers. Compliance, delicacy, and artifice form the foundations of this construction of femininity.

Through their caption titles, many of the Detroit Publishing Company's postcards proclaim a jollier Japanese countenance than the photographs actually depict. In "Japan's Fairest" (see fig. 68), a girl barely at the age of womanhood holds a ball in her hand. Not playing with her toy or acknowledging the camera, she sits impassive. Similarly, "Miss Pomegranite" (see fig. 65) offers a girlish incarnation of femininity that greatly differs from the earthiness of "A Tokio Bell." She seems to evade the camera rather than place herself on display as an example of national beauty.

In many of these postcards women are situated in vague, undifferentiated interiors, beyond the impersonal photographer's studio to the even greater emptiness of a retouched background. Other women are apparently posed out of doors, as in "A Sunny Day in Japan" (fig. 70), yet this photo-

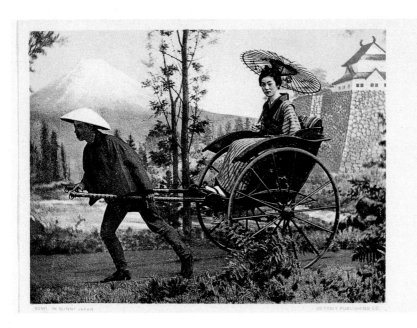

FIGURE 70. "A Sunny Day in Japan," Japan, 1901–1907. Printed and distributed by the Detroit Publishing Company, Detroit.

graph was almost certainly taken within a studio. A strip of stiff, artificial foreground greenery gives way to a flat middle ground occupied by a rickshaw puller and his passenger. Very close by looms Mount Fuji, but it is obviously painted on a flat backdrop or screen. In the earlier period of Japanese photography, such hand-painted backdrops were imported from Europe, which resulted in the incongruous portrayal of traditional Japanese subjects before settings that were loosely derived from landscapes by the Barbizon school. Local backdrop production soon became common, and more appropriate Japanese-style landscapes were substituted. By the turn of the century the European-style portrait studio described by Loti, with its artificial rocks and columns, was assuming a local Japanese character, as is evident in many photographs from the 1870s.[22]

Postcards from the early 1900s locate Japanese femininity within the unreal, fictional space of the photographer's studio. Presenting precise information was the least appropriate possible mode of depiction for images that were intended to meet Western ideas about Japan. Photographs required a certain imprecision in order to allow viewers' own fantasies to operate. The Detroit Publishing Company's Japanese beauties could as easily have been photographed backstage at the D'Oyly Carte Opera Company as in the streets of Tokyo or Kyoto. The Janus-faced masks with which foreign peoples are invested in the perceptions of travelers, photographers, and makers of postcards are normally comprised of one countenance of attraction and another of repulsion. Sometimes the two may be figured as similarity and difference. A typical *National Geographic* strategy of mingling images to suggest the universality of human experience results in the occasional startlingly alien view of an unfamiliar, inassimilable behavior or practice, or in two aspects of difference, the appealingly exotic and the savage.

The cheerful *japonisme* of the Detroit Publishing Company's postcards can be usefully contrasted with a series published in London by the Franciscan Missionaries of Mary on the Missions. It depicts their missions around the world, which apparently specialized in ministering to lepers. Burma, Ceylon, the Belgian Congo, and Japan are all represented in these images. Typical of their postcards is one from Biwasaki, Japan. "THE LEPERS—Workroom of the Lepers" shows a

nun, standing before a cupboard filled with cloth, apparently supervising seven Japanese leper women as they sew at a low table. Slender and ethereal, the nun resembles a waxwork saint. One woman to the lower right, in a position closest to the camera, has been severely disfigured by her disease, which has created deep, irregular corrugations in her face that are painful to behold. The faces of the others are either slightly blurred or averted. While mercy and missionary outreach were the ostensible purposes for this image, fascination mixed with loathing are also sensed here, as they defined many European/American contacts with other cultures and races. Hansen's disease rather than racial difference becomes the legitimized object of the dual fascination and horror in the Franciscans' leper postcards.

Whether these postcard images propose to examine the differences between the Western missionary and the Japanese, or even between the healthy person and the sufferer of

an incurable disease, is unclear. An indication is found in the grand scheme of the Burdick collection. On the same album page with "Lepers at Dinner" is a card published by the American Baptist Foreign Mission Society entitled "A Fukuin Maru Baptismal Scene, Inland Sea, Japan." Here is the true culmination of the missionaries' work: a mass baptism to redeem and secure Japanese souls for Christ.

Turning over one more leaf in the album, a coda is inserted into the miniature narrative on leprous Japanese and salvation through baptism. This series of somewhat later cards from The World in Boston Missionary Exposition includes "Afternoon Tea, Japan Scene" (fig. 71), a tour de force of cross-cultural surrealism. In this view of a simulated Japanese tea house, Bostonians dressed in Japanese-style garments arrive via rickshaw to take tea with a group of similarly attired friends. The setting, however, is more of a papier-mâché simulacrum, a New England fantasy of the Far

FIGURE 71. "Afternoon Tea, Japan Scene," Japan. Distributed by The World in Boston Missionary Exposition.

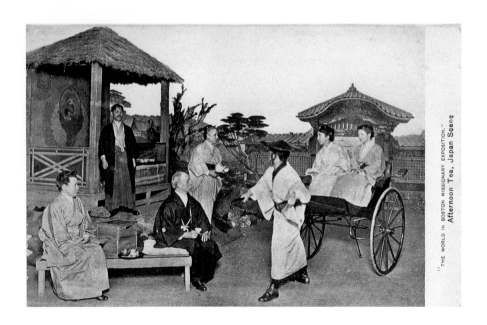

East. In the end, the image resembles a stage set for a play with no audience, only participants interested in creating an illusion. Boston itself has become the set for an all-encompassing performance of *The Mikado,* and the exotic foreigners are not aliens or lepers, but ourselves in costume.

THE SILK INDUSTRY, WORKERS, AND ADVERTISING

In 1904 Japan exported $30.4 million worth of raw silk to the United States.[23] Indeed, Japan's single greatest export was silk, and its most important trading partner was the United States. The Japanese silk industry, a labor-intensive endeavor, involved much handwork and careful attention to sericulture, the demanding process of growing silkworms. If farming was said to be more like gardening in Japan (the country's hilly terrain required complex terracing and crops had to be tended by hand), silk production was closer to agriculture than textile industries in other nations. Combining the handwork of traditional agriculture with mechanized industrialization, silk production was a complicated process that foreigners came to consider uniquely Japanese.

The Burdick collection includes a set of twelve postcard views of sericulture (three are shown here) that were published by the Corticelli Silk Company probably in the 1910s.[24] They are numbered and titled as follows: "Corticelli Moths Laying Eggs on Regulation Japanese Government Egg Paper," "Feeding Corticelli Silkworms just Hatched, and Removing them from Egg Paper," "Feeding Mulberry Leaves to Corticelli Silkworms" (fig. 72), "Selecting Corticelli Silkworms that are Ready to Spin," "Placing Corticelli Silkworms that are Ready to Spin on Twigs or Branches" (fig. 73), "Reeling the Silk from Corticelli Cocoons by Foot Power," "Weighing and Sorting Corticelli Silk Cocoons," "Rewinding Corticelli Silk After it is Dry into Large Skeins," "Filature—Reeling the Silk from Corticelli Cocoons by Power Machinery" (fig. 74), and "Sorting and Tying Skeins of Corticelli Raw Silk from the Small Reels into Large Skeins."

Many of the silk workers seen in these postcard images are young women, but they are workers, not "beauties." The Corticelli name, the silkworms, and even the machinery are accorded more importance than the scores of women who illustrate the processes of the silk industry. In addition to

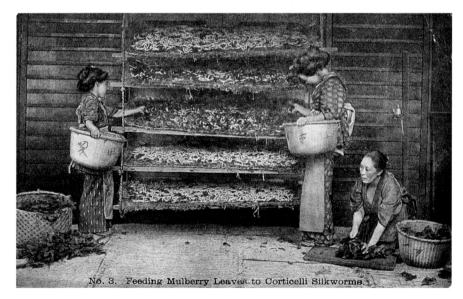

No. 3. Feeding Mulberry Leaves to Corticelli Silkworms.

FIGURE 72. "Feeding Mulberry Leaves to Corticelli Silkworms," Japan, ca. 1910. Distributed by the Corticelli Silk Company, Florence, Massachusetts.

FIGURE 73. "Placing Corticelli Silkworms that are Ready to Spin on Twigs or Branches," Japan, ca. 1910. Distributed by the Corticelli Silk Company, Florence, Massachusetts.

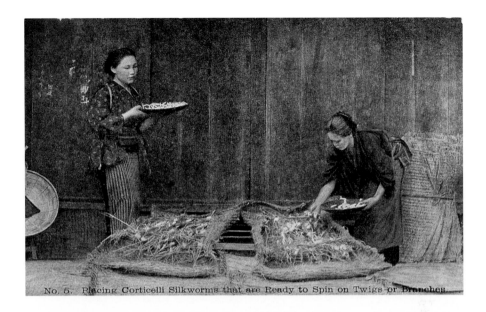

No. 5. Placing Corticelli Silkworms that are Ready to Spin on Twigs or Branches

FIGURE 74. "Filature—Reeling the Silk from Corticelli Cocoons by Power Machinery," Japan, ca. 1910. Distributed by the Corticelli Silk Company, Florence, Massachusetts.

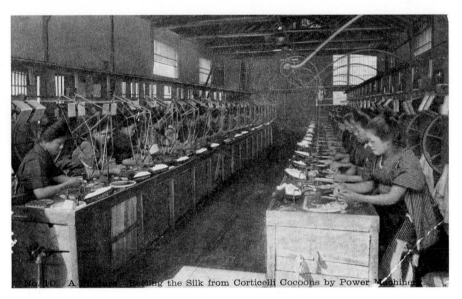

No. 10. A Filature—Reeling the Silk from Corticelli Cocoons by Power Machinery

suppressing the individuality of the workers, the narrative of these postcards also conceals some aspects of silk production. Silk is naturally produced by the larva of the *Bombyx mori* moth, which uses the filament in building cocoons.[25] These larvae extrude silk filaments from two glands on the sides of their bodies and wrap themselves in its continuous length. Unless they are destroyed before reaching maturity, the moths will force their way out of the cocoons and tear the silk into short, broken fibers, thus ruining the purpose of sericulture. It is interesting to note that the cards in the Corticelli series do not represent the most important step in the entire sequence: killing the silkworms within the cocoons. The silkworms themselves are not visible in any of the postcard images—worms and caterpillars were not considered appealing creatures, however useful they might be—and their destruction was tactfully ignored in this series.

Cards in the Corticelli series are far from uniform in approach. The first two postcards depict stylish young women working in refined interiors. In the first, three women serenely gather eggs laid by moths. A tea service is arranged in the foreground, while a painting of Mount Fuji behind them suggests the view through open shoji screens. Two of the women reappear in the next image, their heads bundled in paper caps. By the third card, however, the scene has changed to a rough shed where far less glamorous workers feed mulberry leaves to silkworms. Later cards show industrial interiors not unlike those Lewis Hine photographed in his campaign to document child labor abuses in southern textile mills in the early years of this century. Rows of Japanese young women stoop over elaborate reeling and spinning machines, caged or dwarfed by their mechanical complexity.

These interchangeable workers in an industrial setting contrast sharply with postcards that depict common Japa-

nese workers. Hand-colored postcards of this type, many of which are found in the New York Public Library rather than in the Burdick collection, follow photographic conventions established for genre scenes in the 1860s.[26] Vendors and street performers were often pictured within the studio, feigning their usual pursuits while displaying characteristic props or attributes for the benefit of the camera. Farmers were often photographed outdoors in their actual surroundings. One postcard, "A Farmer Smoking in His Rain Coat" (fig. 75), unsentimentally portrays a thoughtful man in a traditional straw coat. Other images were staged to suggest a task being performed, such as "A Father in the Cook Room," "Pounding Rice for the Rice Cakes," "Winnowing of Ride [*sic*] with Hand and Machine," and "Go Out for Morning-Labor." All of these feature the same model. The uncertain English of the captions makes the country of origin clear, and yet the cards were necessarily meant for an English-speaking audience. One card that portrays a worker without indicating a specific task is "Horse and Keeper returning home" (fig. 76), in which a farm woman with a slightly anxious expression poses with an impassive horse. Unlike the Corticelli cards, these postcards had no product to advertise, and thus they were free to emphasize the roles and characters of individual workers.

In this same vein, the Detroit Publishing Company cards of Japanese women functioned like advertisements without a product. They offered seductive visions to fulfill a lighthearted fantasy, while the Corticelli silk postcards exalted the making of a product at the expense of the workers depicted. Both types differ from Japan's standard genre images of workers.

In the Burdick collection are examples of another category of postcard images of women. Amongst advertising postcards from such nonexotic establishments as the "Minneopa

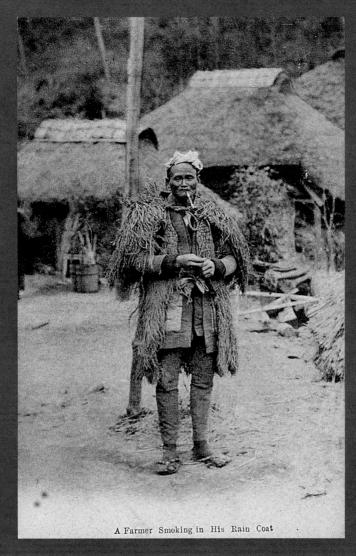

A Farmer Smoking in His Rain Coat

FIGURE 75. "A Farmer Smoking in His Rain Coat," Japan, ca. 1900. Distributed by the Union Postale Universelle.

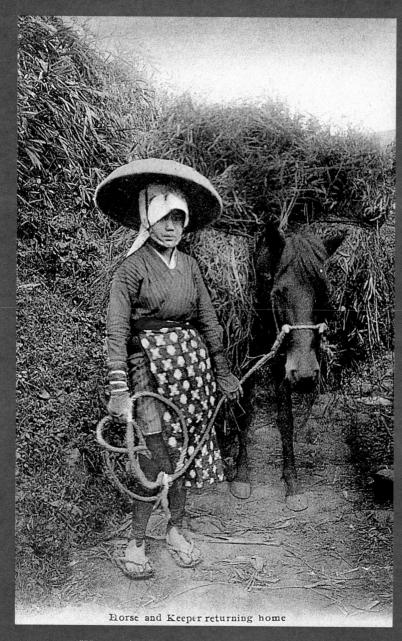

Horse and Keeper returning home

FIGURE 76. "Horse and Keeper returning home," Japan, ca. 1900.

Garage, Second and Cherry Street, Mankato, Minn." are a few from Japanese stores or shops that carried Japanese novelty products. Here, Japanese beauties promote products that are not even pictured. To entice American shoppers, the Mitsukoshi Gofukuten department store in Tokyo placed a sad-faced girl in a kimono on its advertisements (fig. 77). Surrounded by a patterned border and a stave of music, she forlornly grasps an American flag. A triste little Madame Butterfly, her image acknowledged the international character of advertising and of commodity culture.

"Vantine's The Oriental Store" in New York took a different approach by printing its commercial message on the back of an existing hand-tinted Japanese postcard rather than designing its own advertisement. This card, which bears a postmark of 1915, depicts a languorous yet slightly scornful young women smoking opium and reclining before a richly painted folding screen. Associations with the European-created market for opium in nineteenth-century China and the complexities of multinational trade cluster around this woman's image and completely differentiate it from the cultivated innocence of Gilbert and Sullivan's *japonisme*.

FURTHER QUESTIONS

Even if these postcards from the Burdick collection serve as an effective lens through which to study Japanese postcard imagery, they nonetheless afford an extremely circumscribed view of that field of inquiry. The most important questions that remain concern the overall scope of postcard production in Japan. What kinds of images were made, when, and in what numbers? Significant questions of attribution to specific photographers remain open. How many postcard photographers and publishers were at work in Japan at the turn

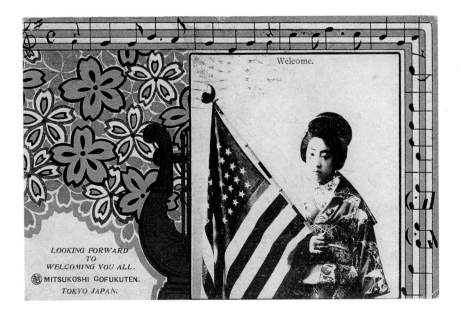

FIGURE 77. "Looking Forward to Welcoming You All. Mitsukoshi Gofukuten. Tokyo, Japan," Japan, ca. 1910. Printed by the Tokyo Printing Company, Japan.

of the century? Did photographers select their own subjects, or did they merely fill orders for publishers? Why were existing stocks of glass plate negatives not reused for postcards as they were in the United States?

Once the basic factual questions about Japanese postcard production are answered or at least hypothesized, it will be possible to turn to larger interpretive concerns. How did cards produced in Japan differ in subject, treatment, and meaning from those manufactured in Europe or America? Many of the cards in the Burdick collection are decidedly not ethnographic in nature. They romanticize rather than scrutinize an elegant society and laud a culture from which Westerners might borrow, appropriate, or impersonate elements. Documentary postcards of Japanese subjects do exist, and both are Western and Japanese in origin.

Some of the Japanese postcards in the Burdick collection reveal close connections between these images and *japonisme* in other media, such as literature, painting, and music. Once the chronologies of postcard production are established, it will be possible to ascertain changing uses of Japanese imagery over time and in different media. Early photographic infatuation with overtly exotic Japanese subjects (such as Beato's famous pictures of severed heads after an execution) eventually gave way to a different kind of imagery in the postcard format. No longer emphasizing cultural differences, the postcards offered visual confirmation about a familiar—if distant and unvisited—land wrapped in tradition. To read all postcards as expressing the same set of historical references is problematic, yet interpretation will be assisted by recovering more information about the precise circumstances and chronology of their production. This case study is but a preliminary sketch of questions waiting to be addressed.

NOTES

I am much indebted to Nadine Orenstein for her help at several crucial stages in my research and in the preparation of this text, to the staff of the New York Public Library's Picture Collection for their remarkable generosity and helpfulness, and to Virginia-Lee Webb for her advice and stimulating discussion of many issues concerning photographic postcards.

1. Clark Worswick, "Photography in Nineteenth Century Japan," in *Japan Photographs 1854–1905* (New York: Japan House Gallery, 1979), p. 130.

2. Japan Photographers Association, *A Century of Japanese Photography*, introduction by John Dower (New York: Pantheon, 1980), p. 3.

3. Ibid., p. 9.

4. Pierre Loti, *Madame Chrysanthème* (Paris: Calman-Levy Editeurs, n.d. [1887]), pp. 226–27 (author's translation).

5. A. Hyatt Mayor, introduction in Jefferson R. Burdick, *Directory of the J. R. Burdick Collection* (New York: Metropolitan Museum of Art, n.d. [ca. 1963]), p. 3.

6. Julia Meech and Gabriel Weisberg, *Japonisme Comes to America: The Japanese Impact on the Graphic Arts 1876–1925* (New York: Harry N. Abrams, 1990).

7. Klaus Berger, *Japonisme in Western Painting from Whistler to Matisse*, trans. David Britt (Cambridge, England: Cambridge University Press, 1992).

8. George Watson Cole, *Postcards, The World in Miniature: A Plan for their Systematic Arrangement* (Pasadena, Calif.: privately published, 1935), n.p.

9. A. Hyatt Mayor, "Jefferson R. Burdick" in Burdick n.d. [ca. 1963], p. 4.

10. Jefferson R. Burdick, in ibid., p. 5.

11. William Henry Jackson, *Time Exposure* (1940; reprint, Albuquerque: University of New Mexico Press, 1986), p. 324.

12. Walter Weston, "The Geography of Japan with Special Reference to its Influence on the Character of the Japanese People," *National Geographic* 40, no. 1 (July 1921), pp. 45–84.

13. Lutz and Collins 1993. These two authors discuss the presentations of varying cultures, including that of Japan, in the pages of *National Geographic*. Although their study considers post-World War II images rather than turn-of-the-century ones, many of their points about the special status accorded Japan apply to this earlier period. Japanese culture is consistently portrayed as being more sophisticated than the "primitive" cultures of Africa, the Pacific Islands, and elsewhere.

14. Literature concerning European picturesque landscapes is extensive. I merely point out parallels between the European tradition and the one in Japan that allowed Hokusai, Hiroshige, and other artists to produce sets of prints depicting famous views and sites within the landscape.

15. Mosco Carner, *Puccini: A Critical Biography* (New York: Alfred A. Knopf, 1968), p. 379.

16. *The Compact Oxford English Dictionary*, 2d ed. (Oxford, England: Clarendon Press, 1991), p. 292.

17. Pierre Loti, "Japoneries d'automne," in Chantal Edel, *Once Upon a Time . . . ,* trans. Linda Coverdale (New York: Friendly Press, 1986), pp. 26–27.

18. Many of the Japanese cards published by the Detroit Photographic Company are represented in two versions in the Burdick collection. The fragile lithographic stones used in the photochrome process frequently became degraded and required regraining before they could be used further. During this process, colors and details were often altered. In the other version of "Wistaria" in the Burdick collection, for example, the young woman carries a pink parasol.

19. Roland Barthes, "The Written Face," in *Empire of Signs,* trans. Richard Howard (New York: Farrar, Straus and Giroux, 1982), pp. 88–89.

20. Serial numbers printed on the face of each card indicate a date. According to Lowe and Papell 1975, the 6000 series, from which most of these images come, was released in 1901, while the 9000 series, from which "A Tokio Bell" and "Japan's Fairest" come, dates from 1905. Cards from the 7000 and 8000 series fall in between these years.

21. Japan Photographers Association 1980, p. 7. It is interesting to note that at this same time caricatures by French artists concerning the Russo-Japanese War were circulating in Paris. See Bruno Perthuis, "Les cartes postales gravées et lithographiées sur la guerre russo-japonaise (1904–1905)," *Gazette des Beaux-Arts* (September 1984), pp. 86–98.

22. Ellen Handy, "Tradition, Novelty and Invention: Portrait and Landscape Photography in Japan, 1860s–1880s," in Melissa Banta and Susan Taylor, *A Timely Encounter: Nineteenth Century Photographs of Japan* (Cambridge, Mass.: Peabody Museum Press, 1988), p. 60.

23. "The Foreign Commerce of Japan," *National Geographic* 16, no. 7 (July 1905), p. 357.

24. I suggest this date primarily on the basis of visual evidence. One interesting note is that the line engravings used to illustrate the stages of a silkworm's life in an article on silk and sericulture in the 1929 *Encyclopedia Britannica* (14th ed.) were supplied courtesy of the Corticelli Silk Company.

25. "Silk and Sericulture," *Encyclopedia Britannica,* 14th ed., vol. 20 (London, 1929), pp. 664–71.

26. Within the New York Public Library's holdings of postcards is an interesting but incomplete series of cards illustrating silk production. These images differ considerably from the Corticelli cards in that they present workers in a fashion similar to that of typical genre photographs or postcards of Japanese workers and tradespeople.

Em. Thill, Bruxelles.

Missionaries of S. Cœur
Missionnaires du S. Cœur, Borgerhout-Anvers
Mission de Coquilhatville (Congo belge)
Commencement du poste de Boënde.

Hommages respectueux
avec
Prières reconnaissantes.

BRUXELLES

BELGIQUE

Mme Vve Emile Claude

Haulage

5

VIRGINIA-LEE WEBB

TRANSFORMED IMAGES

Photographers and Postcards in the Pacific Islands

As in many other parts of the world, numerous photographers were active in the Pacific Islands during the nineteenth and twentieth centuries, and some of their photographs were published in postcard format. As occurred around the globe, many of the photographs emanating from the Pacific can no longer be ascribed to any individual photographer or studio. In these early years of photography, attributions were commonly lost or deliberately omitted, and images were transferred from company to company. A large number of these photographs were used repeatedly in postcard production by different studios, printing companies, and distributors. Nevertheless, the image and producer of the original photograph on the front of the card remain an essential part of the postcard itself.

Focusing on the original photograph as one of the multiple layers that form the artifact "postcard" provides a way to interpret a card within its appropriate historical context as well as within contemporary thinking. Admittedly, emphasizing the photographer and the original image favors one aspect of the postcard over others, yet only through examining details can we detect alterations and transformations made during the transition process from photograph to printed postcard image. Determining the identity of the original photographer as well as the date and context of the image is an initial step in interpreting postcards as an historical resource.

Postcards from the Pacific Islands and the photographers discussed here come from a postcard collection that includes Africa and is housed in the Department of the Arts of Africa, Oceania, and the Americas at the Metropolitan Museum of Art in New York.[1] Represented are a variety of subjects, such as colonial expositions and world's fairs, as well as publishers ranging from missionary societies to museums. Those postcards with photographs taken in countries of the Pacific pro-

vide important source material for studying the colonial period. With its focus on transformations, this case study emphasizes postcards from Australia, New Zealand, Samoa, and the Solomon Islands. A manageable group of individuals and images was selected from the large number of prolific studios that were operating in the area. The study draws attention to the studios of Kerry and Company in Australia; the Burton Brothers, Muir and Moodie, Josiah Martin, William Partington, Frank Denton, and the Iles Brothers in New Zealand; Alfred J. Tattersall, John Davis, and Thomas Andrew of Samoa; John Watt Beattie, the Reverend H. H. Montgomery, and the Reverend George Brown of the Solomon Islands.[2]

CHARLES KERRY AND HENRY KING OF AUSTRALIA

In the late nineteenth century the prominent Sydney studio of Kerry and Company produced many photographs and later postcard views of Australia. Charles Kerry (1857–1928), the studio's owner, operated a highly profitable business that employed several traveling photographers. The organization of Kerry's company and his production techniques exemplify the then-common practice of one photographic firm appropriating and communally publishing images. Works by individual photographers remained anonymous and were published collectively under the name of the studio. For this reason, attributing photographs to specific individuals is especially problematic in postcards.

Publishing views of Sydney and other locations as postcards proved a huge financial success for Kerry and Company.[3] They were printed in and outside of Australia and mailed all over the world. In addition to his own inventory of images, Kerry acquired the negatives of Henry King (1855–1923), a fellow Sydney photographer.[4] Kerry and King's numerous photographs of Aboriginal communities were published and sold by Kerry and Company in various sizes of albumen prints.[5] Images were also republished as postcards in several series.

It was common practice to alter an image substantially when a photograph was transferred to the postcard format. Captions were often rewritten and coloring was added by hand. Together, such changes dramatically altered a photograph's message and content, and further obliterated clues to the identity of the original photographer. One pair of postcards illustrates the type of extreme manipulation that occurred in the transition from photograph to postcard.

The first card, titled "An Aboriginal Family [Se]ries 5. Australian Aboriginals. / Kerry (Copyright), Sydney," was printed with the black-and-white collotype process (fig. 78). The image was taken from an albumen photograph originally titled "Aboriginal Mia Mia" and bearing the Kerry corpus number 75-6, 558.[6] Sent to a "Miss Perry" in Staffordshire, England, the card shows four people near a round shelter at a river's edge. The three women appear in dresses with long sleeves, while the man wears trousers, a long-sleeve shirt, a vest, and a hat. A three-quarter-inch border runs along the lower edge of the front, where a caption is printed. The back is divided.

A second card uses the same photo, but color has been added (fig. 79). The caption has been reverted back to "Australian Aboriginal Mia Mia," quite similar to the title published in Kerry's corpus *(Tyrrell Collection* 1985, unpaginated). A cream-colored, quarter-inch border runs along the bottom edge and right side of the front. "KERRY PHOTO" appears in the lower left corner of the image.

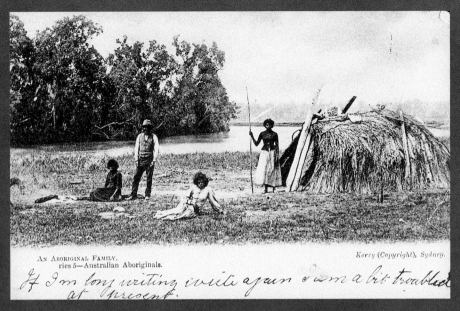

FIGURE 78. "An Aboriginal Family," Australia, ca. 1880-1910. Photographed and published by Kerry and Company, Sydney, Australia.

Australian Aboriginal Mia-Mia

FIGURE 79. "Australian Aboriginal Mia Mia," Australia, ca. 1880–1910. Photographed by Charles Kerry or Henry King. Published by Kerry and Company, Sydney, Australia.

Drastic changes took place between the two versions of the cards. First, the black-and-white postcard was produced using the collotype process, which resulted in no real gray tones, and it was printed on a slightly textured paper stock. In contrast, the color card is a halftone print that has been heavily retouched by an artist with garish yet somehow romantic colors to look almost painterly. For example, in the original photograph as well as the black-and-white card, the sky appears overcast at the horizon. Uneven, fluffy clouds float in the sky. The water's edge is lined with a distinct ridge of foliage. In the color halftone card, however, the elements of the sky are extremely defined and colorful to suggest the beginning or the end of the day. Purple, yellow, and orange clouds float horizontally across the sky. A flock of birds in flight has been added, as have several flowers in the foreground.

Most radically altered was the appearance of the woman seated on the ground to the far left. In the black-and-white photograph she looks like a curly-haired woman in a dark, long-sleeved dress. Repainted in the color version to an allover brown, the woman's skin is now indistinguishable from her dress, which makes the viewer question whether or not she is clothed. While partial nudity of Aboriginal women and men in certain situations is not "inaccurate," the woman was fully dressed in the original photograph.

This color postcard is one of several photographs that were recreated to look like paintings. The quality of the image has been so drastically altered that it no longer represents the original scene. A person seeing only the color card would assume that its atmospheric and cultural elements accurately depict the location. Marketing the romanticized color image further disguised the photograph's initial identity and also perpetuated a stereotypical view of the Aborigines.[7]

THE PHOTOGRAPHERS OF AOTEAROA– NEW ZEALAND

Photography in nineteenth-century New Zealand was a thriving industry. Non-Maori (*pakeha*) photographers were quickly drawn to recording images of the Maori. Portraits and landscapes also proved particularly popular on postcards. As colonial settlements and tourist travel increased in areas where the Maori had always lived, demand for Maori portraits grew. The extraordinary beauty of the New Zealand landscape was an ideal subject for postcards that were in great demand by tourists.

Like many groups of people who were set upon by strangers, the Maori harbored an initial disdain for photographers and their craft. Historians and ethnographers have recorded the evolving relationship that existed between colonial photographers and the Maori.[8] The Maori, they note, initially felt photographs were taking power away from them, yet they rapidly learned to embrace the medium and incorporate images of themselves back into their daily lives. As in numerous other cultures, photographic portraits were soon integrated into Maori funerals, second burials, and memorial ceremonies (King 1984, 2–3). They were placed alongside carved representations of ancestors in community meeting houses.

The prolific representation of the Maori and the incorporation of their images into twentieth-century postcard production is largely due to the work of several photographers. The Burton brothers are probably the best-known figures in early New Zealand photography. They collectively published their work and that of their staff under the name Burton Brothers. Alfred (1834–1914) and Walter (1836–1880) Burton were born in England and set up their first New Zealand stu-

dio in late 1866 (Burton Brothers 1987, 9). Walter took studio portraits, while Alfred traveled to distant locations to take panoramic and topographical views of New Zealand's extraordinary landscape. In 1868 he also documented various colonial settlements, such as those related to the gold mines in Otago (Burton Brothers 1987, 11). After an argument in 1877, the brothers parted. Three years later the relationship ended when Walter tragically took his life in his darkroom (Burton Brothers 1987, 17). Alfred continued the business alone, and he pursued his interest in travel photography by journeying to several islands of Polynesia. In New Zealand he took pictures of the Maori for the growing tourist business, with the assistance of his new partner George Moodie (1865–1947).[9]

Alfred Burton created the work for which his firm is most recognized in 1884 and 1885. He visited the islands of Fiji, Samoa, and Tonga in 1884 (Burton Brothers 1987, 33). There he took 230 photographs that were later published with his notes as The Camera in the Coral Islands (Burton Brothers 1987, 33). On the North Island of New Zealand in April 1885, he made nearly two hundred staged photographs among the Maori communities in Wanganui, Taumarunui, and "King Country," which were later published as The Maori at Home (1885).[10] Although posed, the images comprise an extraordinary visual record of a people fighting to retain their land and culture in the face of encroaching colonials. These photographs became the subject of millions of postcards when the postcard craze seized New Zealand from 1903 to 1912.

By the end of the nineteenth century, thousands of photographs with Maori subject matter had been produced by Europeans, Australians, and New Zealanders for various commercial and religious reasons. An enormous quantity of older photographic images were transformed to fit into the post-card format. At the height of the craze in 1909, between nine and fourteen million cards were posted in New Zealand.[11] Consequently, Burton Brothers photographs remained in circulation as postcards well into the twentieth century.

After the deaths of the Burtons, Thomas M. B. Muir (circa 1852–1945) purchased their inventory of negatives. With the addition of a partner, George Moodie, who had also worked for the Burtons, he renamed the firm Muir and Moodie. Around 1900 they published a significant number of postcards using the inventory they had purchased (Main and Turner 1993, 24). Their business was so profitable that they opened "The Great Post Card Emporium," a store at the corner of Moray Place and Princess Street in Dunedin (Knight 1971, 89). They even sold a postcard view of the building itself. Their postcard production lasted until around 1916.[12] Like other photographers in the Pacific, Muir and Moodie sent images to Europe for printing as postcards by German and Austrian firms (Main and Turner 1993, 24). The results are characteristic of the printing styles of the time, with the photographs reproduced by black collotype and captions in red along the edges (fig. 80).

From these postcards emerges a particular way in which the Maori and their culture were seen and defined by colonials. European canons of representation were firmly in place. Seen through pakeha eyes, the Maori were presented to the world through postcard images of portraits, performances, cultural rituals, daily life, architectural styles, eroticism, facsimiles of paintings, and photo collages assembled as tourist souvenirs. For example, Muir and Moodie initially "cropped their standard whole plate (16 × 21 cm) views and printed them on stiffer paper" for postcards (Main and Turner 1993, 24). Thus, the photographs were literally sized to fit the format. Significant changes in composition resulted

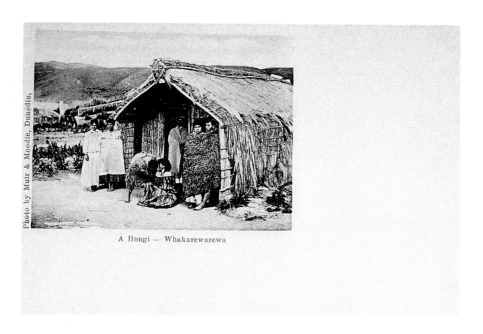

FIGURE 80. "A Hongi—Whakarewarewa," Australia, ca. 1900–1916. Photographed by Alfred Burton, 1885. Published by Muir and Moodie, Dunedin, New Zealand.

and now often make it difficult to connect a postcard image to its original photograph.

A logical vehicle for European photographers, portraiture included highly stylized studio images of well-known individuals. Needless to say, postcards pictured men and women differently, in accordance with set themes. Many of the Eurocentric tropes used in representing sitters were not unique to the indigenous people of New Zealand: such gender specific images were created in photographer's studios around the world.[13] In twentieth-century postcards, systems of representation established in the nineteenth century and before were revised and extended to conform to the contemporary tastes of the world's commercial markets.

Retouching, a major aspect in manipulating portraiture, is evident in two cards in the Metropolitan Museum's collection. One, a color lithograph from the Industria series of postcards distributed in New Zealand, was produced by Fergusson Limited, Sydney and London, and printed by Otto Leder in Meissen, Germany (fig. 81).[14] The second card, created using a halftone process, was distributed by S. Hildesheimer and Company, London and Manchester (fig. 82). A printer attribution for the second card has not yet been determined, but it was made in Germany as well. Both postcards use portraits of a man identified on one card as "Mohi-Tirongomau." The original photograph for the Leder postcard was made in the 1880s by Josiah Martin (1843–1916), who operated a studio in Auckland with William Partington. Although the two photographs differ slightly in pose, they seem to have been taken at the same sitting. A posthumous gelatin silver print from 1916 by William Partington (Metropolitan Museum of Art collection) is identical to the Leder card.[15]

Adding colors was consistently the most obvious way to alter original albumen prints for postcards. Color schemes were often a printing company's trademark. A comparison of the two postcards of Mohi-Tirongomau reveals the different colors that were used. The Hildesheimer card, for example, has reds and a variety of browns and blues for its coloration (see fig. 82). In the Leder card the feathers are colored white. The slight blue cast that covers the entire card has been identified as Iristone or Iristype (see fig. 81).[16] Some printing firms produced entire series in set color styles, regardless of

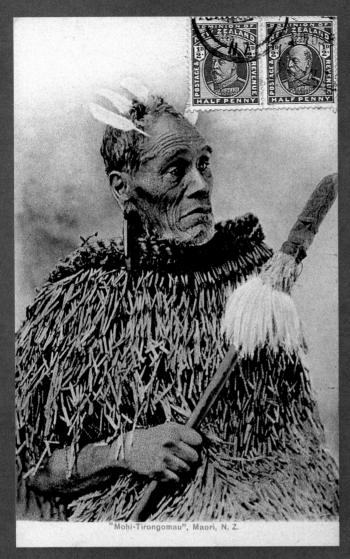

FIGURE 81. "Mohi-Tirongomau," Maori, New Zealand, ca. 1900. Photographed by Josiah Martin, ca. 1880s. Distributed by Fergusson Limited, Sydney, Australia, and London, England.

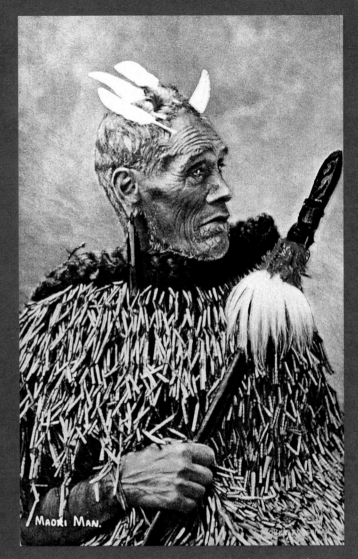

FIGURE 82. "Maori Man" [Mohi], New Zealand, ca. 1900. Photographed by Josiah Martin, ca. 1880s. Distributed by S. Hildesheimer and Company, London and Manchester, England.

the cards' subject matter. Pictorial decisions made by nine-teenth-century photographers were frequently changed again by postcard printers and publishers in the twentieth century.

Josiah Martin's portraits of important Maori leaders often became subjects for postcards produced by different companies. Captions described the leadership abilities of Maori men and their success in political struggles against colonial intruders. A portrait of Rewi Maniapoto (1815–1894) made prior to 1894 was reissued as a halftone postcard by the firm of Harding and Billings around 1912 (fig. 83). Rewi was one of several Ngati Maniapoto chiefs who "fought for Tawhia in the 1860s."[17] He was also photographed with the leaders Tawhana, Taonui, Wetere Te Rerenga, Te Rangituataka, and Te Naunau by Alfred Burton in 1885 at Haerehuku. That group portrait exists in the Metropolitan Museum's collection as an albumen print and as a collotype postcard "Issued by Muir & Moodie Dunedin, N.Z. from their copyright series of Views" (fig. 84).[18]

A 1905 oil painting by Charles Frederick Goldie (1870–1947) depicting Te Aho te Rangi Wharepu of the Ngati Mahuta was also issued as a color lithograph postcard (fig. 85). Here, Goldie emphasized the man's *moko,* or traditional facial tattoos *(Face Value* 1975, cover). This was also done by painters during this period, such as Gottfried Lindauer (1839–1926). European fascination with *moko* also influenced the appearance of postcard imagery. The collotype's suitability to print solid lines in one color enhanced the depiction of traditional tatoos.

Postcard portraits of Maori women were even more numerous than those of men. Images of women were subject to extreme manipulation to make postcards more saleable. Arthur James Iles (1870–1943) was especially famous for his photographic portraits of women (Main and Turner 1993, 23). Iles operated studios in Thames and Rotorua, New

REWI MAHIAPOTO THE GREAT MAORI FIGHTING CHIEF

FIGURE 83. "Rewi Maniapoto. The Great Maori Fighting Chief," New Zealand, ca. 1912. Photographed by Josiah Martin, 1894. Printed and distributed by Harding and Billings, Great Britain.

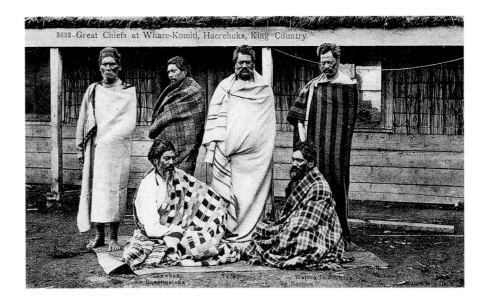

FIGURE 84. "Great Chiefs at Whare-Komiti, Haerehuka, King Country," New Zealand, ca. 1905. Photographed by Alfred Burton, 1885. Published and distributed by Muir and Moodie, Dunedin, New Zealand.

Zealand, and his photographs endured well into the twentieth century. Iles was also known for extensively retouching models directly to emphasize their *moko* and thus to increase the commercial appeal of postcards as tourist souvenirs (Main 1976, 27).

Portraits by Iles of both men and women follow a similar formula, with the model posed directly in front of the camera and usually seen from the waist up. A *korowaii* or *taaniko* type of cloak is draped over the upper body, with one arm or shoulder bare. Written in the negatives across the lower edge of the original albumen photographs are the title, caption, and negative number. Captions were changed or added to situate the women in a seemingly more alluring social context. Common captions include "A Maori Dark-Eyed Maiden" (fig. 86) and "Maori Maiden of High Degree" (fig. 87). Some of his portrait postcards, printed in collotype with undivided backs, were postmarked in 1903. He commissioned different printers and distributors to produce and sell

these cards. One in the collection of the Metropolitan Museum was printed by Valentine and Sons of Dundee, Scotland, and published or distributed by the S. M. and Company (see fig. 87). Valentine, which had been printing picture postcards since the 1890s, translated many of his portraits directly from original photographs.[19] In this instance, the image of a Maori woman was relatively unchanged in the transition from photograph to postcard.

Around 1890 Frank Denton of Wanganui supplied many photographs for Maori clients (King 1984, 2). He also had stock photographs that are quite similar in style to those by Iles. Denton's numerous photographs for the tourist market were turned into postcards via the Wilson Company, such as its F. T. series, which was printed in England (figs. 88 and 89). Although many of Denton's postcard photographs intended for tourists are romantic in pose and theme, others are more straightforward portraits. Maori families even commissioned him to take photographs for ceremonial use (King 1984, 2).

COPYRIGHT. From the painting by C. F. GOLDIE.

A GOOD JOKE
("ALLEE SAME TE PAKEHA")
Te Aho te Rangi Wharepu, a Chief of the
Ngati-Mahuta tribe, Waikato, New Zealand.

FIGURE 85. "A Good Joke ('Alle Same te Pakeha')," New Zealand, after 1905.
Painting of Te Aho te Rangi Wharepu by Charles Frederick Goldie, 1905.

FIGURE 86. "A Maori Dark-Eyed Maiden," New Zealand, ca. 1894. Photographed by Arthur J. Iles, ca. 1894. Printed by Valentine and Sons, Dundee, Scotland. Distributed and published by S. M. and Company.

FIGURE 87. "Maori Maiden of High Degree," New Zealand, ca. 1894. Photographed by Arthur J. Iles, ca. 1894. Printed by Valentine and Sons, Dundee, Scotland. Distributed and published by S. M. and Company.

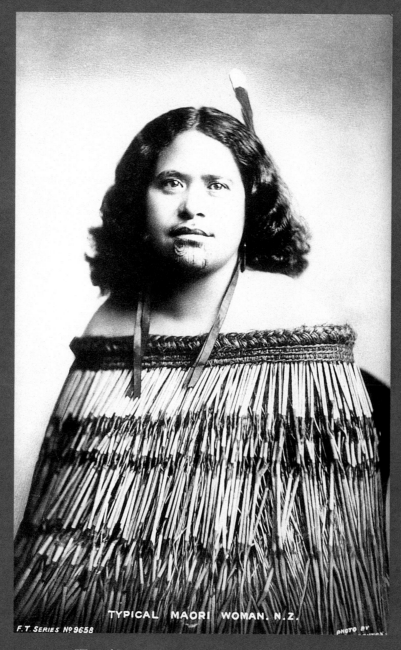

TYPICAL MAORI WOMAN. N.Z.

F.T. SERIES No 9658

PHOTO BY

FIGURE 88. "Typical Maori Woman, N.Z.," New Zealand, ca. 1910.
Photographed by Frank Denton, ca. 1890–1910. Printed and distributed by
Wilson and Company, Auckland, New Zealand.

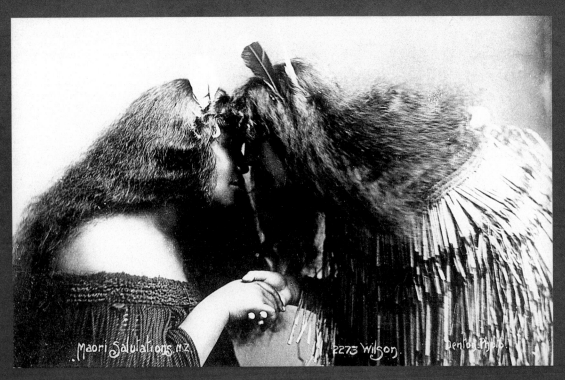

FIGURE 89. "Maori Salutations, NZ," New Zealand, ca. 1910. Photographed by Frank Denton, ca. 1890–1910. Printed and distributed by The Wilson Photo Post Card Company Studios, Auckland, New Zealand.

Certain commercial activities in New Zealand contributed as well to the rise in postcards produced with Maori people as their subject. The natural topographical beauty of the land, especially the thermal region of Whakarewarewa, where Maori communities were located, attracted a large tourist business. The Tourist and Publicity Department, founded in 1901, soon produced "tourist postcards" using posed photographs made in "model" Maori villages.[20] Valentine and Company in Scotland and Frank Duncan in Auckland were leading publishers of these postcards (fig. 90) (Knight 1971, 90).

World's fairs and international expositions also prompted the production of postcards in New Zealand. Postcard kiosks were placed in strategic locations at exposition entrances and throughout the fairgrounds. The firm of Valentine and Sons produced many of the postcards sold at world's fairs.[21] At the New Zealand International Exhibition of Arts and Industries, held in Christchurch from 1 November 1906 through 15 April 1907, postcards of the Maori were extremely popular. A traditional Maori *pa,* or fortified village, was constructed on the fairgrounds (Findling 1990, 196). Replicas of traditional villages from foreign cultures were common attractions at these fairs. A hand-colored collotype postcard with a divided back that was sold and specially postmarked at that exposition is seen in the Metropolitan Museum's collection. It bears a special exposition cancellation that reads "Purchased and Posted at the N.Z. Exhibition, Christchurch, 1906–7."[22] "Greetings from Maoriland" is printed as part of the vertical line that "divides" the back address from the text space (fig. 91).

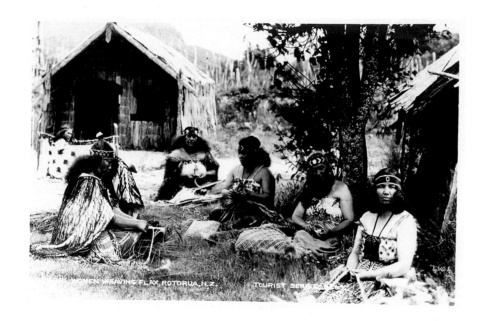

FIGURE 90. "Maori Women Weaving Flax, Rotorua, N.Z.," New Zealand, after 1901. Published by Frank Duncan and Company, Auckland, New Zealand.

FIGURE 91. Verso of a card "Maori Salutation," New Zealand, ca. 1906–7. Distributed by Wilson and Company, New Zealand and Great Britain.

The popularity of portraiture combined with flourishing tourism resulted in the production of a significant number of postcards that used well-known Maori guides as their subject. So numerous are photographs of these guides, and of the women in particular, that these postcards can be used to construct an historical "visual" biography of certain women.[23] A significant number of these portraits were made in Rotorua and include details of Maori architectural carving on a meeting house or gateway entrance. One part of the J. B. series of embossed, color lithographic cards printed in Germany shows "Kathleen 'Maori Guide,' Rotorua" (fig. 92). "Guide Maggie," pictured in front of an elaborately carved Maori doorway (fig. 93), was actually Makereti (1872–1930), who was also known as Maggie Papakura (King 1984, 19). Born in Whakarewarewa, Rotorua, she lived near an area that by the 1890s had become a popular destination for tourists. She was one of several local Maori women who guided visitors

through the area.[24] Postcards with portraits of Makereti were also taken by W. Beattie and Company (fig. 94), Muir and Moodie (fig. 95), and the Iles Brothers (fig. 96).

Collage-type cards that combine photographs of several individuals and scenes offer the epitome of retouching and collective publishing. One card typical of this genre carries the caption "Greetings from Maoriland" and may have been made for the Christchurch exposition (fig. 97). This coated, color lithographic card, printed in Germany from the J. B. series, features twelve photographs arranged inside of a picture frame painted to resemble wood. Shown here are retouched photographs by Daniel L. Mundy (circa 1869), an unidentified photographer, William Beattie (circa 1868), a portrait by Herbert C. Deveril from the mid-1870s, a photo by the Pulman Studio, and one by Samuel Carnell.

A more elaborate collage-type card, probably made in the first decade of the twentieth century, shows how many nine-

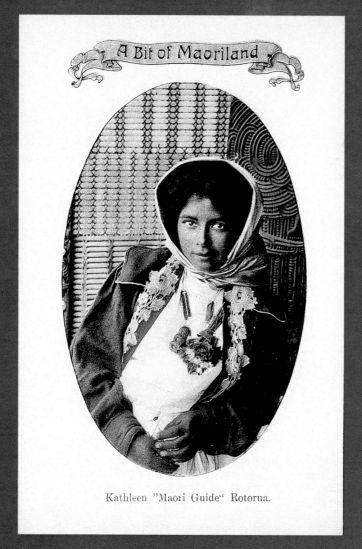

FIGURE 92. "Kathleen 'Maori Guide' Rotorua," New Zealand.
Published by Fergusson and Company, New Zealand.

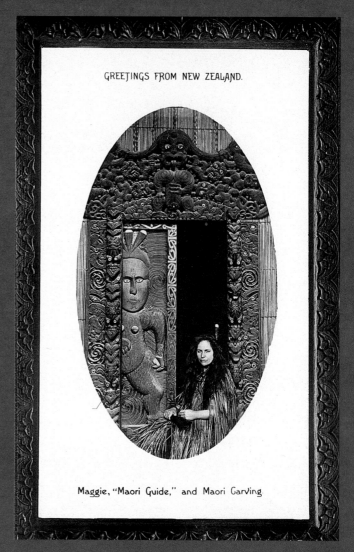

FIGURE 93. "Maggie, 'Maori Guide,' and Maori Carving,"
New Zealand.

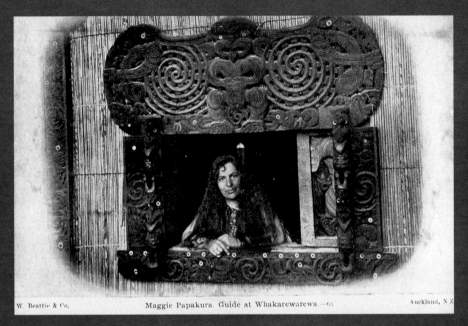

W. Beattie & Co. Maggie Papakura. Guide at Whakarewarewa —61 Auckland, N.Z.

FIGURE 94. "Maggie Papakura, Guide at Whakarewarewa," New Zealand. Photograph likely by J. W. Beattie. Published and distributed by W. Beattie and Company, Auckland, New Zealand.

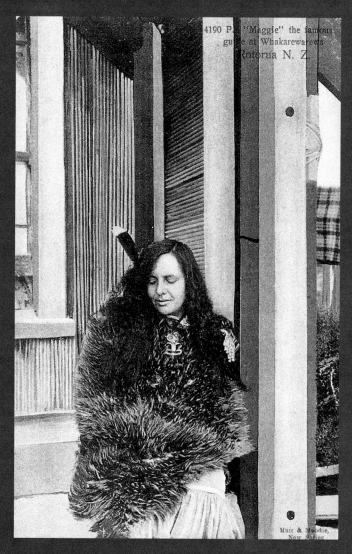

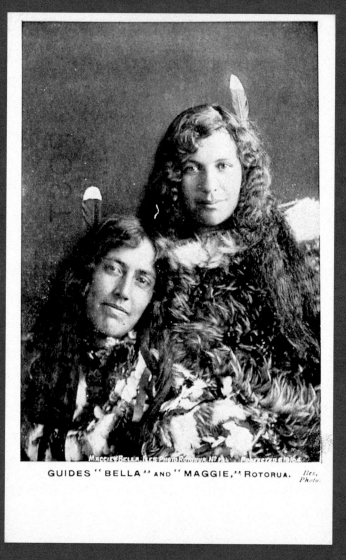

FIGURE 95. "'Maggie the Famous Guide at Whakarewarewa,' Rotorua, N.Z.," New Zealand, ca. 1926. Photographed, published, and distributed by Muir and Moodie, Dunedin, Scotland.

FIGURE 96. "Guides 'Bella' and 'Maggie' [Maggi Papakura and her sister Bella], Rotorua, N.Z.," New Zealand, before 1908.

FIGURE 97. "Greetings from Maoriland," New Zealand. Collage of photographs, ca. 1880–1900. Published and distributed by Fergusson and Company, New Zealand.

teenth-century photographs were appropriated and recolored into postcards (fig. 98). This halftone card produced by James Valentine and Sons was printed in Great Britain. Again, the collage-type format groups together several photographs. The card itself can serve as a reference tool for the work of several photographers working in New Zealand. Two of the seven images were taken by the Valentine family of photographer-printers, most likely by George Valentine (1852–1890). The center vignetted portrait of a "Maori Chief" is also a Valentine photograph. A different postcard was made of this full image showing the sitter in a slightly different pose (fig. 99).

The numerous photographers working in New Zealand in the late nineteenth century generated scores of images for postcards. Some images were used in a dignified manner, while others were absorbed into tourist genres. Further research into the photographers and subjects of these postcards will certainly assist cultural and biographical studies.

THE STUDIOS OF SAMOA

During the nineteenth century the islands of Samoa were home to and visited by several photographers whose work included postcards.[25] Tourism was already flourishing by 1884, when Alfred Burton traveled to Apia and Pago Pago to take photographs for *The Camera in the Coral Islands (Burton Brothers* 1987, 23). In Sydney, Charles Kerry published postcards of Samoa using photographs possibly taken in 1890 by George Bell (Millar 1981, 19, and Nordström 1991, 274). The popularity of these cards as collectibles is indicated on the reverse of "Samoans playing Cards," a postcard by Kerry (fig. 100). There, an unidentified sender in Sydney writes to a correspondent in Paris in 1912, "A fine card for a collection. I have sent you others by letter."

Resident and itinerant photographers did a brisk business selling postcards of their Samoan photographs during the

FIGURE 98. "The Maoris," New Zealand. Collage of photographs, ca. 1880–1900. Published and distributed by James Valentine and Sons, Great Britain.

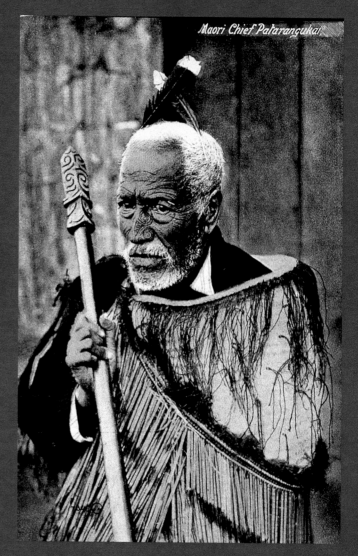

FIGURE 99. "Maori Chief. Patarangukai," New Zealand. Photographed by George Valentine, ca. 1880. Published and distributed by James Valentine and Sons, Great Britain.

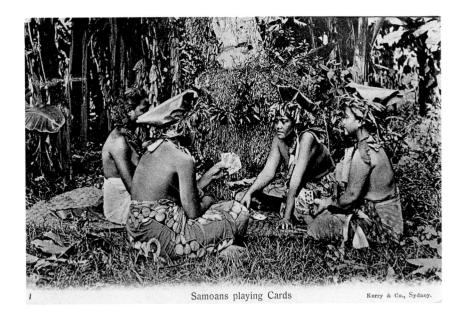

FIGURE 100. "Samoans playing Cards," ca. 1912. Photographed by George Bell, ca. 1890. Published and distributed by Kerry and Company, Sydney.

Samoans playing Cards Kerry & Co., Sydney.

colonial period before World War I and well into the twentieth century. The colonial economy and tourism created a market for postcard images, and shipping routes provided a distribution system for sales and printing.[26] The now-independent nation of Samoa was a German colony during the late 1890s, when the postcard craze extended around the world. Photographers in Apia thus had access to printing firms in Leipzig, Hamburg, and Meissen that used the most sophisticated production techniques of the time. Black-and-white photographs were transformed into high-quality postcards, and captions were added to meet the requirements of consumers. Phrases such as "Grüsse aus Samoa" (fig. 101), "Samoanische Schönheit" (fig. 102), and "Dorfjungfrau, Samoa" typically appear on postcards produced for the German colonial market.[27]

Not surprisingly, landscapes and portraits were popular subjects for Samoan postcards. Such images were well suited to the sophisticated printing techniques available in Germany and the range of inks and even hand-coloring that were used. Trenkler and Company printed extraordinary portraits, with captions translated into English (fig. 103). Such sensitive, dignified, yet thoroughly typical nineteenth-century studio portraits chronicle an indigenous population that was holding firmly to its identity in the face of colonial rule.

Alfred John Tattersall (1861–1951) was probably the most prolific of the photographers then working in Samoa. Born in Auckland, New Zealand, Tattersall moved to the islands in 1886 to work as an assistant to the already established photographer John Davis (Nordström 1995, 124, 127). A prolific portrait photographer, Davis had been living on the island and operating a studio in Apia for quite some time. Tattersall and Davis ran the studio together until the latter's death in 1893.[28] After he acquired Davis's stock of negatives, Tattersall continued to print his images as postcards, which had proved

Grüsse aus Samoa. Samoanische Kuriositäten.

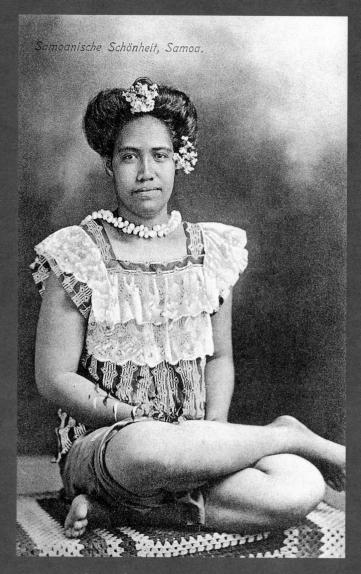

Samoanische Schönheit, Samoa.

FIGURE 101. "Greetings from Samoa," Samoa, ca. 1907. Photograph by A. J. Tattersall, Samoa, ca. 1890s. Printed by Trenkler and Company, Leipzig, Germany.

FIGURE 102. Samoan beauty, Samoa. Photographed by A. J. Tattersall, Samoa, ca. 1890s. Printed by Trenkler and Company, Leipzig, Germany.

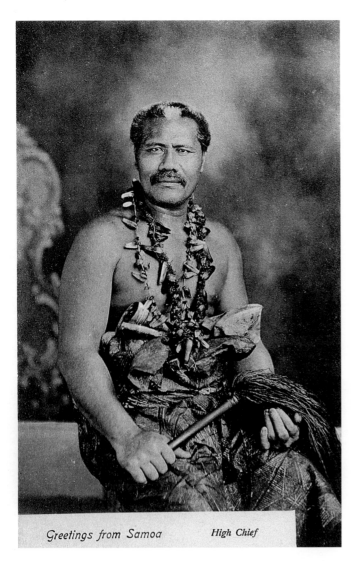

Greetings from Samoa *High Chief*

FIGURE 103. "Greetings From Samoa High Chief," Samoa, ca. 1907. Photographed by A. J. Tattersall, Samoa, ca. 1890s. Printed by Trenkler and Company, Leipzig, Germany.

to be quite popular. A directory in 1907 stated that Tattersall "has a very large collection of postcards, all of the best finish, and showing all forms of life and scenery in the group. These are eagerly sought after by tourists" (Cyclopedia 1983, 104, and Nordström 1995, 21).

This conflation of authorship is evident in the postcards that Tattersall printed years after the photographs were taken by Davis. One such example is seen in a postcard illustrating the construction of a *fale tele* (fig. 104). The caption inscribed in the negative along the lower edge reads, "Building a Samoan House. 44. A. J. T. Photo." The initials point to Tattersall as the photographer. He certainly printed the postcard, as the paper stock used for the card was not available in the nineteenth century. The actual photograph was undoubtedly made by Davis around 1893.[29]

The Western fiction of Samoa and other parts of Polynesia as being "paradise" was perpetuated among European audiences at international expositions. Missionaries helped organize many of these world's fairs, where they displayed objects taken from local populations. Exhibiting these objects as "trophies" along with photographs signified to the Christian world that their missionary work had been successfully completed.

World's fairs and postcards were important sources of mission revenue.[30] Postcards were published and sold to raise funds at several missionary expositions held in Britain, including the Medical Missionary Exposition (Newcastle, 1907), Missionary Exhibition, St. James Hall (Manchester, 1907), the Orient Exhibition of the London Missionary Society (1908), the Great Missionary Exhibition (Bradford, 1908), and the Baptist Missionary Exhibition (Leeds, 1909).[31]

A color halftone card with a divided back, published by the London Missionary Society (LMS) for the Orient Exhi-

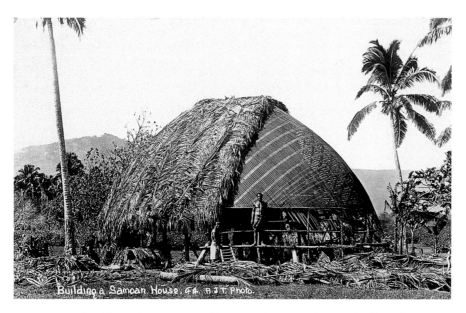

FIGURE 104. "Building a Samoan House," Samoa, after 1890. Photographed by John Davis, ca. 1893–1900. Printed and distributed by A. J. Tattersall, Samoa.

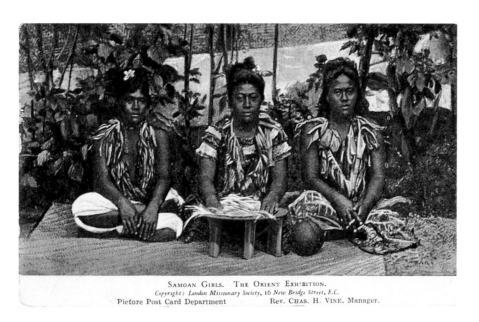

SAMOAN GIRLS. THE ORIENT EXHIBITION.
Copyright: London Missionary Society, 16 New Bridge Street, E.C.
Picture Post Card Department Rev. CHAS. H. VINE, Manager.

FIGURE 105. "Samoan Girls. The Orient Exhibition," 1908. Photographed by John Davis or Kerry and Company, ca. 1890. Published and distributed by the London Missionary Society.

bition, uses a repainted studio photograph (possibly by Davis or Kerry and Company) of three Samoan women seated on a mat with a wooden bowl before them (fig. 105). The systematic way such postcards were organized and distributed is underscored by the caption, "Picture Post Card Department. Rev. Chas. H. Vine, Manager." Selling postcards was obviously big business.

Adding color heightened the appeal of Samoan postcards, which were typically based on black-and-white studio photographs. A color lithographic card printed by Theodor Eismann of Leipzig[32] reflects contemporary printing styles and attests to the worldwide distribution of postcards with Samoan images. This card with a studio portrait of a "Samoan Girl" is postmarked 25 February 1907 from Calcutta and was part of the Th. E. L. series 1009 (fig. 106). To make it marketable in many countries, the word "postcard" was printed in ten languages on the reverse. The unidentified woman is seated in a bentwood chair and wears a combination of local and imported dress. Rather than revealing a painted backdrop, the flat background shows a gradation of colors that starts at the top with a flesh-colored pink tone. Near the middle a grayish blue color gradually increases and becomes

the dominant background color until it meets the pale green "grass" that covers the floor at the bottom. As in other Polynesian cards, this photograph might well have been taken (possibly by Thomas Andrew) in a studio location, with the background later adapted and retouched by another photographer and printer.

MISSIONARY PHOTOGRAPHERS IN THE SOLOMON ISLANDS AND REEF ISLANDS, VANUATU

While postcards of the Solomon Islands and Vanuatu are less well known than those of Australia, New Zealand, or Samoa, their existence nevertheless indicates the pervasiveness of the medium.[33] Drawings and later engravings based on photographs were produced in conjunction with early travel literature. Improved printing techniques led to an increase in images, which made it easier for voyagers, sailors, and other crew members of ships to bring photographs and postcards of the islands with them when they returned to Europe.

Once again, missionaries were among the first Europeans to take photographs of island settlements and prospective converts. Considering the prodigious amount of missionary activity that took place in the Pacific Islands, it is not surprising that postcards with photographs taken by missionaries are today prominent in the corpus of images on the Solomon Islands. One case in point is a postcard with a photograph taken in 1892 by the Reverend H. H. Montgomery, who later became bishop of Tasmania.[34] In a caption along the lower edge appears "Patteson Memorial Cross. Nukapu. Reef Islands" (fig. 107). The card shows a group of unidentified men and women standing in front of a local house. In the foreground a large cross is held erect by a pile of rocks. Several children sit nearby on the ground. The scene is intended as a memorial to Reverend J. C. Patteson, a prominent member of the Melanesian Mission who became bishop. Patteson was a strong influence on the photographer George Brown, who in 1855 was inspired enough to begin his missionary career and eventually become a minister.[35]

This postcard also suggests another attribution, with the words "Beattie, Hobart" identifying the photographer. Beginning around 1879, John Watt Beattie (1859–1930) lived primarily in Hobart, Tasmania, and worked out of several photography studios there.[36] In 1896 he became an official government photographer, which put him in a position to work for the Tasmanian Tourist Association and to collaborate closely with Reverend Montgomery in the Royal Society of Tasmania.[37] Beattie produced many postcards from his own stock of negatives, and he apparently used several negatives that belonged to Reverend Montgomery.[38] In 1906, while traveling with Reverend Montgomery on the mission ship *The Southern Cross,* Beattie took the photographs for which he is now most recognized. Since Reverend Montgomery is known to have used Beattie's camera (Tassell and Wood 1981, 133), caution should be taken when attributing photographs on postcards to Beattie.

The Melanesian Mission published numerous postcards that were probably made by several different photographers and printers. A group of photographic cards published by "The Crown Studios, Sydney" demonstrates how missionary photographers were valuable to the inventory and production of postcards of Pacific people. At the turn of the century Crown Studios operated one of the largest photographic enterprises in the Southern Hemisphere (Davies and Stanbury 1985, 104). Famous for its complete line of photographic services, Crown Studios was especially known for its ability to

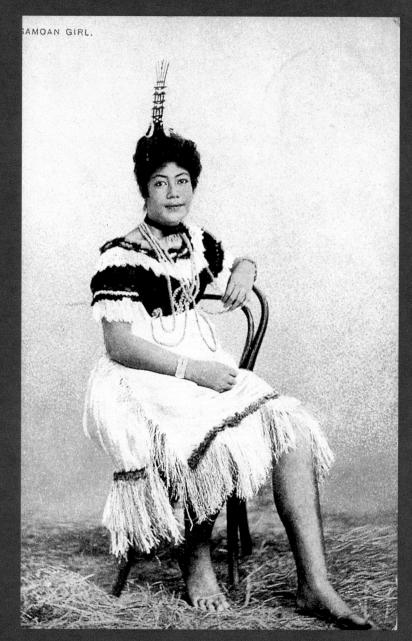

SAMOAN GIRL.

FIGURE 106. "Samoan Girl," Samoa, ca. 1907. Photographed by Thomas
Andrew(?). Printed by Theodor Eismann, Leipzig, Germany.

produce bromide enlargements from any negative. Photographic plates were sent from around the world, enlargements were made, and the finished products were packed and mailed, all by the same firm. The business was not only technically proficient in printing, retouching, and developing, but it was also exceptionally efficient in its packing and postal services.

Businesses such as Crown Studios were particularly useful to missionaries, including Reverend George Brown (1835–1917), whose home mission depot was Sydney. Brown continually sent glass plate negatives and positives from his locations in Melanesia and Polynesia to Crown Studios for printing and enlarging. He requested that the finished prints be forwarded to various colleagues, newspapers, and journals. A significant number of prints made by Crown exist today in pristine condition with their original tissue covers still intact.[39] The fact that Crown Studios had such tremendous access to negatives gave them a distinct advantage in the postcard market. Unlike other postcard producers who had to look for material to publish, photographs came to Crown Studios through the front door and the mail.

A series of postcards depicting the Solomon Islands was produced by Crown Studios and includes images made by Reverend Brown and others. "Discharging Timber for Mission House at Villa [Vella] Larella 16" (fig. 108) documents Brown's establishment of a Wesleyan Methodist station in 1902 with the assistance of a group of craftsmen and fellow missionaries.[40] Lumber is carried onto the shore while a mission ship waits in the distance. Another card in the series shows a "Bow of War Canoe, Rubiana" (fig. 109).[41] An extraordinary carved prow decorated with a human figurehead *(musumusu)* fills the image. Until the late nineteenth century, *musumusu* were frequently hung on the prows of canoes from New Georgia as apotropaic signs while on headhunting

FIGURE 107. "Patteson Memorial Cross. Nukapu. Reef Islands," Melanesia, ca. 1906. Photographed by Rev. H. H. Montgomery. Published by the Melanesian Mission, Westminster, Great Britain.

PATTESON MEMORIAL CROSS, NUKAPU, REEF ISLANDS BEATTIE, HOBART

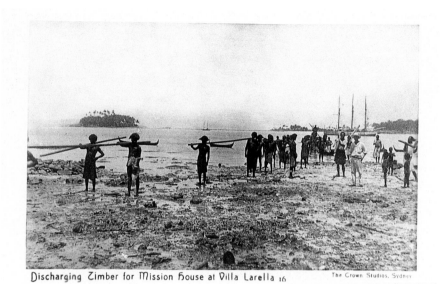

Discharging Timber for Mission House at Villa Larella 16 The Crown Studios, Sydney

FIGURE 108. "Discharging Timber for Mission House at Villa Larella," Melanesia. Photographed by Rev. George Brown(?), ca. 1902. Printed and published by Crown Studios, Sydney, Australia.

raids.[42] Many postcards from the Solomon Islands produced by Crown Studios can today be used to reconstruct mission activity. Others document traditional sculptural and cultural practices and are now valuable resources for studying and reconstructing indigenous cultural forms of expression.

Photographs of the Pacific Islands long endured as postcards and formed some of the first images of the Pacific seen by Westerners. As a medium of communication, these postcards transmitted several different messages that changed from the photographer's original intentions to the preferences of the printer and publisher of the final postcard. The most apparent objectives for such change involved colonial, religious, commercial, and imperialistic needs. Often photographers such as Kerry and Tattersall made photographs that specifically addressed these objectives, while missionary photographers had yet other agendas. In retrospect, their inherent

messages are now easy to identify. In this way, postcards reveal a great deal about European culture, opinions, prejudice, and conventions.

How can postcards be used constructively today to break down conventions established long ago? Like photographs, images on postcards can be deciphered. In the process of analysis, layers of postcard messages can be stripped away and examined separately. Undoubtedly, after identifying the photographers, models, and those local individuals who assisted in the photographic process, the prolific output of these studios will become known. Postcard portraits, for example, should be studied by historians and local communities, so identities can be reconnected to "nameless" faces. Images should be examined by people from many different cultures, and especially by those in communities associated with the original ancestors or locations shown in the photographs. By publishing a sample of the Metropolitan Museum

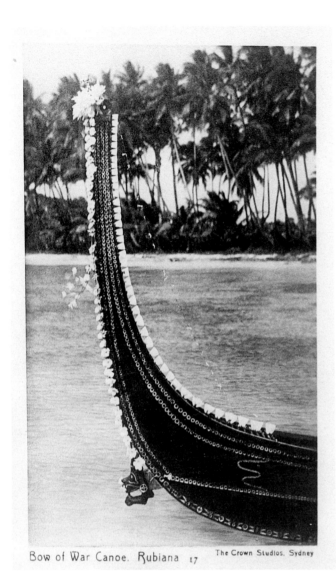

Bow of War Canoe. Rubiana 17 The Crown Studios. Sydney

FIGURE 109. "Bow of War Canoe. Rubiana," Melanesia. Photograph by Rev. George Brown, ca. 1902. Published and printed by Crown Studios, Sydney, Australia.

of Art's collection of postcards from the Pacific Islands, and by focusing on the transformation of older photographic images into mass-produced postcards, it is hoped that this information will become available to a wider audience, and especially those who find their forebears pictured here. It is from them that we need to obtain information and thus expand our knowledge of representations of the Pacific in postcards.

NOTES

1. The collection consists of approximately sixty-four hundred cards. Two-thirds of the collection are images from Africa.

2. The overall collection includes images made in the Andaman Islands, Australia, Bali, Borneo, Caroline Islands, Cook Islands, Fiji, Hawaii, Java, Marianas Islands, Marquesas, Marshall Islands, New Caledonia, New Zealand, Papua New Guinea, the Philippines, Samoa, Tahiti, Tuvalu, and Vanuatu. Images from Australia and New Zealand dominate the Pacific holdings. This may reflect the relative proportion of production of cards in each country.

3. David P. Millar, *Charles Kerry's Federation Australia* (Sydney: David Ell Press, 1981), p. 15.

4. Millar 1981, pp. 26–27. *Tyrrell Collection. Photographic Prints from the Studios of Charles Kerry & Henry King* (Sydney: Australian Consolidated Press, 1985), unpaginated. Notes in this collection cite King as a photographer of Aboriginal communities.

5. Under his company name King also acquired negatives and sold works by other photographers, such as the Reverend William G. Lawes. See Virginia-Lee Webb, "Missionary Photographers in the Pacific Islands: Divine Light," *History of Photography* 21, no. 1 (Spring 1997), pp. 12–22.

6. Glass plate negatives from Kerry and King are now in the Museum of Applied Arts and Sciences, Powerhouse Museum, Sydney. A copy set of prints and captions is housed in the Mitchell Library, published by the Australian Consolidated Press, which owned the negatives between 1980 and 1985. The collection formerly belonged to Tyrrell's Bookstore, Sydney, whose owner purchased the collection in 1929 *(Tyrrell Collection* 1985, unpaginated, and Ann Stephen, "Familiarizing the South Pacific," in *Pirating the Pacific: Images of Trade, Travel, and Tourism* [Sydney: Powerhouse Publishing, 1993], pp. 64–65).

7. Hand-colored collotypes printed by Otto Leder in Meissen, Germany, show how aesthetic choices and color schemes of a particular printer affected the transformation of an image.

8. Michael King, *Maori. A Photographic and Social History* (Auckland: Heinemann Publishers, 1984), pp. 1–36; Michael King, "Maori Images,"

Natural History 94, no. 7 (July 1985), pp. 36-43; *Burton Brothers. Photographers in New Zealand, 1866-1898* (Rotterdam: Museum voor Volkenkunde, 1987), p. 64; and Judith Binney, "Two Maori Portraits: Adoption of the Medium," in Edwards 1992, p. 244.

9. William Main and John B. Turner, *New Zealand Photography From the 1840s to the Present / Nga Whakaahua o Aotearoa Mai i 1840 Ki Naianei* (Auckland and Wellington, New Zealand: PhotoForum, 1993), p. 24.

10. William Main, *Maori in Focus* (Wellington, New Zealand: Millwood Press, 1976), p. 3, and *Burton Brothers* 1987, pp. 62–63.

11. King 1984, p. 2, and Hardwicke Knight, *Photography in New Zealand. A Social and Technical History* (Dunedin, New Zealand: John McIndoe, 1971), p. 89.

12. Hardwicke Knight, *New Zealand Photographers. A Selection* (Dunedin, New Zealand: Allied Press, 1981), unpaginated.

13. Virginia-Lee Webb, "Manipulated Images," in *Prehistories of the Future. The Primitivist Project and the Culture of Modernism,* eds. Elazar Barkan and Ronald Bush (Stanford: Stanford University Press, 1995). Also see Virginia-Lee Webb, "Fact and Fiction: Nineteenth-Century Photographers of the Zulu," *African Arts* 25, no. 1 (January 1992), pp. 50–59, 98–99.

14. The initial attribution of printers was aided by Howard Woody. Unless otherwise stated, attributions for Stengel and Leder were made by him. See Woody's essay in this volume for further discussions of printing styles and related issues.

15. No lifedates have been located for William Partington. He reportedly split from Martin and moved to the Wanganui region. After Martin's death Partington printed a selection of his photographs. See Photographs, *Sotheby's,* New York, sale 5571, 6 May 1987, lot 319.

16. See Howard Woody in this volume for a discussion of the color schemes that can be connected to specific postcard printers.

17. King 1984, 70. Rewi Maniapoto's legendary stance against the British in 1864 also made him a popular model for New Zealand artists. Portraits painted by Gottfried Lindauer and Charles F. Goldie, both of whom often worked from photographs, were reproduced on postcards (see *Face Value. A Study in Maori Portraiture* [Dunedin, New Zealand: Dunedin Public Art Gallery, 1975], unpaginated, and Main 1976, pp. 3, 4, and 113). For example, Lindauer painted Rewi's portrait from photographs by George Pulman (1826–1871), who established a studio in Auckland (Main 1976, 36).

18. This well-known group portrait and its variants are often published to illustrate discussions about the struggle these men led against colonial troops. See King 1984, 70, and *Burton Brothers* 1987, p. 75, fig. 65.

19. C. W. Hill, *Edwardian Entertainments. A Picture Post Card View* (Staffs, England: M. A. B. Publishing, 1978), p. 61.

20. A. H. McLintock, ed., *An Encyclopaedia of New Zealand,* vol. 3 (Wellington, New Zealand: R. E. Owen, Government Printer, 1966), p. 411, and King 1984, p. 16.

21. F. A. Fletcher and A. D. Brooks, *British Exhibitions and Their Postcards, Part 1: 1900–1914* (Holborn, London, England: Fleetway Press, 1978), pp. 36 and 44.

22. Fletcher and Brooks 1978, pp. 55–56, describe the various seals, emblem cachets, or titles that distinguish Valentine world's fair postcards. Special designs were made for postcards and letters sent from world's fairs and expositions. These "exposition cancels" are of great interest to postcard collectors and writers on postal history. For a list of United States cancellations see William J. Bomar, *Postal Markings of United States Expositions* (North Miami, Fla.: David G. Phillips Publishing Company, 1986).

23. For a similar approach, see Joanna Cohan Scherer, "The Public Faces of Sarah Winnemucca," *Cultural Anthropology* 3, no. 2 (May 1988), pp. 178–204.

24. See Ngahuia Te Awekotuku's introduction in Makereti, *The Old-Time Maori* (Auckland, New Zealand: New Women's Press, 1986), p. vi. Biographical details about Makereti are available in the introduction to Makereti 1986.

25. Alison Devine Nordström, "Popular Photography of Samoa: Production, Dissemination, and Use," in Casey Blanton, ed., *Picturing Paradise: Colonial Photography of Samoa, 1875–1925* (Daytona Beach, Fla.: Daytona Community College, 1995), pp. 106–107.

26. See Alison Devine Nordström, "Early Photography in Samoa. Marketing Stereotypes of Paradise," *History of Photography* 15, no. 4 (Winter 1991), pp. 272–86, for biographical details of resident photographers.

27. Cards with the German caption *Gruss aus* or the plural *Grüsse aus* (Greetings from) were seen very early in collotype form and were distributed throughout German-speaking countries and colonies. The caption caught on and was retained well into the twentieth century. The other two captions translate as "Samoan Beauty" and "Young Village Girl."

28. For a view of Davis's studio in Apia see the Mitchell Library Photograph Collection in Sydney (PXA 435, vol. 7, photo F291). A photograph of Tattersall and Davis's studio in Apia is reproduced in *The Cyclopedia of Samoa, Tonga, Tahiti and the Cook Islands* (1907; reprint, Papakura, New Zealand: R. McMillan, 1983), p. 110.

29. Peter Mesenhöller, "Ethnography Considers History: Some Examples from Samoa," in Casey Blanton, ed., *Picturing Paradise: Colonial Photography of Samoa, 1875–1925* (Daytona Beach, Fla.: Daytona Community College, 1995), pp. 44–45.

30. Numerous mission publications chronicled overseas projects. Often these magazines and journals contained solicitations for donations and listed books and souvenir cards that were available for purchase. For example, see the Reverend B. Danks, "Notice to Collectors," *Our Mission Fields* (A Jubilee Pamphlet) (Sydney: Wesleyan Methodist Mission Society, 1902), p. 23.

31. See Fletcher and Brooks 1978, and F. A. Fletcher and A. D. Brooks, *British and Foreign Exhibitions and Their Postcards, Part 2: 1915–1979* (Holborn, London, England: Fleetway Press, 1979) for detailed lists of exhibitions in Britain for which postcards were specially printed and postmarked.

32. Again I am grateful to Howard Woody for this attribution of a printer.

33. Only a few cards in the Metropolitan Museum's collection show Vanuatu. Frederic Angleviel and Max Shekleton are now undertaking an extensive study of postcards of the region. Their research indicates that a large number of cards were produced.

34. The image comes from an album of albumen photographs that was formerly in the collection of Dr. Mitchell and is now in the Mitchell Library (Q988/M). The inscription on the table of contents reads, "To Dr. Mitchell, Views on Melanesia from negatives taken by the Rt. Rev. Dr. Montgomery, Bishop of Tasmania during his visit in 1892." The photograph's index number is 29, and the negative number written in the print is 48.

35. C. Brunsdon Fletcher, "George Brown and the Pacific," *Royal Australian Historical Society Journal and Proceedings* 7, pt. 1 (1921), pp. 1–54.

36. Alan Davies and Peter Stanbury, *The Mechanical Eye in Australia. Photography 1841–1900* (Melbourne, Australia: Oxford University Press, 1985), p. 129.

37. Margaret Tassell and David Wood, *Tasmanian Photographer. From the John Watt Beattie Collection* (Melbourne, Australia: MacMillian Company of Australia, 1981), pp. 7–8.

38. Reverend Montgomery's negatives seem to have been marketed by several commercial photographers. Charles Kerry, for example, published some of Montgomery's Melanesian photographs under his own studio name (Webb 1995, 190).

39. See the George Brown Collection at the Mitchell Library, Sydney (PXB 435), for numerous cabinet-size bromide enlargements made by Crown Studios.

40. For newspaper accounts of Brown's journey to the Solomon Islands, see "Departing Missionaries Founding a New Station," *Sydney Morning Herald,* 3 May 1902, p. 12, and "Scenes in the Solomon Islands," (Sydney) *Town and Country Journal,* 27 September 1902, pp. 31–33.

41. This image may be tentatively attributed to George Brown. A negative has yet to be located that would link it directly to Brown.

42. Deborah Waite, *Art of the Solomon Islands from the Collection of the Barbier-Müller Museum* (Geneva: Musée Barbier-Müller, 1983), p. 116.

Correspondance

Carte Postale.

Adresse

Madame Chappel...
Rue de Chalieu
de
Tirlemont
Belgique

41
779

6 CHRISTRAUD M. GEARY

DIFFERENT VISIONS?

Postcards from Africa by European and African Photographers and Sponsors

The heyday of postcard production and consumption, from circa 1895 to 1920, coincided with momentous events in African history. From 1884–85 onward, after European powers met at the Conference of Berlin and essentially divided up Africa, colonialism shifted into high gear. After colonial explorers and the military surveyed and subjugated vast territories, the systematic economic exploitation of the African continent and its peoples began. Colonial powers also involved themselves in the "civilizing mission" of educating their new African subjects and converting them to the Christian faith.

In the second half of the nineteenth century, physical and cultural anthropology emerged as major academic disciplines that also bolstered expansionist and colonizing efforts. Photography soon became one scientific means to document and survey all aspects of societies that had come under colonial domination. Physical anthropologists, in their efforts to clas-

sify the races of mankind, started to rely on photography and soon established strict guidelines for its application.[1] Ethnographers, particularly those in the German scholarly tradition, created visual inventories of foreign peoples' material culture by taking series of photographs. This pursuit was inspired by the theory that traits of shared material culture could indicate and help to delineate cultural circles or areas (Kulturkreise).

Since the mid-1890s, postcards popularized the colonial endeavor in Africa by depicting the peoples and their indigenous settlements that had come under Western domination as well as the landscapes and geographical features of the colonies. Postcards showed progress and modernity in the African continent by documenting the ever-widening spread of colonial infrastructure, such as the construction of new buildings, roads, bridges, railroads, and industries. They also depict colonial ceremonies, such as the arrival and departure

of colonial governors or important dignitaries from Europe who have been sent to guide or evaluate the progress that had been made (see fig. 125).

In the popular realm, postcards became an ideal vehicle for widely distributing images of the African colonies. Although consensus now exists about the relevance of such postcards in two areas—as historical and ethnographic documents and as visual testimony giving insight into the Western invention of Africa—the *systematic* study of postcard production in and for Africa is only now in its beginning stages. Thus, this brief overview examines some issues that emerge after studying more than seven thousand postcards in the collection of the Eliot Elisofon Photographic Archives at the National Museum of African Art, in addition to postcards in other repositories and in collectors' hands, and those published in several books devoted to postcards from Africa.[2]

POSTCARD PRODUCTION FOR AFRICA

By European standards, postcard production in and for Africa was small and certainly reflected the fewer postcard consumers there. Philippe David estimates that from 1900 to 1960, before the arrival of the first larger postcards in color, total production in and for the African colonial territories, including Madagascar and the independent African countries of Ethiopia and Liberia, fell somewhere between 75,000 to 100,000 different issues.[3] These numbers, beginning in the last decade of the nineteenth century and ending around 1920, are nevertheless impressive. For example, in French Senegal 4,000 to 4,500 different issues were produced between 1901–1902 and 1914–1918 for about fifty-four sponsors;[4] 600 issues between 1894 to circa 1914 in the German colony of Togo for at least nineteen publishers;[5] and approximately 1,500 issues in the years from 1900 to 1920 in the Côte d'Ivoire with at least forty-four sponsors.[6]

Studies such as those conducted by David are unfortunately still lacking for other parts of Africa. Despite this, it is obvious that a strong Belgian postcard industry led to the proliferation of postcards in the former Belgian Congo. One of the most important Belgian postcard producers and printing houses was a company founded in 1898 by Ernest Thill and Nels, two photographers in Brussels.[7] Soon after the company opened, their first postcards with images from the Belgian Congo came on the market, and for decades Thill and Nels maintained a leading position among producers (see figs. 111–13). Among their major clients were Belgian missionary societies that ordered postcards be made from the photographs they submitted. The company still exists today, although it now produces postcards and picture books with local themes for the Belgian market only.

A special case is the postcard industry in South Africa. Extremely prolific postcard producers there created numerous cards that focused on "white" South Africa, its thriving cities with impressive modern buildings, its growing infrastructure, and the country's expansive and beautiful landscapes. According to A. K. W. Atkinson, the earliest South African postcards—Transvaal Republican stationery cards with pictures on the reverse--can be dated to 1896.[8] At the turn of the century, Sallo Epstein and Company in Johannesburg became the largest postcard publisher in southern Africa (fig. 110).[9] Although historical developments in South Africa differed from the rest of the colonized continent, the thematic content of images of indigenous peoples taken by white South African and foreign photographers resembles that of photographers in other colonial territories.

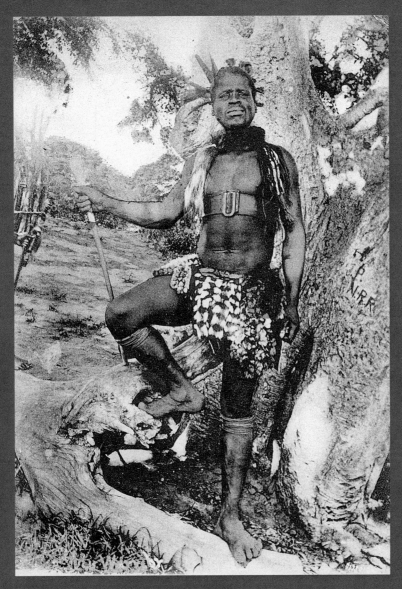

FIGURE 110. "A Zulu Warrior," South Africa, ca. 1900. Published by Sallo Epstein and Company, Durban, South Africa.

WESTERN DISCOURSES ON AFRICA AND AFRICANS

For Western viewers, images and captions on postcards constructed as well as reinforced their knowledge about Africa and its peoples. Postcards helped to perpetuate and encode images of Africa, and they greatly appealed to the Western imagination. Cards produced by major international sponsors, such as François-Edmond Fortier in Dakar (see figs. 116 and 121), and J. Audema in French Central Africa, were often narrowly defined and stereotypical in theme.[10] Admittedly, the commercial success of a postcard depended on its popularity and whether it attracted consumers and collectors or inspired proper sentiments in viewers.

Smaller or local publishers, both Africans and Westerners, sold their products first and foremost to a local clientele. Catering to the immediate interests of their patrons, they often exhibited greater variety in the themes they depicted in their postcards. As Albers and James observed in their study of postcards of Great Basin Indians, local or "private" images directly refer to the world of their purchasers by presenting familiar settings and subjects (Albers and James 1990, 346–48). "Public" images, and by extension postcards produced for an international market, act as metaphors for their consumers, signifying something beyond the actual image to give visual form to Western discourses about Africa.

Postcards, in particular those by international publishers, became integral parts of Western discourses on Africa or, more generally speaking, narratives about the "Dark Continent," which found their expression in textual and visual form in both scholarly and popular arenas. Much like travelers' accounts and similar to commercially distributed photographic albums and other mass-produced images, such as lantern slides and stereographs, postcards belong in the realm of popular representations of Africa. They entered into a complex relationship with images intended for scientific purposes, which were generated by anthropologists and other academics. Scientific and popular forms of representation are commonly perceived as different discursive modes. These modes of expression are not, however, as far apart as might be assumed since they both emanated from and shared common ideological ground.

How then can scientific and popular representations be distinguished from one another? A useful delineation of "popular" might be achieved by designating the intended audience of such representations, as Annie Coombes suggests in her insightful book on the "invention" of Africa (Coombes 1994). She defines popular images as "cultural vehicles, which were accessible to, and consumed by, an educated middle and lower middle-class public with a general interest in the colonies, or with professional stakes in the colonial administration, but who remained outside the academic establishment" (Coombes 1994, 3). Postcards clearly fall into this category.

Postcard representations of Africans, distributed by major international publishers and sponsors from the West, followed parameters that developed over centuries. Indeed, during the past three decades historians, art historians, anthropologists, and literary scholars have examined changing verbal and visual representations of Africa and Africans through the ages. One of these recent publications is Jan Nederveen Pieterse's book *White on Black: Images of Africa and Blacks in Western Popular Culture.* Often conflicting constructions of African peoples encompassed romanticizing views, such as the myth of the "noble savage," which emanated from the age of Enlightenment and Western perceptions of non-Europeans as unspoiled children of nature (Pieterse 1992, 30–34). This trope, although quite resilient,

increasingly gave way to different notions formed during the age of imperialism and the subjugation of the African continent and its peoples.

By the end of the nineteenth century, one of the most salient patterns of Western invention was the characterization of Africans as the antithesis of Westerners. Based on Western conceptualizations of race and character, a system of binary oppositions operated in both textual and pictorial productions.[11] Thus Africans were seen as "primitive," as opposed to "civilized" Westerners. Other juxtapositions expressed in visual form were "naked" versus "clothed" and "light" versus "dark" metaphors, which implied the superiority of the "light" (thus "pure") Westerners over the "dark" (thus "impure") Africans.

In their totality, such oppositions constitute a racist code that underscored many popular Western depictions of Africans. Variations in stereotypes come to the fore depending on regional discourses, the nature of colonial policies, and even idiosyncratic choices of sponsors and photographers. Even so, many postcards of Africans reverberate with stereotypes, especially those cards produced by international publishers.

SOME VISUAL STEREOTYPES

One of the most salient juxtapositions, the "primitive-civilized" dichotomy, becomes particularly apparent in images of missionary work. Most postcards published by missionary societies rely on distinct pictorial strategies or iconographic codes as well as captions to help situate images. An obvious visual characteristic of many mission postcards is the contrast between dark and light, with the missionary father or the nuns, often clad in white, being the white/light (thus "pure") protagonists, and the missionary charges presenting a distinct difference in clothing and race (see fig. 111). Beyond the juxtaposition of skin and clothing color, and by extension race, is the contrast evident in the composition of many images. Frequently the missionary or a missionary sister dominates the Africans from a privileged position by standing in the center of or towering over a group of students, or by being seated, surrounded by missionary pupils. This common iconographic convention reinforces the centrality of the missionary, the hierarchy between the knowing and the unknowing, and thus the ultimate superiority of the whites.

Many mission postcards, and to a lesser degree postcards by other producers and photographers, compare the "uncivilized savage," that is, the "heathen," with the successes of the "civilizing" aspects of missionary work and colonial domination.[12] Those few "before" and "after" photographs that exist weave a narrative parallel to written accounts by showing the same individual "progressing" from the "savage" to the "civilized" state.[13] Numerous other postcards depict one or the other. Civilization among Christianized, baptized Africans is commonly expressed by showing them wearing European-style clothing and holding a cross as a sign of their new faith. Africans were also photographed using examples of new technologies, from sewing machines to bicycles (figs. 111 and 112). Another marker of civilization and conversion was to pose a fully clothed, nuclear family group consisting of a husband, wife, and children (fig. 113) and compare them to the "uncivilized," often seminude, polygamous family against which missionaries strove in their preaching.

As with most postcards, the caption plays a major role in constructing the meaning of a missionary image. By inventing and re-inventing meanings, captions prescribe a way for

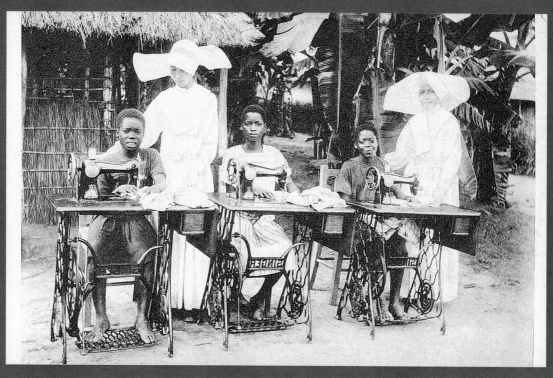

FIGURE III. Sewing lesson, Belgian Congo, ca. 1915. Sponsored by the Mission des Filles de la Charité, Nsona-Mbata, Belgian Congo. Published by Ern. Thill, Brussels, Belgium.

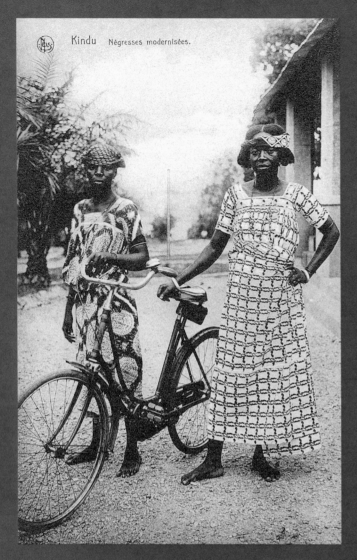

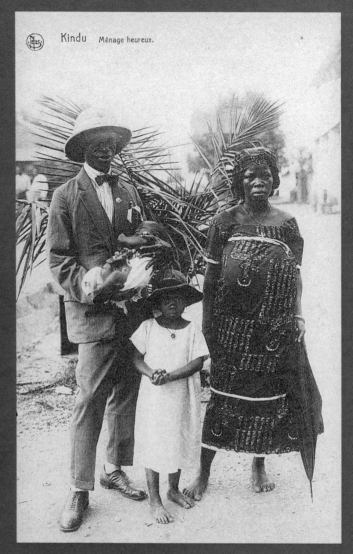

FIGURE 112. Modernized black women, Kindu, Belgian Congo, ca. 1915. Published by Ferraz, Frères. Printed by Nels, Belgium.

FIGURE 113. Happy household, Kindu, Belgian Congo, ca. 1915. Published by Ferraz, Frères. Printed by Nels, Belgium.

the viewer to "read" or interpret an image. In many instances when a postcard caption was changed from an initial caption of an image, the photograph was then shifted into an entirely different realm. An excellent example is a photograph by Anna Wuhrmann, a missionary teacher from 1911 to 1915 with the Basel Mission in the Bamum kingdom, a German possession in what is now the Republic of Cameroon. During her stay in Fumban, the capital of the Bamum kingdom, Wuhrmann created many photographic portraits of the royal family and members of Bamum nobility, a group that the missionaries had especially targeted for conversion. Her unique imagery reveals her personal involvement with her sitters and conveys a certain emotional closeness. In addition, she was an accomplished photographer with an exceptional sense of composition (Geary 1988, 119–29). Among her numerous portraits are two photographs of six-year-old Pö puore, whose Bamum name translates as "they bend down" (fig. 114).[14] In the Basel Mission Archive, the caption of another set of prints indicates that this young girl was the daughter of the king's son-in-law. Wuhrmann placed these intimate portraits with their softly blurred backgrounds in an annotated album that she left at the mission station in Fumban. She donated other copies to the Basel Mission.

When Wuhrmann joined the Missions Evangéliques in Paris and returned to Fumban in 1920, she apparently allowed the French missionary society to use some of her earlier images for postcards.[15] Pö puore now appears on a postcard, having been transformed from an individual to a stereotype. Put differently, she steps out of the "private" realm into the "public" domain (fig. 115). While the actual photograph has not been manipulated or retouched, the caption clearly depersonalizes Pö puore. She becomes "Petite fille de Foumban - Helena," a pretty, young convert (as indicated by her Christian name) from an exotic place in "dark" Africa.

Missionary societies also produced postcards with ethnographic content, obviously with the intent of contributing to the accumulation of knowledge and the encyclopedic survey of the environment and customs of those in Africa. The Italian sisterhood Missioni della Consolata, for example, published lavish sets of postcards that depicted the race, dress and adornment, and daily activities of peoples in East Africa.[16] The White Fathers (Pères Blancs), who operated missions in several African countries and in particular in Rwanda and Burundi, edited sets of ethnographic postcards based on their photographs. These ranged from depictions of the king of Rwanda to members of the Tutsi nobility and the Hutu and Twa populations of Burundi. The French Mission Lyonnais devoted many of its postcards to scenes of African architecture and material culture.

In contrast to the efforts of missionary postcards to provide visual support of narratives about the civilizing effect of colonial-missionary systems on African peoples were postcard images that fed the fantasies of many Western male viewers. Scenes of female nudes or seminudes form a large part of the overall corpus of postcard images from Africa, although they apparently were not uniformly distributed among all African territories.[17] International producers created astonishing series of images of seminude women by posing models in provocative ways (fig. 116). Their inspiration may well have come from postcard depictions in the orientalist tradition of exotic-erotic seminude women in North Africa.[18]

South African postcards serve as an appropriate vehicle for discussing the development and nature of this specific depiction of African women. Certain motifs in the repertoire of South African photographers seem to be among the earliest

CAMEROUN
Petite fille de Foumban - Helena

FIGURE 114. Pö puore (They bend down) Daughter of a Bamum nobleman, Fumban, Cameroon, ca. 1912. Silver gelatin prints. Photographed by Anna Wuhrmann, ca. 1912.

FIGURE 115. Little girl from Fumban - Helena, Fumban, Cameroon, ca. 1920. Photographed by Anna Wuhrmann, ca. 1912. Published by the Missions Evangéliques de Paris, France.

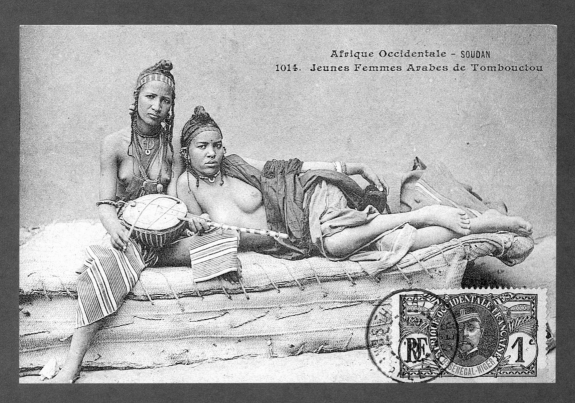

Afrique Occidentale – SOUDAN
1014. Jeunes Femmes Arabes de Tombouctou

FIGURE 116. Young Arab women from Timbuctu, Mali, ca. 1905. Photographed and published by François-Edmond Fortier, Dakar, Senegal.

and most carefully constructed images of this kind found in photography and thus in postcards. Particularly noteworthy are the exotic-erotic representations of Zulu and other indigenous women that have antecedents in earlier renderings of African women. The history of photography in South Africa goes back to the 1840s, when European photographers from France, England, and Scotland established studios in such major urban centers as Cape Town and Durban.[19] In the 1880s and 1890s commercial photographers—including George Taylor Ferneyhough, who since 1876 maintained a studio in Pietermaritzburg and another one in Kimberley; John Wallace Bradley in Durban; and J. E. Middlebrook, who established Premier Studios in the 1870s in the mining town of Kimberley—created photographs showing carefully staged scenes of African life in outside settings. In addition, they produced technically proficient, large-scale albumen prints of Zulu, Xhosa, and Swazi men and women in exotic garb. Many of the women appeared in provocative poses (Webb 1992).

Originally, these enticing photographs were distributed in ornate souvenir albums. One of the earliest such albums was Ferneyhough's *Catalogue of Photographic Views of the Zulu War of 1879,* which contained images from the war front and portraits of several Zulu (Bensusan 1966, 39). Collectors purchased these albums at a time when amateur photography was not yet practiced widely. Many images of Africans were studio portraits staged in front of standardized studio backdrops that had been ordered from Europe. Against such recreations of verdant, lush landscapes and constrained wilderness were placed studio props, such as logs, woven mats, blankets, and animal pelts to suggest the sitters' environment and their closeness to nature and the animal world. This stereotypical association of Africans and "beastliness" long endured in

Western thought and ultimately culminated in likening Africans to animals. Although these perceptions have long been discredited, such racist notions echo in popular representations and myths of today (Pieterse 1992, 30–51).

With the growth of the postcard industry in South Africa, many of these photographs were transformed into richly colored postcards with descriptive captions. One example is an albumen print by John Wallace Bradley taken around 1890 (fig. 117). Its caption in the print reads "R508 A GROUP OF GIRLS - ALL SISTERS." The scene has obviously been staged, as is evident in the pose of the young woman who lounges in front (see Webb 1992, 56–57). Both the image and its caption recur as a postcard published by Hallis and Company in Port Elizabeth, not far from Durban, at the beginning of this century (fig. 118). Coloring and retouching have enhanced the backdrop and the sheets of paper or booklet that the center woman holds. The prim caption masks the image's apparent subtext: the "beastliness" of the women and their sexual availability are clearly expressed in their pose and state of (un)dress.

At the same time, the photographer seems to have played with Western photographic conventions, showing one sitter with sheets of paper or a booklet in her lap. Perhaps this was intended as a visual joke to underscore the sitters' real illiteracy. Upon closer examination, an inscription on the paper reads "Wide World" in yet another attempt at irony. This postcard resembles many other images that show African women alone or in groups. Similar images of African men tend to stress their bellicose characters through dress, adornment, and weaponry. This stereotype had been perpetuated among Westerners since the Zulu War in 1879 (see fig. 110).

In all instances, the justification for these postcards of nude African women, which, if they had been taken of white

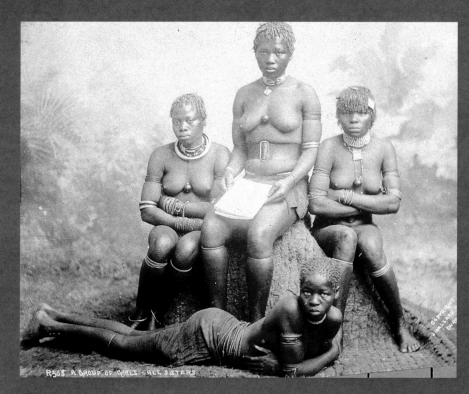

FIGURE 117. "A GROUP OF GIRLS - ALL SISTERS," South Africa, ca. 1890. Albumen print. Photographed by J. Wallace Bradley, Durban, South Africa, ca. 1890.

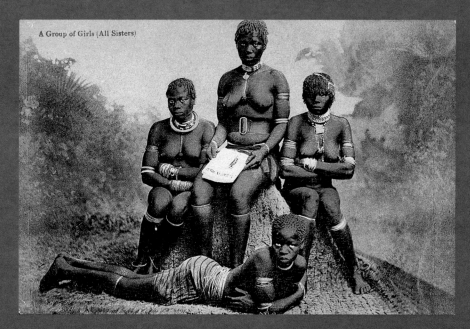

FIGURE 118. "A Group of Girls (All Sisters)," South Africa, ca. 1900. Photographed by J. Wallace Bradley, Durban, South Africa, ca. 1890. Published by Hallis and Company, Port Elizabeth, South Africa, ca. 1900.

European women, would have been considered pornography, is a pretended scientific interest in anthropometry and the classification of races, dress, and adornment. The captions thus become instrumental for inserting images into these categories of pseudo-scientific discourse, and they often repeat the established ethnographic format by referring to "types," "hairdos" and certain forms of dress, or styles of scarification. Although posing nudes often followed the conventions of ethnographic photography, such as the frontal or profile pose or lining up of several subjects, women were frequently made to assume more suggestive poses that have their origin in erotic photography (see fig. 116). Both composition and caption provide what Corbey calls an "alibi for the male, European interest in the body . . . of African women" (Corbey 1988, 87). The depiction of the nude African woman, thinly disguised as scientific undertaking, symbolizes European (male) domination and conquest.

In this context, insights into the ways sitters present themselves or are *allowed* to present the Self in the photographic encounter expands our framework. As Berger, Rouillé and Marbot, Steiger and Taureg, and others have stipulated, in exotic-erotic images the female body is objectified through the male gaze.[20] The body is *shown* to the principal protagonist, that is, the (male) spectator who is absent from view (Berger 1972, 54). By contrast, the body represented as a subject shows *itself* when the sitter presents him or herself to the world (see also Prochaska 1991, 46). This difference is obvious in certain postcard portraits of women and men. When allowed to do so, a female sitter can clearly assume a calm, dignified pose of centrality and project a sense of confidence and wealth through her clothing and posture (fig. 119). This particular image seems to have been the work of an African postcard photographer-sponsor. Indeed, many portraits by

African photographers show sitters in controlled yet proud poses (see figs. 123, 124, 129, and 130).

In the same vein, many photographs of African leaders can be interpreted as careful depictions of how the sitter wanted to be seen. Photographs and by extension postcards of African chiefs in many instances present the sitter as subject. This is especially obvious in photographs of the Bamum king Njoya of Cameroon, which were taken by European photographers between 1902 and 1915 (Geary 1988, 47–61). In fact, depictions of African leaders and their followers or local chiefs interacting with colonial authorities project another common stereotype in postcards. Imagery of chiefs spans the continent, from the Wolof chief in Senegal, to the Zulu chief in South Africa, and the Mangbetu king in the modern Democratic Republic of the Congo (formerly Zaire). Chiefs or kings are on occasion named in postcard captions; mostly they represent an entire ethnic group. Here, the central narrative for Westerners is colonial domination and control over Africans through their leaders. The role played by chiefs and kings either as major allies or as antagonists of the emerging colonial administrations is reflected in the proliferation of this type of imagery. Thus, the stereotype of the loyal chief emerges, expressed visually in his Western attire with colonial medals or in his exotic surroundings with his entourage (see fig. 124). Other leaders, such as King Ovonranmven (Overani) of Benin, who ruled from 1889 to 1897, "made" it onto postcards because of their opposition to colonial rule or their reputation as "blood-thirsty despots" (fig. 120). Not surprisingly, underneath this imagery lingers the noble-ignoble savage dichotomy, the noble African leader versus the brutish despot. Upon closer examination, however, many images of leaders clearly indicate that the sitter willingly presented himself to the camera (see fig. 124).

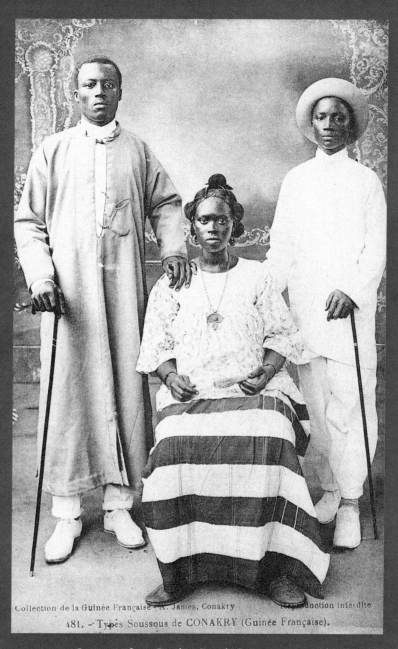

Collection de la Guinée Française - A. James, Conakry Reproduction interdite

481. – Types Soussous de CONAKRY (Guinée Française).

FIGURE 119. Susu types from Conakry, French Guinea, ca. 1900. Photographed and published by Collection de la Guinée Française, A. James, Conakry.

Carefully planned seating arrangements to underscore group hierarchy, and the leader's serene and solemn pose clearly distinguish these images from other genres.

A FRENCH POSTCARD PUBLISHER IN SENEGAL

However important this line of inquiry may be, this brief analysis of recurring stereotypes in postcard imagery will remain a rather impressionistic undertaking if it is not combined with a thorough study of the work of selected photographers-producers. By assessing regional variations and differences in colonial systems, and by placing works within contemporary contexts, it is possible to identify influences on the production of postcards in Africa. Indeed, examining respective works by these photographers-producers—and taking into consideration the complexities of the postcard industry—may be the only way to gain a better understanding of the dynamics of these popular constructions of African peoples. Most of these figures associated with African postcards, however, remain elusive. Little is known of their origins, lives, and careers in this particular line of business.

One exception is François-Edmond Fortier (1862–1928), a postcard photographer and distributor based in Dakar (Senegal). Several scholars, foremost among them Philippe David, have documented and analyzed his oeuvre (David 1978 and Prochaska 1991).[21] David's edited inventory of Fortier's postcards provides an excellent case study of the thematic scope and dynamics of postcard production in Africa (David 1986–88). Fortier was born in the small town of Celles s/ Plaine in the Vosges mountains of France. Although it is not known when he moved to Senegal, he was definitely in Saint-Louis by 1899. One of his postcards shows the rebel

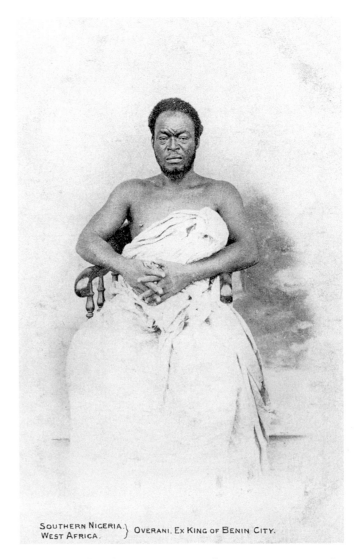

FIGURE 120. "Southern Nigeria, West Africa. Overani. Ex King of Benin City," Nigeria, ca. 1897.

Samory Touré, whom the French had captured in the Côte d'Ivoire in 1898 and then transported to Saint-Louis (the capital of French West Africa until 1905) before they exiled him to Gabon. For reasons that remain uncertain, Fortier ceased to practice photography in Saint-Louis after 1905.

According to David, Fortier later owned a store in Dakar, which remained in operation into the 1920s. There he sold stationery, books, perfume, ostrich and heron feather pens, native curios, and of course, postcards. Although he also established business branches in Sierra Leone, Lagos, and Paris, all of his postcards are marked "Fortier, Dakar." Fortier, who photographed all of his postcard images himself, undertook several trips in French West Africa, including one to Guinea in 1902/1903, and his most famous excursion to what is now Mali in 1905/1906. He visited Kankan, Bamako, Tombouctou, and Kayes. In January and February of 1908 he traveled to Guinea with Gouverneur General Merleau-Ponty and documented the visit in seventy-three postcards. That April and May he served as official photographer to Milliès-Lacroix, the French minister of the colonies, and accompanied him along the West African coast to Guinea, Côte d'Ivoire, and Dahomey, now the Republic of Benin (Prochaska 1991, 47). More than 160 postcards document this voyage, the last major trip that Fortier took.

After ten years of original camera work, Fortier apparently gave up photography around 1910. All of the postcards that appeared after that date are re-issues of older images (David 1986, 3–4). He relied on a stock of at least 4,000 images for distribution, and he conceivably took numerous other photographs that were never made into postcards. Unfortunately, none of his negatives has survived, because his two daughters were unable to maintain his business after Fortier's death in 1928. David estimates that Fortier issued around 8,200 different postcards during his lifetime, a rather large output in comparison to other postcard producers in the region.

The themes of Fortier's postcards reflect his own preoccupations and interests as well as those of his contemporaries in the colonial territory. His main patrons were French colonials, traders, administrators, and numerous other Europeans who lived in or traveled through Senegal. According to David Prochaska, 1,268 Europeans and 17,179 Africans resided in Dakar in 1904. In that same year the census calculated that 1,077 Europeans and 22,993 Africans lived in Saint-Louis (Prochaska 1991, 45). Being located in Dakar, a major port with scores of travelers coming through each year, no doubt made the postcard business more lucrative. Many cards documented the growth of Dakar and other cities with a sizeable white population. Many captions specified these views by providing street names and indicating particular colonial buildings. Depictions of African settlements, by contrast, often communicated very general information, such as indicating an "African village" or designating an ethnic group. They are metaphors, a *pars pro toto* substitution, for the entirety of ethnic groups and their settlements. In addition to such views, Fortier's cards illustrated the world of work and social life (mainly of the colonials, but in some instances also of Africans in their indigenous settings), and commemorated political and historical events, such as two visits by high-ranking government officials (Prochaska 1991, 44–45).

Other Fortier postcards that depict inhabitants of Senegal and French West Africa contain hints of racial imagery, yet they also crosscut themes. A beautifully colored studio portrait of a Senegalese trader not only documents the sitter's type and race, but it also alludes to his lucrative occupation (fig. 121). The image's vertical composition is reminiscent of fine portraits of Europeans, while the sitter's patterned dress and surroundings recall depictions of the exotic Orient. Looking straight into the camera and elegantly placing his

hand on a table, the subject clearly knew that he was being photographed, and he willingly participated in the elaborate construction of the image. One reason for Fortier's commercial success may be found in the resemblance of his imagery to popular postcards from North Africa, which were in turn inspired by orientalist imagery.

Like many of his colleagues, Fortier advertised his expertise in depicting "native types,"[22] and he frequently photographed nude and seminude girls and women in erotic poses. These postcards resemble similar depictions of North African women, most obviously among them Fortier's own cards of Moorish or Arab women (see fig. 116), whose light skin appealed to the European male imagination (see also Alloula 1986). In more than three hundred cards entitled "études," Fortier used models and, as Prochaska points out, took great liberty with captions, as did his counterparts in northern and southern Africa (Prochaska 1991, 44). Thus the same model may appear as Lébou (an ethnic group living near Dakar) in one postcard or as Wolof in another. As such liberties with captions indicate, the *raison d'être* for these cards was not to create an accurate, systematic overview of races but rather to form a body of commercial work that would satisfy the desires of Western voyeurs.

AFRICAN POSTCARD PHOTOGRAPHERS AND SPONSORS

While postcard production catered almost exclusively to Western clients and their tastes, not all postcard photographers and sponsors were Europeans. Along the West African coast early indigenous photographers ventured into the postcard business at the turn of the nineteenth century. Given the area's open, cosmopolitan atmosphere and its long exposure to Europe, particularly through centuries of trade with Portugal and The Netherlands, it is not surprising that indigenous postcard production emerged here.

This situation provides us with the opportunity to explore whether marked differences exist between aesthetics and themes, and by extension stereotypes, of Western and African postcard producers. In essence, did African photographers exercise a different vision? Also, how did the photographer and his subject interact? Holding with the observation of the sitter being either an object or a subject of the camera, were sitters better able and permitted to express Self in these postcards? We must keep in mind that many of the images were initially taken as portraits and were quite likely intended for a purpose other than postcard production. These fundamental questions still require indepth research, but some preliminary insights might guide further investigation.

Compared to the thousands of Europeans in the postcard industry, the number of African postcard producers and photographers was quite small. This amount includes Creoles from Sierra Leone,[23] who had taken up the lucrative business of photography and catered to both an African and a Western clientele. Typically, Creoles readily embraced European innovations, photography among them. Vera Viditz-Ward, who has researched Sierra Leonian photographers, notes that as early as 1857 a daguerrotypist by the name of A. Washington placed a newspaper ad to announce his arrival in Freetown. This may have been the African-American Augustus Washington (b. 1820/21), who had worked in the United States and Liberia before moving to Freetown in 1854.[24]

Few of the Creole photographers and postcard producers in Sierra Leone or their counterparts in other regions of West Africa have been documented—a task that still awaits researchers. The coastal area was home to numerous African photographers, many of whom were itinerants. Their studio

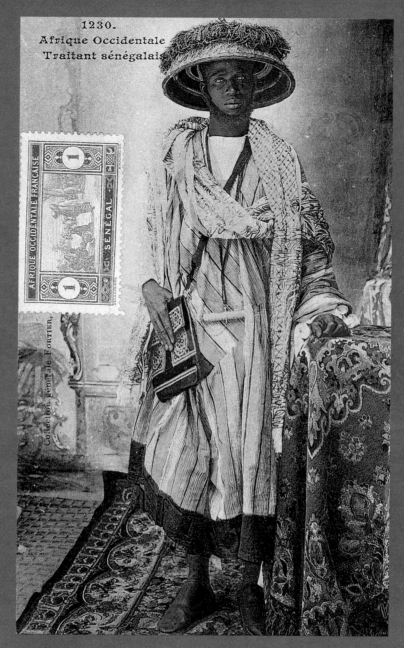

FIGURE 121. Senegalese trader in West Africa, ca. 1905. Photographed and published by François-Edmond Fortier, Dakar.

setups tended to be quite simple. A plain or painted backdrop mounted on a wall instantly transported the subject into the affluent ambiance of a European parlor or classical landscape. On occasion this simple arrangement is visible in photographs and even postcards (see fig. 128).

In many instances, the names of African postcard photographers and/or sponsors are known only from postcard imprints. Names such as Alphonse Owondo in Guinea, G. Kanté in the Côte d'Ivoire (see David 1982, 33), and Antoine Kiki, who was based in Porto Novo (now in the Republic of Bénin), indicate that the photographers were Africans. Other African photographers, however, had English, Dutch, or Portuguese names, which makes it difficult to identify them. Businesses called "Comptoir Parisien à Conakry, édit." (Guinea) or "The Jumbo Studio, Freetown" (Sierra Leone) may well have been owned by Africans. The Comptoir Parisien certainly employed African photographers. One of its cards, for instance, bears the caption "Féticheurs et danseurs de Farannah. Fetichers and dancers at Farannah." The dual use of French and English captions suggests the card was distributed in francophone and anglophone areas of West Africa. Interestingly, the identical image appears on another postcard that bears the imprint "Alphonse Owondo, opérateur" (fig. 122). This card, with the year 1903 written on its front, displays a different caption, which places the photograph in a particular context. Its caption "CONAKRY - concours agricole - Groupes de Féticheurs et danseurs

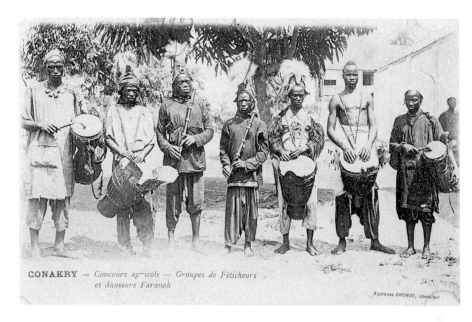

FIGURE 122. Conakry - Agricultural exhibition - groups of Faranah fetish priests and dancers, French Guinea, ca. 1910. Photographed by Alphonse Owondo, Guinea.

Faranah" [Conakry - agricultural exhibition - groups of Faranah fetish priests and dancers] indicates that the image was taken by Owondo at an agricultural fair in Conakry. As was customary in postcard production, the card was thus edited and re-edited with different captions and imprints.

Alex Agbaglo Accolatse (Togo)

Among the better-known African postcard photographers and producers was Alex Agbaglo Accolatse (David 1986–87, 16, 20–21). Born around 1880 to the ruling family of Keta in what was then the Gold Coast, Accolatse moved to Lomé, the capital of German Togoland, around 1900. According to David, he was one of the first professional African photographers during the German colonial period, sharing this distinction with F. F. Olympio and the Aguiar brothers. Acco-

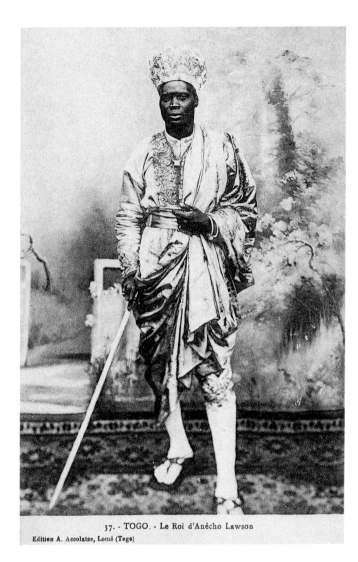

37. - TOGO. - Le Roi d'Anécho Lawson

Edition A. Accolatse, Lomé (Togo)

FIGURE 123. Lawson, the king of Anecho, Togo, ca. 1905. Photographed by A. Accolatse, Togo.

latse at times acted as official photographer for the Germans, in particular German missionaries of the Norddeutsche Missionsgesellschaft based in Bremen.[25] After World War I and during the 1920s, he maintained an active studio and frequently traveled the coast from Lagos to Accra. Appropriately for his multilingual clientele, Accolatse produced postcards with French and English captions. David, whose groundbreaking research in Togo introduced Accolatse to Western scholars, discovered that the photographer was a gentleman, a Freemason, and an eminent member of the Eglise Evangelique in Togo. He retired from photography in the late 1950s and died in Lomé in March 1971 at more than ninety years of age.

In the kingdom of Anecho near the town of Lomé, Accolatse photographed King Lawson, who, in his splendid dress, poses in front of a classical garden backdrop (fig. 123). Interestingly, Lawson was not the king of Anécho, as stated in the postcard caption, but he did hail from an important lineage that rivaled the chiefs. His garments of hybrid European and African styles richly decorated with embroidery indicate his aspirations for power and recognition, as does the very act of having his photograph taken. Here, Lawson confidently displays his Self to the public.[26]

W. S. Johnston (Ghana and Sierra Leone)

It is not known whether W. S. Johnston, another African photographer who produced postcards, was from Ghana or Liberia. Viditz-Ward suggests he was a Creole from Sierra Leone.[27] Like many of his colleagues, Johnston traveled to the major cities of the West African coast that were under British colonial rule, stopping in places such as Bathurst in the Gambia, Lagos in Nigeria, and Accra in Ghana, where he usually spent several weeks. In anticipation of upcoming vis-

its, he advertised his services in local newspapers. One such advertisement appeared on the front page of the *Sierra Leone Times* on 6 May 1893 (Viditz-Ward 1987, 514).

> W. S. Johnston, photographer begs to inform the public that he is prepared during his visiting tour to Sierra Leone, which will only extend to a few weeks, to receive sitters at his residence in Howe Street and to solicit their kind patronage. Specimens can be seen during business hours: 7 to 11 a.m. and 1 to 5 p.m. Pictures of all sizes are taken. Negatives kept. Copies may be had always. Landscapes, views of the Gold Coast, Lagos, Sierra Leone and Native Types are always on hand. Charges moderate.

Apparently, Johnston decided to settle permanently in Freetown, where he operated a successful studio that was later taken over by his sons (Viditz-Ward 1987, 514). Views from throughout West Africa and portraits of so-called native types became the hallmark of Johnston's postcards. Among other photographs, he took images in Elmina, an ancient town on the Ghanaian coast. There he also photographed the Elmina regent Kweku Ando with two attendants seated next to a British gentleman in uniform (fig. 124). From 1884 to 1898, Kweku Ando acted as one of the regents, after the British deported the legitimate Elmina chief Kobena Igyan to Sierra Leone in 1873.[28] Judging by the regent's serene pose and spread legs, a posture that behooves rulers, he senses the importance of this occasion and presents his Self in the manner in which he wants to be seen. Also of interest is the fact that this card was mailed from Sierra Leone and arrived in Brussels on 30 November 1906, although Johnston took the picture at least eight years earlier. One of his color postcards shows a "Fantee woman" from the Gold Coast.[29] Also mailed in Sierra Leone but by a different sender, this card arrived in Brussels on 30 June 1907.

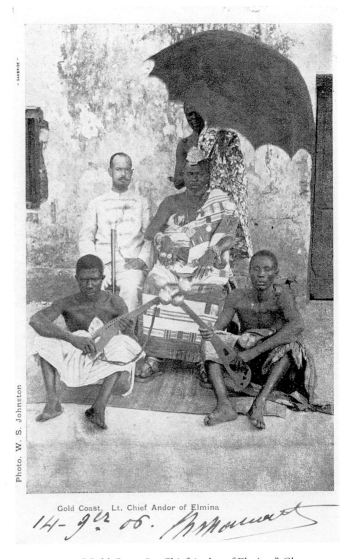

Photo. W. S. Johnston

Gold Coast, Lt. Chief Andor of Elmina

FIGURE 124. "Gold Coast. Lt. Chief Andor of Elmina," Ghana, ca. 1905. Photograph by W. S. Johnston, Sierra Leone, ca. 1897. Published by Sanbride.

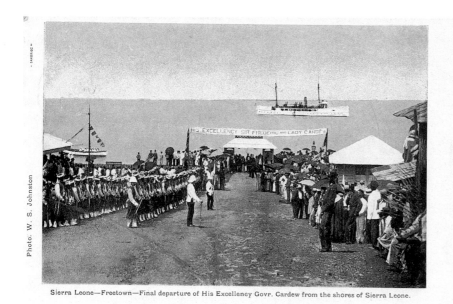

Photo. W. S. Johnston

Sierra Leone—Freetown—Final departure of His Excellency Govr. Cardew from the shores of Sierra Leone.

FIGURE 125. "Sierra Leone—Freetown—Final departure of His Excellency Govr. Cardew from the shores of Sierra Leone," ca. 1905. Photographed by W. S. Johnston, Sierra Leone, 1900. Published by Sanbride.

Like many of his contemporaries with a modicum of success, Johnston also produced photographs and postcards documenting colonial events, such as the visit of the Duke and Duchess of Connaught to Sierra Leone in 1910 or a view of the "Final departure of His Excellency Govr. Cardew from the shores of Sierra Leone," a colored card that is postmarked "Lagos 08" (fig. 125). The photograph, however, was taken in 1900, when Colonel Sir Frederick Cardew K.C.M.G. left Sierra Leone after a six-year appointment as governor.[30] Historical information from written sources establishes the year when the photograph was actually taken, whereas the postmark attests to the longevity and wide geographical distribution of Johnston's postcards.

Judging by these photographs, Johnston's work was artistically composed and technically excellent. The color postcard of Cardew's departure, for example, indicates his strong sense of symmetry and balance, as in the way he depicted the troops, and it contains a certain narrative quality, with the

ship visible at a distance. Its viewpoint also verifies Johnston's privileged position as an official photographer of the event. Judging by the senders and the points of origin of his postcards, Johnston must have had a fine assortment of images ready for travelers passing through Freetown. His cards appealed to British resident colonials and well-to-do local Creole families who prided themselves on their sophistication, advanced tastes, and wealth.

Alphonso and Arthur Lisk-Carew (Sierra Leone)

Among the most prolific Creole photographers and postcard producers in Sierra Leone were Alphonso and Arthur Lisk-Carew, brothers who operated a studio and business establishment in Freetown. Alphonso, the older brother (1888–1969), opened the studio in 1905. In 1918, his younger brother Arthur joined him in the business, which eventually grew to include the sale of photographic materials, stationery, postcards, so-called fancy goods, and toys. Known among locals as

a respected citizen with a penchant for innovations, Alphonso Lisk-Carew imported the first motorized bicycles to Freetown and later ran a movie house (Viditz-Ward 1985, 48). The brothers' clients included British colonials and those affluent Creoles who cherished photography as a means to present Self. According to the *Red Book of West Africa,* a description of commercial and industrial facts, figures, and resources first published in 1920, the Lisk-Carew brothers were exceptional photographers.[31]

> Photography in its highest phases emerges from the plane of mechanical operation into the realm of art far beyond the commonplace of ordinary achievement, and it is the aim of Mssrs. Lisk-Carew Bros. to exemplify in their portraiture all those pleasing details which, whilst apparently casual, are the outcome of long experience and close study of the best means and methods for securing superlative results. They are adepts in the judgment of light and shade, and in determining the psychological moment when to snap the shutter of the camera so as to secure the most pleasing expression of the sitter (Macmillan 1968, 267).

Their studio and store attracted tourists mainly because of the sale of postcards and souvenir photographs. The *Red Book* raves:

> There is probably no establishment in Freetown that is visited by more passengers from steamers than that of Messrs. Lisk-Carew Bros. The reason of [*sic*] its popularity is because of its extensive stock of postcard views of Freetown and Sierra Leone, as well as because of its large assortment of fancy goods, stationery, and photographic requisites (Macmillan 1968, 267).

Judging by the number of postcards preserved in collections and offered by postcard dealers today, the Lisk-Carew brothers operated a longlasting, international trade rather than a local postcard business. Their cards were sold up and down the west coast of Africa well into the 1950s.

For this brief study, a sample of 125 Lisk-Carew cards, no doubt only a small portion of their entire output, was analyzed.[32] The sample contained ninety-eight postcards with different themes and twenty-seven re-issues. Assigning dates to postcard images proved difficult. Since Alphonso Lisk-Carew entered professional photography in 1905, no image was taken before that year. Another assistance is the credit line used by the Lisk-Carew Brothers, which ranges from "A. Lisk-Carew, Photo, Freetown, Sierra Leone" to "L. C. Brothers." Since Alphonso's considerable photographic skills were known to British colonials in the area, he was at times selected photographer for the British colonial administration. He was chosen, for example, to take the official photograph to document the state visit of the Duke and Duchess of Connaught to Freetown in December 1910. According to Viditz-Ward, these photographs were well received, and the British honored the brothers by presenting them with the royal coat of arms when they were appointed photographers to the Duke of Connaught. Soon thereafter they received permission to use the line "Patronized by H.R.H. The Duke of Connaught" on all their photographs and postcards (Macmillan 1968, 267). Postcards printed after 1910 carry this line, but that of course does not indicate when the images on the cards were actually taken.

One of their most popular series of images featured photographs of the Bundu (also called the Sande) society, which the Lisk-Carew brothers photographed on several trips into the African hinterland (Viditz-Ward 1985, 48). An extremely popular photograph from the series is entitled "Natives Dressed for the Dance of the Bundoo Devils," which pictures women surrounding two female masqueraders with Sowo masks of

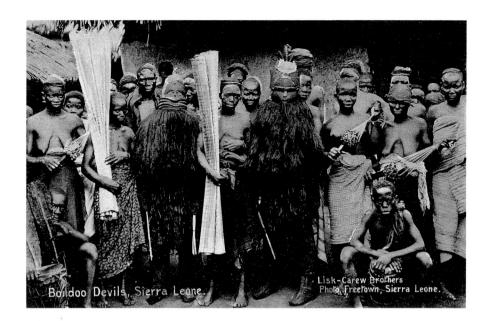

Bondoo Devils, Sierra Leone.

Lisk-Carew Brothers
Photo, Freetown, Sierra Leone.

FIGURE 126. "Bondoo Devils, Sierra Leone," ca. 1915. Photographed and published by Lisk-Carew Brothers, Freetown, Sierra Leone, ca. 1910.

the women's Sande society.[33] The postcard version of this photograph, which bears the caption "Bondoo Devils, Sierra Leone," was re-issued repeatedly with divided and undivided verso.[34] For the colored version (fig. 126), the British printer, who apparently was not familiar with the monochrome helmet masks made from dark wood, took great liberties and imaginatively added vivid colors. One mask is colored green and pink, while the other displays an elaborate headdress in yellow, green, and pink, a typical Victorian color scheme devised to please foreign patrons.

Colonials and Western visitors were intrigued with the Sande society, which they encountered among the Mende and many other peoples in Sierra Leone, Liberia, and Guinea.[35] In fact, images of the Sande society occur on several Lisk-Carew postcards, such as those of young female initiates, entitled Bundo or Bondu girls (fig. 127). This photograph demonstrates why postcards with Lisk-Carew images enjoyed such popularity. In it, four young women pose before a classical backdrop, much as if they were in a Victorian

photography studio. Two of them are seated, elegantly holding their hands in their laps. The other two stand, with one spreading her arms and the other resting her hand on the shoulder of a seated girl. Both their dress and their coiffures are elaborate and exotic.

This photograph's extraordinary, European-style composition becomes even more evident when it is compared to a similar image by another African photographer that was published by Comptoir Parisien in Conakry, Guinea (fig. 128). Here, similarly dressed women, who are described as "young circumcised girls after the operation," are lined up in front of a rather dilapidated paper backdrop, the edges of which are fully visible in the picture. They stare straight into the camera lens. From a Western perspective, this image lacks the aesthetic appeal of the Lisk-Carew photograph. This comparison underscores the technical and aesthetic accomplishments of the Lisk-Carew brothers and explains why their photographs and postcards generated such international demand.

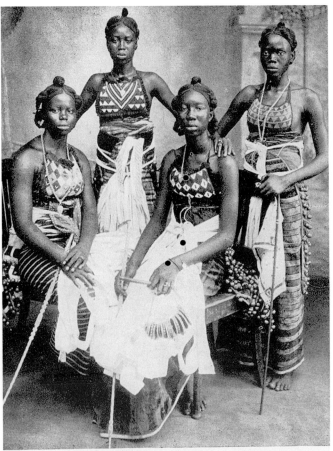

Lisk-Carew Brothers, Photo., Freetown, Sierra Leone. Registered.

BONDU GIRLS, SIERRA LEONE.

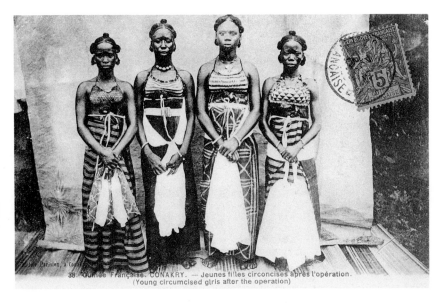

38. Guinée Française. CONAKRY. — Jeunes filles circoncises après l'opération.
(Young circumcised girls after the operation)

FIGURE 128. Young girls after circumcision, Conakry, French Guinea, ca. 1905. Published by Comptoir Parisien, Conakry, Guinea.

FIGURE 127. "Bondu Girls, Sierra Leone," ca. 1910. Photographed and published by Lisk-Carew Brothers, Freetown, Sierra Leone, ca. 1910.

N. Walwin Holm and J. A. C. Holm, a.k.a. Photoholm
 (Nigeria and Ghana)

N. Walwin Holm and J. A. C. Holm were a father-son team who produced photographs and later postcards.[36] The father, N. Walwin, was born in 1865 and started his photography business in Accra, Ghana, around 1882. He moved to Lagos in 1896 and opened a studio there, "where his clever photographic work enhanced his reputation as an expert in all branches of the art" (Macmillan 1968, 132). In 1897, the year the British destroyed the Benin Kingdom in Nigeria, Walwin became a member of the British Royal Photographic Society, but he left his business in 1910 to study law in England. Seven years later he returned to Lagos as a barrister. His son J. A. C. Holm, who was born in 1888 in Accra, was educated at the Church Missionary Society Grammar School and the Roman Catholic school in Lagos. He joined the family photography business around 1906 and ran it during his father's absence. In 1919 J. A. C. Holm reestablished the Accra studio, where he became an "exponent of photography in all its branches" (Macmillan 1968, 210). N. Walwin Holm initially produced splendid albumen prints for souvenir albums.[37] At the beginning of the twentieth century, father and son turned their attention to reproducing some of their finest images in postcards.[38]

Nineteen "Photoholm" postcards, two of which show the same image, are in the Eliot Elisofon Photographic Archives Collection. Most of these images are devoted to views of colonial Lagos, such as the marina, government house, law court, and railway station in Wasimi. Subjects depicted in cards range from laborers at the Lagos canal works to parishioners leaving a Catholic church service and the St. Jude's Choir in Enute Metta in Lagos, with African choirboys holding hymnals. The Holms also took numerous portraits of clients, which occasionally were made into postcards and

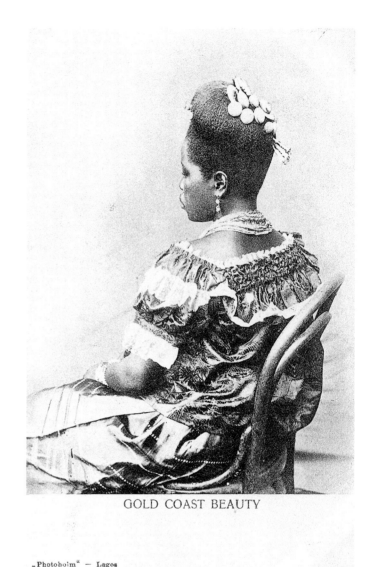

GOLD COAST BEAUTY

„Photoholm" — Lagos

FIGURE 129. "Gold Coast Beauty," Ghana, ca. 1900. Photographed by N. Walwin or J. A. C. Holm, Lagos, Nigeria, and Accra, Ghana. Printed in Germany.

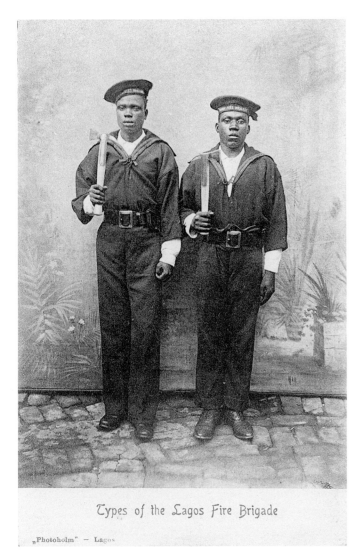

Types of the Lagos Fire Brigade

"Photoholm" – Lagos

FIGURE 130. "Types of the Lagos Fire Brigade," Nigeria, ca. 1900. Photographed by N. Walwin or J. A. C. Holm, Lagos, Nigeria, and Accra, Ghana. Printed in Germany.

thus moved from the private to the public realm. Among them is an unusually posed portrait of a "Gold Coast Beauty" that focuses attention on the woman's elegant dress and elaborate coiffure (fig. 129). Another studio portrait shows two members of the Lagos Fire Brigade, wearing sailor-style uniforms and holding short axes, posed before a painted studio backdrop of architectural elements and plants (fig. 130). The caption "Types of the Lagos Fire Brigade" clearly objectifies the subjects and shifts them from a personal portrait setting in which they display Self into the anonymity of "types," following a transformatory process that resembles missionary postcard production.

The Holms also depicted towns and chiefdoms in the region beyond Lagos and Accra. Two of their postcard images were taken in Badagry, a chiefdom near Lagos. One shows a chair market at which Africans sold European-style chairs and benches of indigenous production. Another, captioned "High Life in Badagry" with a certain amount of irony, features a chief or wealthy man in a hammock carried by two servants. Such postcards, as well as another one of Gelede masqueraders in male and female attire (fig. 131), clearly have ethnographic overtones and must have appealed to Western clients. Even this small selection of cards confirms the Holms' broad approach to photography and their accomplishments in creating evocative portraits and depicting modern architecture and more conventional topics in an ethnographic-anthropological mode.

A DIFFERENT VISION?

Comparing postcard production by Western and African photographer-sponsors raises intriguing questions and challenges the familiar categories into which postcards traditionally have been assigned. If postcards showing foreign peoples

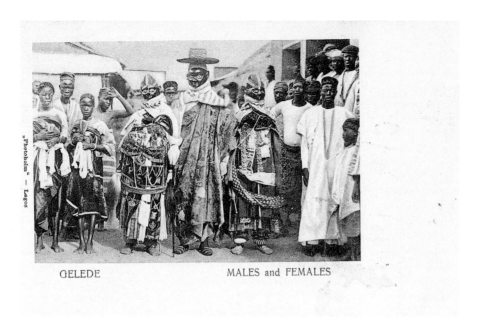

GELEDE MALES and FEMALES

FIGURE 131. "GELEDE MALES and FEMALES," Nigeria, ca. 1900. Photographed by N. Walwin or J. A. C. Holm, Lagos, Nigeria, and Accra, Ghana. Printed in Germany.

are the ultimate expression of Western discourses about the Other, a tangible manifestation of the "us and them" dichotomy, where do these African postcards fit? Are there any discernible differences between postcards produced by Western photographer-sponsors and African ones? Or did Westerners and Africans share similar visions?

First of all, we should distinguish between local and international producers of postcards in the African realm. Of the African photographers and producers discussed here, at least two belong into the "international" category: the Lisk-Carew brothers and the father-son team of Photoholm. They catered to a Western clientele who acquired postcards as souvenirs and collectors' items, and thus no doubt expected a full range of themes, including stereotypes. Even in a limited review of Lisk-Carew samples, thematic emphases become apparent. The majority of the postcards depict Freetown and other cen-

ters in Sierra Leone, while others illustrate ethnographic and exotic themes. In fact, the Lisk-Carew brothers even offered conventionally staged erotic postcards (fig. 132), although their selection was small in comparison to the output of Fortier or Audema. Nevertheless, the composition of the image and the poses of the young women well exemplify such photography. One woman raises her arms invitingly above her head to better expose her breasts to the viewer. Oil rubbed on their skin highlights the women's black bodies. The caption is as denigrating as many others invented by Westerners. "Damsels of shining virtue - primitive by nature. Sierra Leone" ironically articulates Western tropes about Africa and African women. Yet when compared to a postcard image of Zulu girls (see fig. 118), these women appear to be relaxed in a way not commonly seen in exotic-erotic photographs by Europeans. Obviously, the expectations of the Western clientele shaped the production of and marketplace for postcards, or put differently, the postcard medium established its own particular conventions that had to be followed in order to achieve economic success.

Other dynamics were certainly at work, too. Beyond the cosmopolitan setting of the West African coast, which had long been the site of interaction between Europeans and Africans, many African photographers may have found themselves in the role of the Other, the observer. When the Lisk-Carew brothers traveled into the hinterland of Sierra Leone to take photographs, they undoubtedly encountered rural peoples far different from the inhabitants of their so-

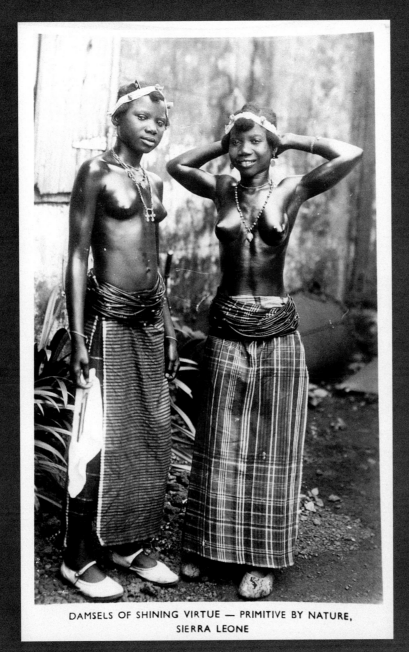

DAMSELS OF SHINING VIRTUE — PRIMITIVE BY NATURE,
SIERRA LEONE

FIGURE 132. "Damsels of Shining Virtue - Primitive by Nature. Sierra Leone,"
ca. 1915. Photographed by Lisk-Carew Brothers, Freetown, Sierra Leone.

phisticated urban setting. In that context, the Sande or Bundu women's society must have seemed as exotic to them as it did to Western visitors. The same may have been true for the urbane and widely traveled father-son team of Photoholm. The photographer by definition becomes the Other.

By transforming photographs into postcards, even images taken in the "private" realm can shift categories and become inserted into the powerful discourse surrounding postcards. Thus a poised portrait of three individuals by A. James (who very likely was an African photographer) moves into the public domain as a depiction of "Soussou Types" (see fig. 119). The same can be said of Photoholm's "Gold Coast Beauty" (see fig. 129). Are the dynamics of postcard production and the photographic conventions established by Western photographers so powerful as to unify the vision of the Western and African photographers? Only further research will tell.

Some of the issues that should come to the fore are distinctions between private and public images, the sitter's intention when the photograph was taken, and the interaction between photographer and subject in constructing the image. Indeed, as many of the portraits by African photographers indicate, a powerful dialogue exists between subject and photographer, and it shapes the final impact of many postcards. The self-assured "Soussou Types," the remarkably unconventional depiction of the "Gold Coast Beauty," the poised appearance of the "Bondu Girls," and the proud demeanor of the "Types of the Lagos Fire Brigade" ultimately suggest a particular vision and dynamic that may have shaped the postcard production of African photographers-sponsors.

NOTES

1. Elizabeth Edwards, "Photographic 'Types': The Pursuit of Method," *Visual Anthropology* 3, nos. 2–3 (1990), pp. 289–315. See also Edwards 1992.

2. Several outstanding contributions have been made, including Gardi's book about Djenné (see Bernard Gardi, Pierre Maas, and Geert Mommersteeg, *Djenné, il y a cent ans* [Basel: Museum für Völkerkunde, 1995]) and two catalogues of postcards in the Côte d'Ivoire and Guinea (see André and Afo Guenneguez, *Centenaire de la Côte d'Ivoire 1887/1888–1988 en cartes postales* [Abidjan, Côte d'Ivoire: Arts et Editions, 1988] and P. S. Grant Dürr, B. Sivan, and E. Tompapa, *Images de Guinée (1890–1925). Réalisations d'après les collections de cartes postales* [Conakry: Editions Imprimerie Mission Catholique, 1991]). In France, postcard researchers and scholars interested in photography formed the "Association images et mémoires," which is based in Paris.

3. Philippe David, "La carte postale africaine (1900–1960). Essai de bilan. Invitation à la recherche," *Revue juridique et politique, indépendance et coopération* 40, nos. 1–2 (1986), p. 168.

4. Philippe David, "La carte postale sénégalaise de 1900 à 1960. Production, éditions et signification: un bilan provisoire," *Notes Africaines* 157 (January 1978), p. 5.

5. Philippe David, "Iconographie Togolaise ancienne et patrimoine national," *Etudes togolaises,* n.s. 31-34 (1986–87), p. 7.

6. Philippe David, "La carte postale ivoirienne de 1900 à 1960. Un bilan iconographique et culturel provisoire," *Notes Africaines* 174 (April 1982), pp. 30–31.

7. Marie-Anne Wilssens, "'Nels' levert al sedert vorige eeuw achterkant van 'zonnige groeten.'" *De Standaard* (17 August 1990), p. 15.

8. A. K. W. Atkinson, "South African Picture Postcards," *Africana Notes and News* 25, no. 7 (September 1983), pp. 227–28.

9. In contemporary South Africa, groups such as the Southern Africa Postcard Research Group pursue the study and collection of historical postcards; see ibid.

10. Jan Nederveen Pieterse, *White on Black: Images of Africa and Blacks in Western Popular Culture* (New Haven and London: Yale University Press, 1992). Pieterse defines "stereotype" in the following way: "In cognitive psychology stereotypes are taken to be schemas or sets which play a part in cognition, perception, memory and communication. Stereotypes are based on simplification and generalization, or the denial of individuality; they can either be negative or positive. Though they may have no basis in reality, stereotypes are real in their social consequences, notably with regard to the allocation of roles. They tend to function as self-fulfilling prophecies" (ibid., p. 11).

11. Albert Wirz, "Beobachtete Beobachter: Zur Lektüre völkerkundlicher Fotografien," in *Fremden-Bilder,* ed. Martin Brauen, Ethnographische Schriften Zürich, ESZ 1 (Zurich: Völkerkundemuseum der Universität Zürich, 1982), p. 58.

12. Raymond Corbey, "Der Missionar, die Heiden und das Photo: Eine methodologische Anmerkung zur Interpretation von Missionsphotographien," *Zeitschrift für Kulturaustausch* 40, no. 3 (1990), pp. 460–65.

13. See, for example, imagery of Native Americans in Lonna M. Malmsheimer, "'Imitation White Man': Images of Transformation at the

Carlisle Indian School" *Studies in Visual Communication* II, no. 4 (1980), pp. 54–75.

14. Bamum names are usually a combination of attributes, nouns, or verbs and thus can be translated.

15. See also figure 16 in *Mères et enfants de l'Afrique d'autrefois* (Abidjan, Côte d'Ivoire: UNICEF, 1979), which shows a postcard of a 1912 Rein-Wuhrmann photograph of Daniel Pam, who in the caption becomes "'Sans Souci,' un des nos élèves instituteurs" ("Happy go lucky," one of our pupils in teacher's training).

16. A fine set of these images can be found in the photographic archives of the Pitt Rivers Museum at the University of Oxford in England.

17. Corbey 1989, and Raymond Corbey, "Weisser Mann—Schwarze Frau. Erotische Inszenierungen aus dem kolonialen Afrika," *Zeitschrift für Kulturaustausch* 40, no. 3 (1990), pp. 479–82. See also Corbey 1988.

18. Alloula 1986. Also see David Prochaska, "Fantasia of the Phototèque: French Postcard Views of Colonial Senegal," *African Arts* 24, no. 4 (1991), pp. 40-47, 98.

19. A. Bensusan, *Silver Images: History of Photography in Africa* (Cape Town, South Africa: Howard Timmins, 1966).

20. John Berger, *Ways of Seeing* (London: British Broadcasting Corporation and Penguin Books, 1972); André Rouillé and Bernard Marbot, *Le corps et son image. Photographies du dix-neuvième siècle* (Paris: Contrejour, 1986); and Ricabeth Steiger and Martin Taureg, "Körperphantasien auf Reisen: Anmerkungen zum ethnographischen Akt," in *Das Aktfoto, Ansichten vom Körper im fotografischen Zeitalter: Ästhetik, Geschichte, Ideologie*, eds. Michael Köhler and Gisela Barche (Munich: Bucher, 1985), pp. 116–36.

21. Also see Gérard Bosio and Michel Renaudeau, *Souvenirs du Senegal* (Dakar: Visiafric, 1983).

22. See the advertisement on the verso of a portrait taken by Fortier in 1900. There he describes his services as "Photographie artistique, industrielle" and gives as his specialty as "Collection de Vues" and "Types Indigènes" (David 1978, p. 11).

23. Creoles were a mixed population of liberated slaves, many of whom had come from the Yoruba realm of Nigeria and from the Gold Coast, and later had escaped from the United States or Jamaica. In addition, the British navy recaptured slaves when they intercepted slave vessels after the British slave trade had been abolished in 1807. Creoles settled in Sierra Leone throughout the mid-nineteenth century and soon formed a group with a distinct identity. They maintained many elements of their African heritage, but they prided themselves on being more educated and Westernized than other segments of Sierra Leone's population.

24. Vera Viditz-Ward, "Alphonso Lisk-Carew: Creole Photographer," *African Arts* 19, no. 1 (November 1985), p. 46; Vera Viditz-Ward, "Notes Toward a History of Photography in Sierra Leone, West Africa," *Exposure* 28, no. 3 (1991–92), pp. 16–22; and George Sullivan, *Black Artists in Photography, 1840–1940* (New York: Cobblehill Books, 1996).

25. Accolatse's photographs might well be among those works that were transferred by the Norddeutsche Missionsgesellschaft to the Staats-

archiv Bremen. It also seems that Accolatse's photographs illustrate a slim volume about early photographs by travelers from Bremen. See Hartmut Müller, *"So sahen wir Afrika." Afrika im Spiegel früher Bremer Kolonialfotografie, 1882-1907* (Bremen: Staatsarchiv Bremen, 1984), and in particular photographs on pp. 40, 41, and 43.

26. Lawson was a member of one of the most important families in Anécho, and he was related to the chief's family. Pro-British, the Lawsons opposed the German takeover of Togo. The true identity of the "king" remains a mystery. He is either G. A. Lawson or one of his brothers who had initially lived in Lagos. See Samuel Decalo, *Historical Dictionary of Togo* (Metuchen, N. J.: Scarecrow Press, 1976), p. 108.

27. Vera Viditz-Ward, "Photography in Sierra Leone, 1850–1918," *Africa* 57, no. 4 (1987), p. 514.

28. J. Sylvanus Wartemberg, *Sao Jorge d'El Mina, Premier West African European Settlement. Its Traditions and Customs* (Ilfracombe, North Devon: Arthur H. Stockwell, 1950), pp. 88–89.

29. Christraud Geary, ed., *Historical Photographs of Africa,* special issue of *African Arts* 24, 4 (October 1991), cover.

30. T. N. Goddard, *The Handbook of Sierra Leone* (London: Grant and Richards, 1925).

31. Allister Macmillan, *The Red Book of West Africa: Historical and Descriptive Commercial and Industrial Facts, Figures and Resources* (1920; reprint, London: Frank Cass, 1968).

32. I thank Virginia-Lee Webb of the Metropolitan Museum of Art for giving me access to the museum's sizeable holdings of Lisk-Carew postcards at the Photograph Study Collection in the Department of the Arts of Africa, Oceania, and the Americas.

33. See Viditz-Ward 1985, p. 49, for a reproduction of the albumen print in the collection of the Foreign Office and Commonwealth Library in London.

34. "Devil" is a Creole term for masqueraders from different masquerade societies. Although the term very likely derived from missionaries' pejorative designation of all "pagan" masqueraders, it is now an expression of respect for the spiritual essence of the mask costume. See John W. Nunley, *Moving with the Face of the Devil: Art and Politics in Urban West Africa* (Urbana and Chicago: University of Illinois Press, 1987), p. xv.

35. For a more detailed description of the Sande and of Western perceptions of this society see Ruth B. Phillips, *Representing Women: Sande Masquerades of the Mende of Sierra Leone* (Los Angeles: UCLA Fowler Museum of Cultural History, 1995).

36. *Commonwealth in Focus: 130 Years of Photographic History* (Victoria, Australia: International Cultural Corporation of Australia Limited, 1982), p. 118.

37. See the Himburg Photographic Album with images from Nigeria (National Museum of African Art; ref. A1995-24).

38. Flora S. Kaplan, "Some Uses of Photographs in Recovering Cultural History at the Royal Court of Benin, Nigeria," *Visual Anthropology* 3, 2–3 (1990), p. 319, and Nicolas Monti, *Africa Then: Photographs 1840–1918* (New York: Alfred A. Knopf, 1987), pp. 8, 164, and 166.

BELGISCH CONGO

M' et Mme F. Denulet

rue Marconi n° 39.

Forest - Bruxelles.

Belgique - Europe

Chers Cousin et Cousine

A l'occasion du jour de l'An
à l'occasion un prochain de route
nous nous faisons un plaisir... mai 1934,
envoyer son heur... nos meilleurs faic... de
et de... nos meilleurs...
Ainsi que... Marcel. On...
Berthe et Adrienne

BIBLIOGRAPHY

Albers, Patricia. 1980a. Postcards of the Brule Sioux by John A. Anderson. *Barr's Post Card News* 5 (September): 4.

———. 1980b. Raphael Tuck and Sons American Indian Postcards. *Barr's Post Card News* 2 (October): 4.

———. 1982a. The Work of Sumner W. Matteson. *Barr's Post Card News* 3 (June): 23–24.

———. 1982b. American Indian Postcards by the Illustrated Post Card Company. *Barr's Post Card News* 4 (November): 5.

———. 1983a. E. C. Kropp's American Indian Postcards. *Barr's Post Card News* 5 (May): 23.

———. 1983b. Introduction. In *The Hidden Half: Studies of Plains Indian Women.* Edited by Patricia Albers and Beatrice Medicine. Lanham Park, Md.: University Press of America.

———. 1995. Enchanted, Enduring, and Exotic Images of Southwestern Indians: A View from the Picture Post Card, 1898 to the Present. Paper presented at the symposium *Imaging the West,* Autry Heritage Museum, Los Angeles, California (June).

Albers, Patricia C., and William R. James. 1982. Postcard Images of the American Indian: Collectible Sets of the Pre-1920 Era. *American Postcard Journal* 7, no. 6 (July): 17–20.

———. 1983. Tourism and the Changing Image of the Great Lakes Indian. *Annals of Tourism Research* 10, no. 1:128–48.

———. 1984a. The Dominance of Plains Indian Imagery on the Picture Postcard. In *Fifth Annual 1981 Plains Indian Seminar in Honor of Dr. John Ewers.* Edited by George Horse Capture and Gene Balls. Cody, Wy.: Buffalo Bill Historical Center.

———. 1984b. Utah's Indians and Popular Photography in the American West: A View From the Picture Postcard. *Utah Historical Quarterly* 52, no. 1 (winter): 72–91.

———. 1985. Images and Reality: Postcards of Minnesota's Ojibway People, 1900–1980. *Minnesota History* 49, no. 6 (summer): 229–40.

———. 1986. A "Real" American Cupid. *Postcard Collector* 4, no. 2:22–23.

———. 1987a. Wisconsin Indians on the Picture Postcard: A History in Photographic Stereotyping. *Lore* 37 (autumn): 3–19.

———. 1987b. Illusion and Illumination: Visual Images of American Indian Women in the West. In *The Women's West.* Edited by Susan Armitage and Betsy Jameson. Norman, Okla.: University of Oklahoma Press.

———. 1987c. Tourism and the Changing Image of Mexico. Paper presented at the Society for Applied Anthropology Meetings, Oaxaca, Mexico (April).

———. 1988. Travel Photography: A Methodological Approach. *Annals of Tourism Research* 15, no. 1:134–58.

———. 1990. Private and Public Images: A Study of Photographic Contrasts in Postcard Pictures of Great Basin Indians, 1898-1919. *Visual Anthropology* 3:343–66.

Alloula, Malek. 1986. *The Colonial Harem.* Minneapolis: University of Minnesota Press.

Altick, Robert D. 1978. *The Shows of London.* Cambridge, Mass.: Harvard University Press.

Andrews, B. 1975. *A Directory of Post Cards, Artists, Publishers, and Trademarks.* Irving, Tex.: Little Red Caboose.

Atkinson, A. K. W. 1983. South African Picture Postcards. *Africana Notes and News* 25, no. 7 (September): 227–28.

Babcock, Barbara. 1993. Bearers of Value, Vessels of Desire: The Reproduction of the Reproduction of Pueblo Culture. *Museum Anthropology* 17, no. 3:43–57.

Barthes, Roland. 1982. The Written Face. In *Empire of Signs.* Translated by Richard Howard. New York: Farrar, Straus and Giroux.

Belous, Russell, and Robert Weinstein. 1969. *William Soule, Indian Photographer at Fort Sill, Oklahoma, 1869–1874.* Los Angeles, Calif.: Ward Ritchie Press.

Benedict, Burton, et al. 1984. *The Anthropology of World's Fairs.* London and Berkeley: Scolar Press.

Bennett, Tony. 1988. The Exhibitionary Complex. *New Formations* 4 (Spring): 73–102.

———. 1995. *The Birth of the Museum.* New York: Routledge.

Bensusan, A., 1966. *Silver Images: History of Photography in Africa.* Cape Town, South Africa: Howard Timmins.

Berger, John. 1972. *Ways of Seeing.* London: British Broadcasting Corporation and Penguin Books.

———. 1980. *About Looking.* New York: Pantheon Press.

Berger, Klaus. 1992. *Japonisme in Western Painting from Whistler to Matisse.* Translated by David Britt. Cambridge, England: Cambridge University Press.

Berkhofer, Robert, Jr. 1978. *The Whiteman's Indian.* New York: Vintage Press.

Binney, Judith. 1992. Two Maori Portraits: Adoption of the Medium. In Elizabeth Edwards. *Anthropology and Photography, 1860-1960.* New Haven and London: Yale University Press in association with the Royal Anthropological Institute.

Blair, John G. 1988. *Modular America: Cross-Cultural Perspectives on the Emergence of an American Way.* New York: Greenwood Press.

Blanton, Casey, ed. 1995. *Picturing Paradise: Colonial Photography of Samoa, 1875–1925.* Daytona Beach, Fla.: Daytona Community College.

Bomar, William J. 1986. *Postal Markings of United States Expositions.* North Miami, Fla.: David G. Phillips Publishing Company.

Bosio, Gérard, and Michel Renaudeau. 1983. *Souvenirs du Senegal.* Dakar: Visiafric.

Bourdieu, Pierre. 1990. *Photography: A Middle Brow Art.* 1965. Reprint, Palo Alto, Calif.: Standford University Press.

Bradford, Phillips Verner, and Harvey Blume. 1992. *Ota Benga: The Pygmy in the Zoo.* New York: St. Martin's Press.

Breitbart, Eric. 1997. *The World on Display.* Albuquerque: University of New Mexico Press.

Brown, Reverend George. 1865–1916. Correspondence, Journals, Letterbooks, Notebooks, Typescripts, Manuscripts. George Brown Collection, Mitchell Library, Sydney.

Burdick, Jefferson R. N.d. [ca. 1963]. *History of the J. R. Burdick Collection.* New York: Metropolitan Museum of Art.

———. N.d. *Pioneer Post Cards.* Reprint, New York: Nostalgia Press.

Burton Brothers. Photographers in New Zealand, 1866–1898. 1987. Rotterdam: Museum voor Volkenkunde.

Carner, Mosco. 1968. *Puccini: A Critical Biography.* New York: Alfred A. Knopf.

Castles, Jean. 1971. Fred Miller: "Boxpotapesh" of Crow Agency. *Montana: The Magazine of Western History* 21 (July): 85–92.

Certeau, Michel de. 1984. *The Practice of Everyday Life.* Berkeley: University of California Press.

Child, Brenda. 1994. Introduction in *Portraits of Native Americans: Photographs from the 1904 Louisiana Purchase Exposition.* New York: New Press.

Cole, George Watson. 1935. *Postcards, The World in Miniature: A Plan for their Systematic Arrangement.* Pasadena, Calif.: privately published.

Commonwealth in Focus: 130 Years of Photographic History. 1982. Victoria, Australia: International Cultural Corporation of Australia Limited.

Coombes, Annie E. 1994. *Reinventing Africa: Museums, Material Culture and Popular Imagination.* New Haven and London: Yale University Press.

Corbey, Raymond. 1988. Alterity: The Colonial Nude. *Critique of Anthropology* 8, no. 3:75–91.

———. 1989. *Wildheid en beschaving. De Europese verbeelding van Afrika.* Baarn, The Netherlands: Ambo.

———. 1990a. Der Missionar, die Heiden und das Photo. Eine methodologische Anmerkung zur Interpretation von Missions-photographien. *Zeitschrift für Kulturaustausch* 40, no. 3:460–65.

———. 1990b. Weisser Mann—Schwarze Frau. Erotische Inszenierungen aus dem kolonialen Afrika. *Zeitschrift für Kulturaustausch* 40, no. 3:479–82.

———. 1993. Ethnographic Showcases, 1870–1930. *Cultural Anthropology* 8, no. 3:338–69.

The Cyclopedia of Samoa, Tonga, Tahiti and the Cook Islands. 1983. 1907. Reprint, Papakura, New Zealand: R. McMillan.

Danks, Reverend B. [1902?] *Our Mission Fields.* Sydney: Wesleyan Methodist Mission Society. [A Jubilee Pamphlet.]

David, Philippe. 1978. La carte postale sénégalaise de 1900 à 1960. Production, éditions et signification: un bilan provisoire. *Notes Africaines* 157 (January): 3–12.

———. 1982. La carte postale ivoirienne de 1900 à 1960. Un bilan iconographique et culturel provisoire. *Notes Africaines* 174 (April): 29–39.

———. 1986. La carte postale africaine (1900-1960). Essai de bilan. Invitation à la recherche. *Revue juridique et politique, indépendance et coopération* 40, nos. 1–2:166–77.

———. 1986–87. Iconographie Togolaise ancienne et patrimoine national. *Etudes togolaises,* n.s. 31-34:5–25.

———. 1986–88. *Inventaire générale des cartes postales Fortier.* 3 vols. Saint-Julien-du-Sault: Fostier.

Davies, Alan, and Peter Stanbury. 1985. *The Mechanical Eye in Australia. Photography 1841-1900.* Melbourne, Australia: Oxford University Press.

Decalo, Samuel. 1976. *Historical Dictionary of Togo.* Metuchen, N.J.: Scarecrow Press.

Deloria, Vine, Jr. 1973. Warriors of the Tall Grass. *Rocky Mountain Magazine* (June): 33–39.

———. 1981. The Indians. In *Buffalo Bill and the Wild West.* Brooklyn, N.Y.: Brooklyn Museum of Art.

Dippie, Brian. 1992. Representing the Other: The North American Indian. In *Anthropology and Photography, 1860–1960.* Edited by Elizabeth Edwards. New Haven and London: Yale University Press in association with the Royal Anthropological Institute.

Dürr, P. S. Grant, B. Sivan, and E. Tompapa. 1991. *Images de Guinée (1890–1925). Réalisations d'après les collections de cartes postales.* Conakry: Editions Imprimerie Mission Catholique.

Edwards, Elizabeth. 1990. Photographic "Types": The Pursuit of Method. *Visual Anthropology* 3, nos. 2–3:289–315.

———, ed. 1992. *Anthropology and Photography, 1860–1960.* New Haven and London: Yale University Press in association with the Royal Anthropological Institute.

Ewers, John. 1968. The Emergence of the Plains Indians as the Symbol of the North American Indian. In *Indians on the Upper Missouri.* Norman, Okla.: University of Oklahoma Press. Originally published in Smithsonian *Report for 1964* (1965), publication 4636: 531–44.

Fabian, Johannes. 1983. *Time and the Other: How Anthropology Makes its Object.* New York: Columbia University Press.

Face Value. A Study in Maori Portraiture. 1975. Dunedin, New Zealand: Dunedin Public Art Gallery.

Farr, William E. 1984. *The Reservation Blackfeet, 1882–1945, A Photographic History of Cultural Survival.* Seattle: University of Washington Press.

Findling, John E., and Kimberly D. Pelle, eds. 1990. *Historical Dictionary of World's Fairs and Expositions, 1851–1988.* Westport, Conn.: Greenwood Press.

Fleming, Paula, and Judith Luskey. 1986. *The North American Indians in Early Photographs.* New York: Harper and Row.

———. 1993. *Grand Endeavors of American Indian Photography.* Washington, D.C.: Smithsonian Institution Press.

Fletcher, C. Brunsdon. 1921. George Brown and the Pacific. *Royal Australian Historical Society Journal and Proceedings* 7, pt. 1:1-54.

Fletcher, F. A., and A. D. Brooks. 1978. *British Exhibitions and Their Postcards, Part 1: 1900–1914.* Holborn, London, England: Fleetway Press.

———. 1979. *British and Foreign Exhibitions and Their Postcards, Part 2: 1915–1979.* Holborn, London, England: Fleetway Press.

The Foreign Commerce of Japan. 1905. *National Geographic* 16, no. 7 (July).

Gardi, Bernard, Pierre Maas, and Geert Mommersteeg. 1995. *Djenné, il y a cent ans.* Basel, Switzerland: Museum für Völkerkunde.

Geary, Christraud M. 1988. *Images from Bamum: German Colonial Photography at the Court of King Njoya, Cameroon, West Africa, 1902–1915.* Washington, D.C.: National Museum of African Art and Smithsonian Institution Press.

———, ed. 1991. *Historical Photographs of Africa.* Special issue of *African Arts* 24, no. 4 (October).

Gidley, Mick. 1992. *Representing Others: White Views of Indigenous Peoples.* Exeter, England: Exeter University Press.

Goddard, T. N. 1925. *The Handbook of Sierra Leone.* London: Grant and Richards.

Goode, George Brown. 1898. The Museums of the Future. In *Annual Report of the United States National Museum: Year Ending June 30, 1897.* Washington, D.C.: U.S. Government Printing Office.

Green, Rayna. 1988. The Indian in Popular American Culture. In *Handbook of North American Indians.* Vol. 4, *The History of White-Indian Relations.* Edited by W. Washburn. Washington, D.C.: Smithsonian Institution Press.

Greenhalgh, Paul. 1988. *Ephemeral Vistas: The Expositions Universelles, Great Exhibitions and World's Fairs, 1851–1939.* Manchester, England: Manchester University Press.

Guenneguez, André, and Afo Guenneguez. 1988. *Centenaire de la*

Côte d'Ivoire 1887/1888–1988 en cartes postales. Abidjan, Côte d'Ivoire: Arts et Editions.

Handy, Ellen. 1988. Tradition, Novelty and Invention: Portrait and Landscape Photography in Japan, 1860s–1880s. In Melissa Banta and Susan Taylor. *A Timely Encounter: Nineteenth Century Photographs of Japan.* Cambridge, Mass.: Peabody Museum Press.

Harjo, Joy. 1992. The Place of Origins. In *Partial Recall.* Edited by Lucy R. Lippard. New York: New Press.

Harris, Neil, et al. 1993. *Grand Illusions: Chicago's World's Fair of 1893.* Chicago: Chicago Historical Society.

Harvey, Joy Dorothy. 1983. Races Specified, Evolution Transformed: The Social Context of Scientific Debates Originating in the Société d'Anthropologie de Paris, 1859–1902. Ph.D. diss. Harvard University.

Hathaway, Nancy. 1990. *Native American Portraits: 1862–1918.* San Francisco: Chronicle Books.

Heski, Thomas M. 1978. *The Little Shadow Catcher: D. F. Barry.* Seattle: Superior Publishing Company.

Hill, C. W. 1978. *Edwardian Entertainments. A Picture Post Card View.* Staffs, England: M. A. B. Publishing.

Hinsley, Curtis M. 1991. The World as Marketplace: Commodification of the Exotic at the World's Columbian Exposition, Chicago, 1893. In *Exhibiting Cultures: The Poetics and Politics of Museum Display.* Edited by Ivan Karp and Steven D. Lavine. Washington, D.C.: Smithsonian Institution Press.

Horse Capture, George P. 1977. The Camera Eye of Sumner Matteson. *Montana: The Magazine of Western History* 27, no. 3:58–70.

Hunter, Jefferson. 1987. *Image and Word: The Interaction of Twentieth-Century Photographs and Texts.* Cambridge, Mass.: Harvard University Press.

Jackson, William Henry. 1986. *Time Exposure.* 1940. Reprint, Albuquerque: University of New Mexico Press.

Jagow, Kurt, ed. 1938. *Letters of the Prince Consort, 1831–1861.* New York: E. P. Dutton.

Jameson, Frederic. 1990. Modernism and Imperialism. In *Nationalism, Colonialism, and Literature.* Edited by Terry Eagleton, Frederic Jameson, and Edward W. Said. Minneapolis: University of Minnesota Press.

Japan Photographers Association. 1980. *A Century of Japanese Photography.* Introduction by John Dower. New York: Pantheon.

Kaplan, Flora S. 1990. Some Uses of Photographs in Recovering Cultural History at the Royal Court of Benin, Nigeria. *Visual Anthropology* 3, nos. 2–3:317–41.

King, Michael. 1984. *Maori. A Photographic and Social History.* Auckland, New Zealand: Heinemann Publishers.

———. 1985. Maori Images. *Natural History* 94, no. 7 (July): 36–42.

Klamkin, Marian. 1974. *Picture Postcards.* New York: Dodd, Mead.

Knight, Hardwicke. 1971. *Photography in New Zealand. A Social and Technical History.* Dunedin, New Zealand: John McIndoe.

———. 1981. *New Zealand Photographers. A Selection.* Dunedin, New Zealand: Allied Press.

Kopytoff, Igor. 1986. The Cultural Biography of Things: Commoditization as Process. In *The Social Life of Things: Commodities in Cultural Perspective.* Edited by Arjun Appadurai. Cambridge, England: Cambridge University Press.

Kreis, Karl. 1992. "Indians" on Old Picture Postcards. *European Review of Native American Studies* 6, no. 1:39–48.

Lambert, Kirby. 1996. The Lure of the Parks. *Montana: The Magazine of Western History* 46, no. 1 (Spring): 42–55.

Lebovics, Herman. 1992. *True France: The Wars over Cultural Identity.* Ithaca, N.Y.: Cornell University Press.

Leonard, A. 1991. F. G. O. Stuart's German Printer (Jack Foley Research on C. G. Röder). *Picture Postcard Monthly* (Great Britain) (July): 21-23.

Lippard, Lucy R., ed. 1992. *Partial Recall.* New York: New Press.

Loti, Pierre. N.d. [1887]. *Madame Chrysanthème.* Paris: Calman-Levy Editeurs.

———. 1986. Japoneries d'automne. In Chantal Edel. *Once Upon a Time. . . .* Translated by Linda Coverdale. New York: Friendly Press.

Lowe, J. L. 1982. *Walden's Post Card Enthusiast Revisited.* Ridley Park, Penn.: Deltiologists of America.

Lowe, J. L., and B. Papell. 1975. *Detroit Publishing Company Collectors' Guide.* Newton Square, Penn.: Deltiologists of America.

Lutz, Catherine A., and Jane L. Collins. 1993. *Reading National Geographic.* Chicago: University of Chicago Press.

Lyman, Christopher. 1982. *The Vanishing Race and Other Illusions.* New York: Pantheon Press.

McLintock, A. H., ed. 1966. *An Encyclopaedia of New Zealand.* Vol. 3. Wellington, New Zealand: R. E. Owen, Government Printer.

MacKenzie, John M. 1984. *Propaganda and Empire: The Manipulation of British Public Opinion, 1880–1960.* Manchester, England: Manchester University Press.

Macmillan, Allister. 1968. *The Red Book of West Africa: Historical and Descriptive Commercial and Industrial Facts, Figures and Resources.* 1920. Reprint, London: Frank Cass.

Main, William. 1976. *Maori in Focus.* Wellington, New Zealand: Millwood Press.

Main, William, and John B. Turner. 1993. *New Zealand Photography From the 1840s to the Present / Nga Whakaahua o Aotearoa Mai i*

1840 Ki Naianei. Auckland and Wellington, New Zealand: Photo-Forum.

Malmsheimer, Lonna M. 1980. "Imitation White Man": Images of Transformation at the Carlisle Indian School. *Studies in Visual Communication* 11, no. 4:54–75.

Mayor, A. Hyatt. N.d. [ca. 1963]. Introduction in Jefferson R. Burdick. *Directory of the J. R. Burdick Collection*. New York: Metropolitan Museum of Art.

Mead, D. M. 1969. *Traditional Maori Clothing*. Wellington, New Zealand: A. H. and A. W. Reed.

Meech, Julia, and Gabriel Weisberg. 1990. *Japonisme Comes to America: The Japanese Impact on the Graphic Arts 1876–1925*. New York: Harry N. Abrams.

Megson, Frederic H., and Mary S. Megson. 1992. *American Exposition Postcards, 1870–1920*. Martinsville, N.J.: privately printed.

Mères et enfants de l'Afrique d'autrefois. 1979. Abidjan, Côte d'Ivoire: UNICEF.

Mesenhöller, Peter. 1989. Kulturen zwischen Paradies und Hölle. In *Der geraubte Schatten*. Edited by Thomas Theye. Munich: Münchner Stadtmuseum.

———. 1995. Ethnography Considers History: Some Examples from Samoa. In *Picturing Paradise: Colonial Photography of Samoa, 1875–1925*. Edited by Casey Blanton. Daytona Beach, Fla.: Daytona Community College.

Millar, David P. 1981. *Charles Kerry's Federation Australia*. Sydney: David Ell Press.

Monti, Nicolas. 1987. *Africa Then. Photographs 1840–1918*. New York: Alfred A. Knopf.

Morgan, Hal, and Andreas Brown. 1981. *Prairie Fires and Paper Moons. The American Photographic Postcard: 1900–1920*. Boston: David R. Godine.

Müller, Hartmut. 1984. *So sahen wir Afrika. Afrika im Spiegel früher Bremer Kolonialfotografie, 1882–1907*. Bremen, Germany: Staatsarchiv Bremen.

Moses, Lester G. 1991. Indians on the Midway: Wild West Shows and the Indian Bureau at World's Fairs, 1893–1904. *South Dakota History* 21:220.

Mulvey, Laura. 1989. *Visual and Other Pleasures*. Bloomington: University of Indiana Press.

Mydin, Iskander. 1992. Historical Images—Changing Audiences. In *Anthropology and Photography, 1860–1960*. Edited by Elizabeth Edwards. New Haven and London: Yale University Press in association with the Royal Anthropological Institute.

Ngahuia Te Awekotuku. 1986. Introduction in Makereti. *The Old-Time Maori*. Auckland, New Zealand: New Women's Press.

Ngugi wa Mbugua. 1991. Saga of Samburu Postcard. *Daily Nation* (Nairobi, Kenya), 27 February.

Nordström, Alison Devine. 1991. Early Photography in Samoa. Marketing Stereotypes of Paradise. *History of Photography* 15, no. 4 (Winter): 272–86.

———. 1995. Popular Photography of Samoa: Production, Dissemination, and Use. In *Picturing Paradise: Colonial Photography of Samoa, 1875–1925*. Edited by Casey Blanton. Daytona Beach, Fla.: Daytona Community College.

Nunley, John W. 1987. *Moving with the Face of the Devil. Art and Politics in Urban West Africa*. Urbana and Chicago: University of Illinois Press.

Perthuis, Bruno. 1984. Les cartes postales gravées et lithographiées sur la guerre russo-japonaise (1904–1905). *Gazette des Beaux-Arts* (September): 86–98.

Peterson, Nicolas. 1985. The Popular Image. In *Seeing the First Australians*. Edited by Ian and Tamsin Donaldson. Sydney: George Allen and Unwin.

Phillips, Ruth B. 1995. *Representing Women. Sande Masquerades of the Mende of Sierra Leone*. Los Angeles: UCLA Fowler Museum of Cultural History.

Pieterse, Jan Nederveen. 1992. *White on Black: Images of Africa and Blacks in Western Popular Culture*. New Haven and London: Yale University Press.

Pilling, Arnold R. 1978. Stock Dating and Mount Dating of Early Photographs. Paper presented in Detroit.

———. 1986. Dating Photographs. *Ethnohistory: A Researcher's Guide, Studies in Third World Societies* 35:167–226.

Prochaska, David. 1990. The Archive of *Algérie Imaginaire*. *History and Anthropology* 4 (April): 373–420.

———. 1991. Fantasia of the Photothèque: French Postcard Views of Colonial Senegal. *African Arts* 24, no. 4:40–47, 98.

Reynolds, Frank A. 1971. Photographs from the Dixon/Wannamaker Expedition, 1913. *Infinity: The American Society of Magazine Photographers' Trade Journal*.

Rieske, William M., and Verla P. Rieske. 1974. *Historic Indian Portraits: 1898 Peace Jubilee Celebration*. Salt Lake City: Historic Indian Publishers.

Rony, Fatimah Tobing. 1992. Those Who Squat and Those Who Sit: The Iconography of Race in the 1895 Films of Félix-Louis Regnault. *Camera Obscura* 28 (January): 262–89.

Rouillé, André, and Bernard Marbot. 1986. *Le corps et son image. Photographies du dix-neuvième siècle*. Paris: Contrejour.

Ryan, D. B. 1982. *Picture Postcards in the United States, 1893–1918*. New York: C. N. Potter.

Rydell, Robert W. 1984. *All the World's a Fair*. Chicago: University of Chicago Press.

———. 1992. Introduction in *Books of the Fairs*. Chicago: American Library Association.

———. 1993. *World of Fairs*. Chicago: University of Chicago Press.

Rydell, Robert W., and Nancy E. Gwinn, eds. 1993. *Fair Representations: World's Fairs and the Modern World*. Amsterdam: VU University Press.

Said, Edward. 1978. *Orientalism*. New York: Pantheon Books.

Scherer, Joanna. 1975. "You Can't Believe Your Eyes": Inaccuracies in Photographs of North American Indians. *Studies in the Anthropology of Visual Communication* 2, no. 2:67–79.

———. 1988. The Public Faces of Sarah Winnemuca. *Cultural Anthropology* 3, no. 2:178–204.

Schneider, William H. 1982. *An Empire for the Masses: The French Popular Image of Africa, 1870–1900*. Westport, Conn.: Greenwood Press.

Schroeder-Gudehus, Brigitte, and Anne Rasmussen. 1992. *Les Fastes du progrès*. Paris: Flammarion.

Scott, Gertrude M. 1990. Village Performance: Villages of the Chicago World's Columbian Exposition of 1893. Ph.D. diss. New York University.

Scott, James C. 1985. *Weapons of the Weak: Everyday Forms of Peasant Resistance*. New Haven: Yale University Press.

Slotkin, Richard. 1981. The "Wild West." In *Buffalo Bill and the Wild West*. Brooklyn, N.Y.: Brooklyn Museum of Art.

Smith, J. R. 1908. *The Ocean Carrier*. New York: G. P. Putnam's Sons.

Steiger, Ricabeth, and Martin Taureg. 1985. Körperphantasien auf Reisen: Anmerkungen zum ethnographischen Akt. In *Das Aktfoto, Ansichten vom Körper im fotografischen Zeitalter: Ästhetik, Geschichte, Ideologie*. Edited by Michael Köhler and Gisela Barche. Munich: Bucher.

Stephen, Ann. 1993. Familiarizing the South Pacific. In *Pirating the Pacific: Images of Trade, Travel, and Tourism*. Sydney: Powerhouse Publishing.

Stewart, Susan. 1984. *On Longing. Narratives of the Miniature, the Gigantic, the Souvenir, the Collection*. Baltimore and London: Johns Hopkins University Press.

Stocking, George W., Jr., ed. 1985. *Objects and Others: Essays on Museums and Material Culture*. History of Anthropology 3. Madison: University of Wisconsin Press.

Street, Brian. 1992. British Popular Photography: Exhibiting and Photographing the Other. In *Anthropology and Photography, 1860–1960*. Edited by Elizabeth Edwards. New Haven and London: Yale University Press in association with the Royal Anthropological Institute.

Sullivan, George. 1996. *Black Artists in Photography, 1840–1940*. New York: Cobblehill Books.

Tagg, John. 1988. *The Burden of Representation: Essays on Photographies and Histories*. Amherst: University of Massachusetts Press.

Tassell, Margaret, and David Wood. 1981. *Tasmanian Photographer. From the John Watt Beattie Collection*. Melbourne, Australia: MacMillian Company of Australia.

Trachtenberg, Alan. 1989. *Reading American Photographs*. New York: Hill and Wang.

Tyrrell Collection. Photographic Prints from the Studios of Charles Kerry and Henry King. 1985. Sydney: Australian Consolidated Press.

Viditz-Ward, Vera. 1985. Alphonso Lisk-Carew: Creole Photographer. *African Arts* 19, no. 1 (November): 46–51, 88.

———. 1987. Photography in Sierra Leone, 1850–1918. *Africa* 57, no. 4:512–17.

———. 1991–92. Notes Toward a History of Photography in Sierra Leone, West Africa. *Exposure* 28, no. 3:16–22.

Waite, Deborah. 1983. *Art of the Solomon Islands from the Collection of the Barbier-Müller Museum*. Geneva: Musée Barbier-Müller.

Wartemberg, J. Sylvanus. 1950. *Sao Jorge d'El Mina, Premier West African European Settlement. Its Traditions and Customs*. Ilfracombe, North Devon: Arthur H. Stockwell.

Webb, Virginia-Lee. 1992. Fact and Fiction: Nineteenth-Century Photographs of the Zulu. *African Arts* 25, no. 1 (January): 50–59, 98–99.

———. 1995. Manipulated Images. In *Prehistories of the Future. The Primitivist Project and the Culture of Modernism*. Edited by Elazar Barkan and Ronald Bush. Stanford: Stanford University Press.

———. 1997. Missionary Photographers in the Pacific Islands: Divine Light. *History of Photography* 21, no. 1 (Spring): 12–22.

Weston, Walter. 1921. The Geography of Japan with Special Reference to its Influence on the Character of the Japanese People. *National Geographic* 40, no. 1 (July): 45–84.

Williams, William Appleman. 1980. *Empire as a Way of Life*. New York: Oxford University Press.

Wirz, Albert. 1982. Beobachtete Beobachter: Zur Lektüre völkerkundlicher Fotografien. In *Fremden-Bilder*. Edited by Martin Brauen. Zurich: Völkerkundemuseum der Universität Zürich.

Worswick, Clark. 1979. Photography in Nineteenth Century Japan. In *Japan Photographs 1854–1905*. New York: Japan House Gallery.

PHOTOGRAPHIC SOURCES

Information that is incomplete remains undetermined.

1
"66 Dakar - Ecole Indigène," ca. 1900–1905
[Dakar - Indigenous school]
Publisher: A. Albaret, Dakar, Senegal
National Museum of African Art
Smithsonian Institution, Washington, D.C.
Eliot Elisofon Photographic Archives

2
"66 Dakar - Ecole Indigène" (Verso)

3
"London Life.—Omnibus," ca. 1907
Sepia collotype
8.9 X 14.1 cm
Printer: Eyre and Spottiswoode, London, England
Sponsor: J. J. Samuels, London
Howard Woody Postcard Collection

4
"The Chattahoochee Valley Collectors' Club," Columbus, Georgia,
 ca. 1910
(Verso) #A-5411
Color lithograph
8.7 X 13.7 cm
Printer: Curt Teich Company, Chicago
Distributor: S. H. Kress and Company
Howard Woody Postcard Collection

5
"Vue De Port Au Prince," Haiti, ca. 1895
[View of Port au Prince, Haiti]
F5021
Color lithograph (ten hues)
9.2 X 14 cm
Printer: Kunstanstalt J. Miesler, Berlin, Germany
Howard Woody Postcard Collection

6
"Hindo Temple and Nauch Girls, Ceylon," ca. 1898
Collotype
8.7 X 13.8 cm
Printer: Stengel and Company, Dresden, Germany
Howard Woody Postcard Collection

7
"Mohamedan Woman," India, ca. 1900
"Chromo-Lichtdruck," chromo-collotype, color lithograph (ten hues)
13.7 X 9 cm
Printer: Knackstedt and Näther Company, Hamburg, Germany
Howard Woody Postcard Collection

8
"Japanerinnen beim Briefschreiben. Internationale Kunst-,
 Kunsthistorische und grosse Gartenbau-Ausstellung, Düsseldorf 1904.
 Offizielle Postkarte No. 27."
[Japanese women writing letters. International Art, Art Historical and
 Gardening Exhibition, Dusseldorf 1904. Official Postcard no. 27],
 Germany, 1904

"Auto-Chrom," chromo-halftone, color lithograph (six hues)
13.8 X 9 cm
Printer: Louis Glaser Company, Leipzig, Germany
Publisher: Schmitz and Olbertz, Germany
Howard Woody Postcard Collection

9
"The Shwe Dagon Pagoda, Rangoon," Burma, ca. 1904
"Photo-Iris," chromo-collotype, color lithograph (six hues)
8.8 X 14 cm
Printer: Otto Leder Company, Meissen, Germany
Distributor: Watts and Skeen (location undetermined)
Howard Woody Postcard Collection

10
"Langenthal, Hotel Bären," Switzerland, ca. 1898
("Gruss aus" postcard)
#1978
Color lithograph (eight hues)
9.2 X 14.1 cm
Printer: Kretzschmar and Schatz, proprietor Hermann Seibt,
 Meissen, Germany
Howard Woody Postcard Collection

11
"Langenthal, Hotel Bären," ca. 1898 (Verso)

12
Manufacturer's receipt card, 1908 (Verso)
#27291
8.7 X 13.9 cm
Distributor and importer: Hugh C. Leighton Company, Portland, Maine
Howard Woody Postcard Collection

13
Sample card, advertisement, ca. 1908 (Verso)
#1325
9 X 14 cm
Distributor and importer: Hugh C. Leighton Company, Portland, Maine
Howard Woody Postcard Collection

14
Portrait of L. A. Wilkinson, 1910
(Jobber's sample card)
#B7893
Half-tone
8.8 X 13.8 cm
Distributor and importer: Edwin F. Branning and Son, New York
Howard Woody Postcard Collection

15
Portrait of L. A. Wilkinson, 1910 (Verso)

16
"Girls Dormitory, Carroll College, Waukesha, Wis.," Wisconsin,
 ca. 1907
#62463

"Machine Colored Chromo," chromo-collotype, color lithograph
 (six hues)
9 X 14 cm
Printer: Knackstedt and Näther Company, Hamburg, Germany
Distributor and importer: Rotograph Company, New York
Howard Woody Postcard Collection

17
"Girls Dormitory, Carroll College, Waukesha, Wis." (Verso)

18
"View of an Interior Section of the Daylight Plant, Chilton Printing Co.,
 Market and 49th Sts., Phila.," Philadelphia, ca. 1910
Chromo-halftone, color lithograph (four hues)
8.8 X 13.9 cm
Printer: Chilton Printing Company, Philadelphia
Howard Woody Postcard Collection

19
"View of an Interior Section of the Daylight Plant, Chilton Printing Co.,
 Market and 49th Sts., Phila.," ca. 1910 (Verso)

20
"The Daylight Plant of the Chilton Company, Philadelphia, Pa. Largest
 Manufacturers of High-Grade Colored Advertising Post Cards in
 America," Philadelphia, 1910
Chromo-halftone, color lithograph (four hues)
8.8 X 13.5 cm
Printer: Chilton Printing Company, Philadelphia
Howard Woody Postcard Collection

21
"The Daylight Plant of the Chilton Company, Philadelphia, Pa. Largest
 Manufacturers of High-Grade Colored Advertising Post Cards in
 America," Philadelphia, 1910 (Verso)

22
"Post Card Exchange, Birmingham, Ala. W. H. Faulkner, Proprietor," 1913
#A-2957
Chromo-halftone, color lithograph (five hues)
8.8 X 13.7 cm
Printer: Curt Teich Company, Chicago
Sponsor: Post Card Exchange, Birmingham, Alabama
Howard Woody Postcard Collection

23
"Our Factory in Dresden - Germany," ca. 1907
(External view of Stengel and Company)
Chromo-collotype, color lithograph
14 X 9 cm
Printer: Stengel and Company, Dresden, Germany
Jose Rodriquez Postcard Collection

24
"Our Factory in Dresden - Germany," ca. 1907 (Verso)

25
"Fijian Village," Fiji, ca. 1900
#56,805
Collotype
8.8 × 13.7 cm
Printer: Stengel and Company, Dresden, Germany
Sponsor: A. M. Brodziak and Company, Suva, Fiji
Howard Woody Postcard Collection

26
"Tanger (sud) | Maroc," Morocco, ca. 1899
[Tangier (south), Morocco]
#29,531
Chromo-collotype, color lithograph (ten hues)
9.1 × 14.2 cm
Printer: Stengel and Company, Dresden, Germany
Sponsor: Hell, Tangiers, Morocco
Howard Woody Postcard Collection

27
"South African Ricksha Boys," ca. 1904
#8232
Chromo-collotype, color lithograph (six hues)
8.8 × 13.8 cm
Printer: Stengel and Company, Dresden, Germany
Sponsor: A. Rittenberg, Durban, South Africa
Howard Woody Postcard Collection

28
"Tiberias from the Lake," Palestine, ca. 1911
"Platinotype," collotype
8.7 × 13.9 cm
Printer: C. G. Röder Company, Leipzig, Germany
Howard Woody Postcard Collection, Gift of Chris McGregor

29
"Tiberias from the Lake," Palestine, ca. 1911
"Collotype-Antique," collotype
8.7 × 13.9 cm
Printer: C. G. Röder Company, Leipzig, Germany
Howard Woody Postcard Collection, Gift of Chris McGregor

30
"Tiberias from the Lake," Palestine, ca. 1911
"Doubletone Crystal," collotype
8.7 × 13.9 cm
Printer: C. G. Röder Company, Leipzig, Germany
Howard Woody Postcard Collection, Gift of Chris McGregor

31
"Tiberias from the Lake," Palestine, ca. 1911
"Heliodore," chromo-collotype, color lithograph (six hues)
8.7 × 13.8 cm
Printer: C. G. Röder Company, Leipzig, Germany
Howard Woody Postcard Collection, Gift of Chris McGregor

32
"Tiberias from the Lake," Palestine, ca. 1911
"Bromo-Iris," chromo-collotype, color lithograph (six hues)
8.7 × 13.8 cm
Printer: C. G. Röder Company, Leipzig, Germany
Howard Woody Postcard Collection, Gift of Chris McGregor

33
"Tiberias from the Lake," Palestine, ca. 1911
"Photochrome-Substitute," chromo-collotype, color lithograph (six hues)
8.7 × 13.8 cm
Printer: C. G. Röder Company, Leipzig, Germany
Howard Woody Postcard Collection, Gift of Chris McGregor

34
"Singapore. Variety of Fruits," Malaysia, ca. 1907
Collotype
8.9 × 13.7 cm
Printer: Knackstedt and Näther Company, Hamburg, Germany
Howard Woody Postcard Collection

35
"World's Columbian Exposition," Chicago, 1893
Silver gelatin print
Smithsonian Institution Archives, Washington, D.C.

36
"A Native Dance by the Wild Tribe of Igorrotes, in the Philippine
 Village. St. Louis World's Fair," 1904
Stereograph, silver gelatin print
Photographer: T. W. Ingersoll
Distributor: Canvassers
Library of Congress, Washington, D.C.

37
"Marseille - Exposition Coloniale - Grand Palais de la Côte Occidentale
 d'Afrique," France
[Marseille - Colonial exposition - Large hall of the West African Coast]
L.P.114
National Museum of African Art
Smithsonian Institution, Washington, D.C.
Eliot Elisofon Photographic Archives

38
"Cascade Gardens," St. Louis, 1904
Publisher: J. Koehler, New York
Frederick H. and Mary S. Megson Postcard Collection

39
"Exposition de Reims, 1903 — Le Village Noir. Tisserand - Visite
 Ministérielle," France
[Exposition in Reims, 1903 — The black Village. Weaver - Ministerial visit.]
Photographer and/or printer: L. B. R.
National Museum of African Art
Smithsonian Institution, Washington, D.C.
Eliot Elisofon Photographic Archives

40
"Ang-Ia and Da-Go-Mai. Igorrote Women Weavers," Seattle, 1909
Publisher: Park, 1909
Frederick H. and Mary S. Megson Postcard Collection

41
"Indigenas Balantas—Guiné (Rosita). Exposiçao Colonial Portugueza—
 Porto 1934," Portugal
[Indigenous Balante—Guinea (Rosita). Colonial Exposition—
 Porto 1934]
Publisher: Lit. Invicta, Porto, Portugal
National Museum of African Art
Smithsonian Institution, Washington, D.C.
Eliot Elisofon Photographic Archives

42
"A View from Zomba Plateau, Nyasaland," Malawi.
The Metropolitan Museum of Art, New York
Department of the Arts of Africa, Oceania, and the Americas
Photograph Study Collection

43
"Musée des Colonies. Exposition Coloniale Internationale —
 Paris 1931," France
[Museum of the Colonies. International Colonial Exposition —
 Paris 1931]
Printer: Braun & Cie, Imp.
National Museum of African Art
Smithsonian Institution, Washington, D.C.
Eliot Elisofon Photographic Archives

44
"Columbia. Eskimo Queen. Seattle Alaska-Yukon-Pacific International
 Exposition," Seattle, 1909
Publisher: Oakes Photo
Frederick H. and Mary S. Megson Postcard Collection

45
"Congo Belge Mweka. Jeune Homme Bakuba," Belgian Congo, 1958
[Mweka, Belgian Congo. Young Kuba man]
The Metropolitan Museum of Art, New York
Department of the Arts of Africa, Oceania, and the Americas
Photograph Study Collection

46
"Tall Man Dan (Sioux)," South Dakota, ca. 1900
Publisher: Valentine and Sons, Great Britain
Patricia Albers Postcard Collection

47
Laura Standing Bear, Sichangu Lakota from the Rosebud Reservation in
 South Dakota, ca. 1905
Distributor: Barnum and Bailey
Printer: Weiner, Great Britain
Patricia Albers Postcard Collection

48
Luther Standing Bear, a Sichangu Lakota from the Rosebud Reservation
 in South Dakota, ca. 1905
Printer: Weiner, Great Britain
Sponsor: Barnum and Bailey
Patricia Albers Postcard Collection

49
"Minnie Left Hand, Cheyenne Indian," Oklahoma, before 1908
Printer: Germany, ca. 1908
Publisher: The American News Company, Buffalo, New York
Patricia Albers Postcard Collection

50
"Chief Standing Bear, Laura Standing Bear and Alexandra Pearl Olive
 Birmingham England Standing Bear, June 7, 1903"
Printer: Weiner, Great Britain
Patricia Albers Postcard Collection

51
"Kiowa Papoose asleep"
Publisher: Illustrated Postcard Company, New York
Patricia Albers Postcard Collection

52
"To My Valentine," ca. 1915
Patricia Albers Postcard Collection

53
"Following the Old Travois Trail, McDermott Country, Glacier National
 Park, Montana. See America First," 1915
#5838
Photographer: Roland Reed
Publisher: H. H. Tammon, Denver, for the Great Northern
 Railroad Company
Patricia Albers Postcard Collection

54
"Cowboy Trading with Indians—Sign Language," 1909
Photographer: W. H. Martin
Publisher: North American Postcard Company, Kansas City, Missouri
Patricia Albers Postcard Collection

55
"Interior of Crow Teepee"
Sponsor: C. S. Trading Company, Sheridan, Wyoming
Patricia Albers Postcard Collection

56
"Wolf Voice Brothers and Family," ca. 1905
Photographer and publisher: E. L. Huffman, Miles City, Montana
Patricia Albers Postcard Collection

57
"Osage Indian Squaw and Papoose. Oklahoma"
Sponsor: Osage Indian Curio Company, Pawhuska, Oklahoma

Printer: Albertype Company, New York
Patricia Albers Postcard Collection

58
"Indians. 1908. Platte. S.D.," South Dakota
Patricia Albers Postcard Collection

59
"Omaha Dance, Sioux Indians, Murdo, S.D.," South Dakota, ca. 1910
Printer: Germany
Sponsor: Irwin, the Druggist, Murdo, South Dakota
Patricia Albers Postcard Collection

60
"Kiowa Indian Band, Indian Mission, Hobart, Okla.," Oklahoma
Printer: Germany
Publisher: C. E. Wheelock and Company, Peoria, Illinois
Sponsor: H. H. Johnson Post Office Bookstore, Hobart, Oklahoma
Patricia Albers Postcard Collection

61
Crow Indians, Montana, ca. 1909
Inscription: "Brings, 1909"
Silver gelatin print
Patricia Albers Postcard Collection

62
Northern Cheyenne girls, Montana, ca. 1910
Inscription: "Indian Kids"
Silver gelatin print
Patricia Albers Postcard Collection

63
"Three Little Maids from School Are We," Japan, 1901–1907
#6946
Printer and distributor: Detroit Photographic Company, Detroit
Patricia Albers Postcard Collection

64
"A Fair Japanese," Japan, 1901–1907
#6949
Printer and distributor: Detroit Photographic Company, Detroit
Patricia Albers Postcard Collection

65
"Miss Pomegranite" [sic], Japan, 1901–1907
#6952
Printer and distributor: Detroit Photographic Company, Detroit
The Metropolitan Museum of Art, New York
Jefferson R. Burdick Collection
Gift of Jefferson R. Burdick

66
"Queen of the Geisha," Japan, 1901–1907
Printer and distributor: Detroit Publishing Company, Detroit
The Metropolitan Museum of Art, New York

Jefferson R. Burdick Collection
Gift of Jefferson R. Burdick

67
"Wistaria" [sic], Japan, 1901–1907
Printer and distributor: Detroit Publishing Company, Detroit
The Metropolitan Museum of Art, New York
Jefferson R. Burdick Collection
Gift of Jefferson R. Burdick

68
"Japan's Fairest," Japan, 1901–1907
Printer and distributor: Detroit Publishing Company, Detroit
Patricia Albers Postcard Collection

69
"A Tokio Bell" [sic], Japan, 1901–1907
Printer and distributor: Detroit Publishing Company, Detroit
Patricia Albers Postcard Collection

70
"A Sunny Day in Japan," Japan, 1901–1907
Printer and distributor: Detroit Publishing Company, Detroit
The Metropolitan Museum of Art, New York
Jefferson R. Burdick Collection
Gift of Jefferson R. Burdick

71
"Afternoon Tea, Japan Scene," Japan
Distributor: The World in Boston Missionary Exposition
The Metropolitan Museum of Art, New York
Jefferson R. Burdick Collection
Gift of Jefferson R. Burdick

72
"Feeding Mulberry Leaves to Corticelli Silkworms," Japan, ca. 1910
Distributor: Corticelli Silk Company, Florence, Massachusetts
The Metropolitan Museum of Art, New York
Jefferson R. Burdick Collection
Gift of Jefferson R. Burdick

73
"Placing Corticelli Silkworms that are Ready to Spin on Twigs or
 Branches," Japan, ca. 1910
Distributor: Corticelli Silk Company, Florence, Massachusetts
The Metropolitan Museum of Art, New York
Jefferson R. Burdick Collection
Gift of Jefferson R. Burdick

74
"Filature—Reeling the Silk from Corticelli Cocoons by Power
 Machinery," Japan, ca. 1910
Distributor: Corticelli Silk Company, Florence, Massachusetts
The Metropolitan Museum of Art, New York
Jefferson R. Burdick Collection
Gift of Jefferson R. Burdick

75
"A Farmer Smoking in His Rain Coat," Japan, ca. 1900
Distributor: Union Postale Universelle
The New York Public Library
Picture Collection

76
"Horse and Keeper returning home," Japan, ca. 1900
The New York Public Library
Picture Collection

77
"Looking Forward to Welcoming You All. Mitsukoshi Gofukuten.
 Tokyo, Japan," ca. 1910
Printer: Tokyo Printing Company, Japan
The Metropolitan Museum of Art, New York
Jefferson R. Burdick Collection
Gift of Jefferson R. Burdick

78
"An Aboriginal Family," Australia, ca. 1880–1910
Photographer and publisher: Kerry and Company, Sydney, Australia
The Metropolitan Museum of Art, New York
Department of the Arts of Africa, Oceania, and the Americas
Photograph Study Collection

79
"Australian Aboriginal Mia Mia," ca. 1880–1910
Photographer: Charles Kerry or Henry King
Publisher: Kerry and Company, Sydney, Australia
The Metropolitan Museum of Art, New York
Department of the Arts of Africa, Oceania, and the Americas
Photograph Study Collection

80
"A Hongi—Whakarewarewa," Australia, ca. 1900–1916.
Photographer: Alfred Burton, 1885
Publisher: Muir and Moodie, Dunedin, New Zealand
The Metropolitan Museum of Art, New York
Department of the Arts of Africa, Oceania, and the Americas
Photograph Study Collection

81
"Mohi-Tirongomau," Maori, New Zealand, ca. 1900
Photographer: Josiah Martin, ca. 1880s
Printer: Otto Leder Company, Meissen, Germany
Distributor: Fergusson Limited, Sydney, Australia, and London, England
The Metropolitan Museum of Art, New York
Department of the Arts of Africa, Oceania, and the Americas
Photograph Study Collection

82
"Maori Man" [Mohi], New Zealand, ca. 1900
Photographer: Josiah Martin, ca. 1880s
Printer: Germany

Distributor: S. Hildesheimer and Company, London and
 Manchester, England
The Metropolitan Museum of Art, New York
Department of the Arts of Africa, Oceania, and the Americas
Photograph Study Collection

83
"Rewi Maniapoto. The Great Maori Fighting Chief," New Zealand,
 ca. 1912
Photographer: Josiah Martin, 1894
Printer and distributor: Harding and Billings, Great Britain
The Metropolitan Museum of Art, New York
Department of the Arts of Africa, Oceania, and the Americas
Photograph Study Collection

84
"Great Chiefs at Whare-Komiti, Haerehuka, King Country," New
 Zealand, ca. 1905
#3622
Photographer: Alfred Burton, 1885
Printer: Germany
Publisher and distributor: Muir and Moodie, Dunedin, New Zealand
The Metropolitan Museum of Art, New York
Department of the Arts of Africa, Oceania, and the Americas
Photograph Study Collection

85
"A Good Joke ('Alle Same te Pakeha')," New Zealand, after 1905
Painting of Te Aho te Rangi Wharepu by Charles Frederick Goldie, 1905
The Metropolitan Museum of Art, New York
Department of the Arts of Africa, Oceania, and the Americas
Photograph Study Collection

86
"A Maori Dark-Eyed Maiden," New Zealand, ca. 1903
Photographer: Arthur J. Iles, ca. 1894
Printer: Valentine and Sons, Dundee, Scotland
Distributor and publisher: S. M. and Company
The Metropolitan Museum of Art, New York
Department of the Arts of Africa, Oceania, and the Americas
Photograph Study Collection

87
"Maori Maiden of High Degree," New Zealand, ca. 1903
Photographer: Arthur J. Iles, ca. 1894
Printer: Valentine and Sons, Dundee, Scotland
Distributor and publisher: S. M. and Company
The Metropolitan Museum of Art, New York
Department of the Arts of Africa, Oceania, and the Americas
Photograph Study Collection

88
"Typical Maori Woman, N.Z.," New Zealand, ca. 1910
Photographer: Frank Denton, ca. 1890–1910

Printer and distributor: Wilson and Company, F. T. Series, Auckland, New Zealand
The Metropolitan Museum of Art, New York
Department of the Arts of Africa, Oceania, and the Americas
Photograph Study Collection

89
"Maori Salutations, NZ," New Zealand, ca. 1910
Photographer: Frank Denton, ca. 1890–1910
Printer and distributor: Wilson Photo Post Card Company Studios, Auckland, New Zealand
The Metropolitan Museum of Art, New York
Department of the Arts of Africa, Oceania, and the Americas
Photograph Study Collection

90
"Maori Women Weaving Flax, Rotorua, N.Z. Tourist Series 8264," New Zealand, after 1901
Printer: Germany
Publisher and distributor: Frank Duncan and Company, Auckland, New Zealand
The Metropolitan Museum of Art, New York
Department of the Arts of Africa, Oceania, and the Americas
Photograph Study Collection

91
Verso of a card "Maori Salutations," New Zealand, ca. 1906–7
Distributor: Wilson and Company, New Zealand and Great Britain
The Metropolitan Museum of Art, New York
Department of the Arts of Africa, Oceania, and the Americas
Photograph Study Collection

92
"Kathleen 'Maori Guide' Rotorua," New Zealand
Printer: Germany
Publisher: Fergusson and Company, New Zealand
The Metropolitan Museum of Art, New York
Department of the Arts of Africa, Oceania, and the Americas
Photograph Study Collection

93
"Maggie, 'Maori Guide,' and Maori Carving," New Zealand
The Metropolitan Museum of Art, New York
Department of the Arts of Africa, Oceania, and the Americas
Photograph Study Collection

94
"Maggie Papakura, Guide at Whakarewarewa," New Zealand
Photographer: J. W. Beattie (?)
Publisher and distributor: W. Beattie and Company, Auckland, New Zealand
The Metropolitan Museum of Art, New York
Department of the Arts of Africa, Oceania, and the Americas
Photograph Study Collection

95
"'Maggie the Famous Guide at Whakarewarewa,' Rotorua, N.Z.," New Zealand, ca. 1926
4190 P
Photographer, publisher, and distributor: Muir and Moodie, Dunedin, New Zealand
The Metropolitan Museum of Art, New York
Department of the Arts of Africa, Oceania, and the Americas
Photograph Study Collection

96
"Guides 'Bella' and 'Maggie,' Rotorua" [Maggie Papakura and her sister Bella], New Zealand, before 1908
Photographer, publisher, and distributor: Arthur Iles, New Zealand
The Metropolitan Museum of Art, New York
Department of the Arts of Africa, Oceania, and the Americas
Photograph Study Collection

97
"Greetings from Maoriland," New Zealand
Printer: Germany
Publisher and distributor: Fergusson and Company, J. B. Series, New Zealand
Collage of photographs by Daniel L. Mundy, William Beattie, Herbert C. Deveril, Pulman Studio, and Samuel Carnell, ca. 1880–1900
The Metropolitan Museum of Art, New York
Department of the Arts of Africa, Oceania, and the Americas
Photograph Study Collection

98
"The Maoris," New Zealand
Collage of photographs by several photographers, ca. 1880–1900
Publisher and distributor: James Valentine and Sons, Great Britain
The Metropolitan Museum of Art, New York
Department of the Arts of Africa, Oceania, and the Americas
Photograph Study Collection

99
"Maori Chief. Patarangukai," New Zealand
Photographer: George Valentine, ca. 1880s
Publisher and distributor: James Valentine and Sons, Great Britain
The Metropolitan Museum of Art, New York
Department of the Arts of Africa, Oceania, and the Americas
Photograph Study Collection

100
"Samoans playing Cards," ca. 1912
Photographer: George Bell, ca. 1890
Publisher and distributor: Kerry and Company, Sydney, Australia
The Metropolitan Museum of Art, New York
Department of the Arts of Africa, Oceania, and the Americas
Photograph Study Collection

101
"Grüsse aus Samoa," Samoa, ca. 1907
[Greetings from Samoa]
Photographer: A. J. Tattersall, Samoa, ca. 1890s
Printer: Trenkler and Company, Leipzig, Germany
The Metropolitan Museum of Art, New York
Department of the Arts of Africa, Oceania, and the Americas
Photograph Study Collection

102
"Samoanische Schönheit, Samoa," Samoa
[Samoan beauty, Samoa]
Photographer: A. J. Tattersall, Samoa, ca. 1890s
Printer: Trenkler and Company, Leipzig, Germany
The Metropolitan Museum of Art, New York
Department of the Arts of Africa, Oceania, and the Americas
Photograph Study Collection

103
"Greetings From Samoa High Chief," Samoa, ca. 1907
Photographer: A. J. Tattersall, Samoa, ca. 1890s
Printer: Trenkler and Company, Leipzig, Germany
The Metropolitan Museum of Art, New York
Department of the Arts of Africa, Oceania, and the Americas
Photograph Study Collection

104
"Building a Samoan House," Samoa, after 1900
Silver gelatin print
Photographer: John Davis, ca. 1893–1900
Printer and distributor: A. J. Tattersall, Samoa
The Metropolitan Museum of Art, New York
Department of the Arts of Africa, Oceania, and the Americas
Photograph Study Collection

105
"Samoan Girls. The Orient Exhibition," 1908
Photographer: John Davis or Kerry and Company, ca. 1890
Publisher and distributor: London Missionary Society,
 Picture Post Card Department
The Metropolitan Museum of Art, New York
Department of the Arts of Africa, Oceania, and the Americas
Photograph Study Collection

106
"Samoan Girl," Samoa, ca. 1907
Photographer: Thomas Andrew (?)
Printer: Theodor Eismann, Leipzig, Germany
The Metropolitan Museum of Art, New York
Department of the Arts of Africa, Oceania, and the Americas
Photograph Study Collection

107
"Patteson Memorial Cross. Nukapu. Reef Islands," Melanesia, ca. 1906
Photographer: Rev. H. H. Montgomery
Publisher: Melanesian Mission, Church House, Westminster,
 Great Britain
The Metropolitan Museum of Art, New York
Department of the Arts of Africa, Oceania, and the Americas
Photograph Study Collection

108
"Discharging Timber for Mission House at Villa Larella," Melanesia
Photographer: Rev. George Brown (?), ca. 1902
Printer and publisher: The Crown Studios, Sydney, Australia
The Metropolitan Museum of Art, New York
Department of the Arts of Africa, Oceania, and the Americas
Photograph Study Collection

109
"Bow of War Canoe. Rubiana," Melanesia
Photographer: Rev. George Brown, 1902
Printer and publisher: The Crown Studios, Sydney, Australia
The Metropolitan Museum of Art, New York
Department of the Arts of Africa, Oceania, and the Americas
Photograph Study Collection

110
"A Zulu Warrior," South Africa, ca. 1900
Postmarked: 1907
Publisher: Sallo Epstein and Company, Durban, South Africa
National Museum of African Art
Smithsonian Institution, Washington, D.C.
Eliot Elisofon Photographic Archives

111
"La leçon de couture," Belgian Congo, ca. 1915
[Sewing lesson]
Sponsor: Mission des Filles de la Charité, Nsona-Mbata, Belgian Congo
Publisher: Ern. Thill, Brussels, Belgium
National Museum of African Art
Smithsonian Institution, Washington, D.C.
Eliot Elisofon Photographic Archives

112
"Kindu Négresses modernisées," Belgian Congo, ca. 1915
[Kindu modernized black women]
Printer: Nels, Belgium
Publisher: Ferraz, Frères
National Museum of African Art
Smithsonian Institution, Washington, D.C.
Eliot Elisofon Photographic Archives

113
"Kindu Ménage heureux," Belgian Congo, ca. 1915
[Kindu Happy household]
Printer: Nels, Belgium

Publisher: Ferraz, Frères
National Museum of African Art
Smithsonian Institution, Washington, D.C.
Eliot Elisofon Photographic Archives

114
"Pö puore (Sie beugen sich) Tochter eines Vornehmen in Bamum,"
 Fumban, Cameroon, ca. 1912
[Pö puore (They bend down) Daughter of a Bamum nobleman]
Silver gelatin prints
Photographer: Anna Wuhrmann, ca. 1912
Courtesy Église Évangélique, Fumban, Cameroon

115
"CAMEROUN Petite fille de Foumban - Helena," Fumban, Cameroon,
 ca. 1920 [Cameroon Little girl from Fumban - Helena]
Communication dated September 1924
Photographer: Anna Wuhrmann, ca. 1912
Publisher: Missions Evangéliques de Paris, France
National Museum of African Art
Smithsonian Institution, Washington, D.C.
Eliot Elisofon Photographic Archives

116
"Afrique Occidentale - Soudan. 1014. Jeunes Femmes Arabes de
 Tombouctou," Mali, ca. 1905
[West Africa - Sudan. 1014. Young Arab women from Timbuctu]
Photographer and publisher: François-Edmond Fortier, Dakar, Senegal
National Museum of African Art
Smithsonian Institution, Washington, D.C.
Eliot Elisofon Photographic Archives

117
"A GROUP OF GIRLS - ALL SISTERS," South Africa, ca. 1890
16. 'R508
Albumen print
Photographer: J. Wallace Bradley, Durban, South Africa, ca. 1890
The Metropolitan Museum of Art, New York
Department of the Arts of Africa, Oceania, and the Americas
Photograph Study Collection

118
"A Group of Girls (All Sisters)," South Africa, ca. 1900
Photographer: J. Wallace Bradley, Durban, South Africa, ca. 1890s
Publisher: Hallis and Company, Port Elizabeth, South Africa
National Museum of African Art
Smithsonian Institution, Washington, D.C.
Eliot Elisofon Photographic Archives

119
"Types Soussous de CONAKRY (Guinée Francaise)," French Guinea,
 ca. 1900 [481. - Susu types from Conakry (French Guinea)]
481
Photographer and publisher: Collection de la Guinée Française,
 A. James, Conakry, Guinée
National Museum of African Art
Smithsonian Institution, Washington, D.C.
Eliot Elisofon Photographic Archives

120
"Southern Nigeria, West Africa. Overani. [Ovonramwen]. Ex King of
 Benin City," Nigeria, ca. 1897
National Museum of African Art
Smithsonian Institution, Washington, D.C.
Eliot Elisofon Photographic Archives

121
"Afrique Occidentale. Traitant sénégalais," Senegal, ca. 1905
[West Africa. Senegalese trader]
1230
Photographer and publisher: François-Edmond Fortier, Dakar, Senegal
National Museum of African Art
Smithsonian Institution, Washington, D.C.
Eliot Elisofon Photographic Archives

122
"CONAKRY - Concours agricole - Groupes de Féticheurs et danseur
 Faranah," French Guinea, ca. 1910
[Conakry - Agricultural exhibition - groups of Faranah fetish priests
 and dancers]
Photographer: Alphonse Owondo, Guinea
National Museum of African Art
Smithsonian Institution, Washington, D.C.
Eliot Elisofon Photographic Archives

123
"Togo. - Le Roi d'Anécho Lawson," Togo, ca. 1905
[Togo. Lawson, the king of Anecho]
37
Photographer: A. Accolatse, Togo
National Museum of African Art
Smithsonian Institution, Washington, D.C.
Eliot Elisofon Photographic Archives

124
"Gold Coast. Lt. Chief Andor of Elmina," Ghana, ca. 1905
Communication dated 1906
Photographer: W. S. Johnston, Sierra Leone, ca. 1897
Publisher: "Sanbride"
National Museum of African Art
Smithsonian Institution, Washington, D.C.
Eliot Elisofon Photographic Archives

125
"Sierra Leone—Freetown—Final departure of His Excellency Govr. Cardew from the shores of Sierra Leone," ca. 1905
Postmarked 1908
Photographer: W. S. Johnston, Sierra Leone, 1900
Publisher: "Sanbride"
National Museum of African Art
Smithsonian Institution, Washington, D.C.
Eliot Elisofon Photographic Archives

126
"Bondoo Devils, Sierra Leone," ca. 1915
Photographers and publishers: Lisk-Carew Brothers, Freetown, Sierra Leone, ca. 1910
National Museum of African Art
Smithsonian Institution, Washington, D.C.
Eliot Elisofon Photographic Archives

127
"Bondu Girls, Sierra Leone," ca. 1910
Photographers and publishers: Lisk-Carew Brothers, Freetown, Sierra Leone, ca. 1910
National Museum of African Art
Smithsonian Institution, Washington, D.C.
Eliot Elisofon Photographic Archives

128
"Guinée Française. CONAKRY.—Jeunes filles circoncises après l'opération," French Guinea, ca. 1905
[French Guinea. Conakry.—Young girls after circumcision]
38
Postmarked 1906
Producer: Comptoir Parisien, Conakry, Guinea
National Museum of African Art
Smithsonian Institution, Washington, D.C.
Eliot Elisofon Photographic Archives

129
"Gold Coast Beauty," Ghana, ca. 1900
Photographer: N. Walwin or J. A. C. Holm, Lagos, Nigeria, and Accra, Ghana
Printer: "Printed at the works in Germany"
National Museum of African Art
Smithsonian Institution, Washington, D.C.
Eliot Elisofon Photographic Archives

130
"Types of the Lagos Fire Brigade," Nigeria, ca. 1900
Photographers: N. Walwin or J. A. C. Holm, Lagos, Nigeria, and Accra, Ghana
Printer: "Printed at the works in Germany"
National Museum of African Art
Smithsonian Institution, Washington, D.C.
Eliot Elisofon Photographic Archives

131
"GELEDE MALES and FEMALES," Nigeria, ca. 1900
Photographer: N. Walwin or J. A. C. Holm, Lagos, Nigeria, and Accra, Ghana
Printer: "Printed at the works in Germany"
National Museum of African Art
Smithsonian Institution, Washington, D.C.
Eliot Elisofon Photographic Archives

132
"Damsels of Shining Virtue - Primitive by Nature. Sierra Leone," ca. 1915
Photographer and publisher: Lisk-Carew Brothers, Freetown, Sierra Leone
The Metropolitan Museum of Art, New York
Department of the Arts of Africa, Oceania, and the Americas
Photograph Study Collection

CONTRIBUTORS

PATRICIA C. ALBERS is director of the American West Center and Professor of Anthropology at the University of Utah. In addition to her extensive writings on visual representations of American Indians on postcards, she has published many different works on American Indian women and on intertribal relations.

CHRISTRAUD M. GEARY is curator of the Eliot Elisofon Photographic Archives at the National Museum of African Art, Smithsonian Institution, Washington, D.C. She received her doctorate in cultural anthropology from Frankfurt University, Germany. She is the author of numerous articles and several books on photography in Africa, and African art and history.

ELLEN HANDY is associate curator at the International Center of Photography in New York. She received her Ph.D. in Art History from Princeton University. Handy has curated exhibitions and written extensively on both nineteenth- and twentieth-century photography.

ROBERT W. RYDELL is professor of history at Montana State University–Bozeman. He is the author of *All the World's a Fair* (1984) and *World of Fairs* (1993) both published by the University of Chicago Press. Rydell recently held a research fellowship at the Netherlands Institute for Advanced Study, where he codirected a project that investigated the reception of American mass culture in Europe.

VIRGINIA-LEE WEBB is archivist, Photograph Collection, Department of the Arts of Africa, Oceania, and the Americas, at the Metropolitan Museum of Art, New York. She received her Ph.D. in art history from Columbia University, New York, as a Marcia and John Friede Fellow in Oceanic Art. She has organized exhibitions on colonial photography and published numerous articles about photographers working in the Pacific Islands and Africa.

HOWARD WOODY is distinguished professor emeritus at the Art Department of the University of South Carolina, specializing in research of historical postcards. He has published his postcard research in numerous articles in national journals and lectured extensively on the topic. He is currently coeditor of the eight-volume *South Carolina Postcards. The Golden Era: 1898–1930*, published by *Images in America*.

INDEX